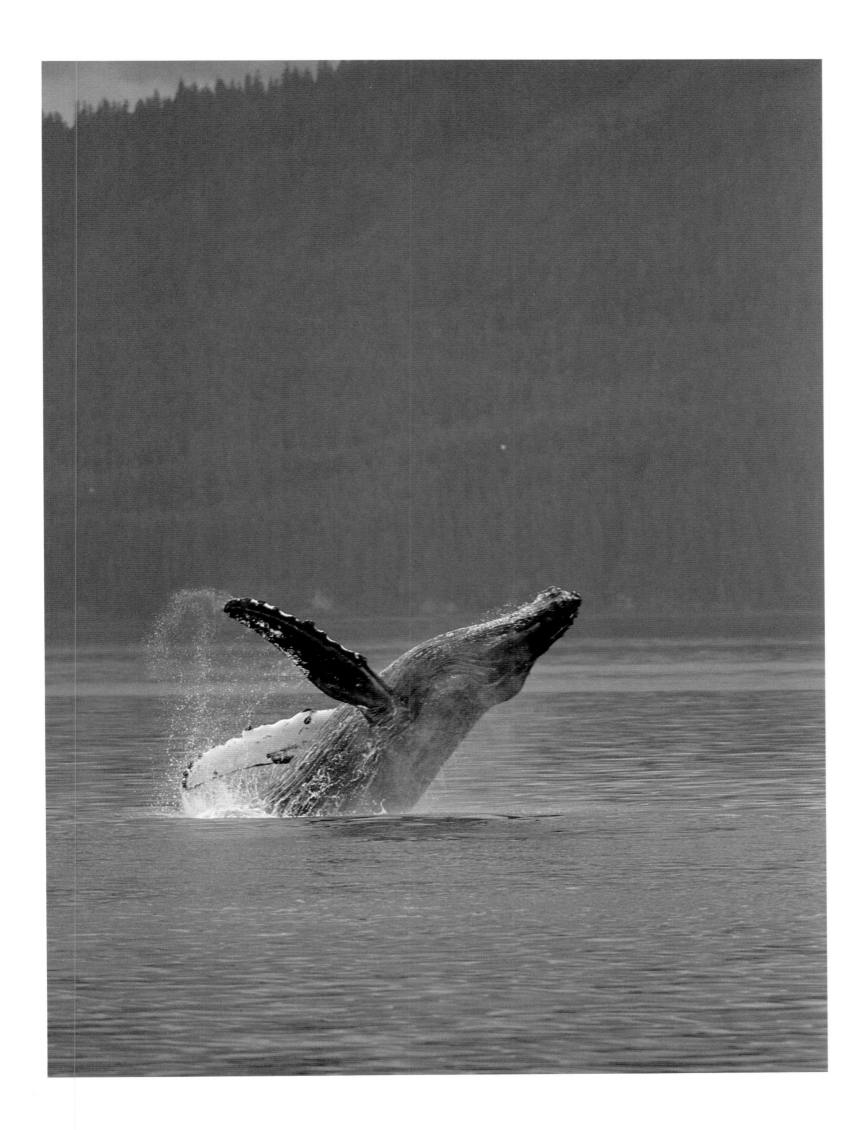

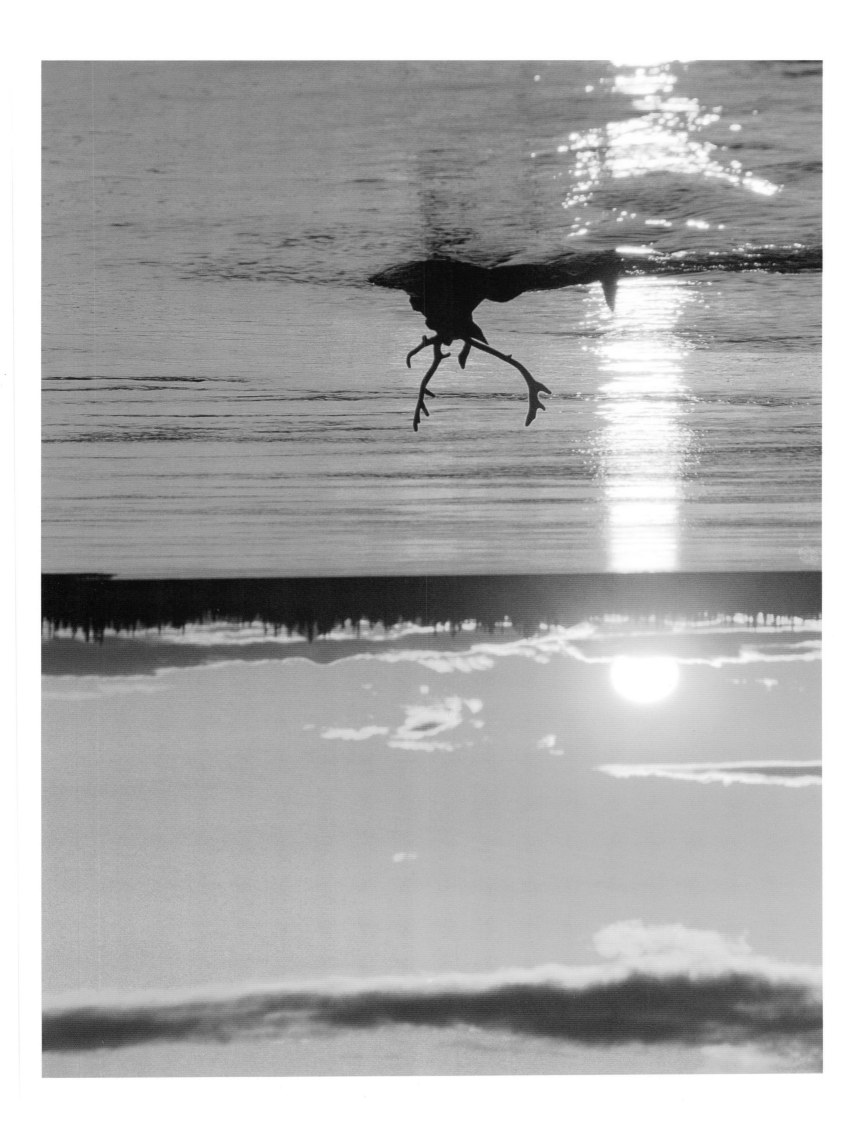

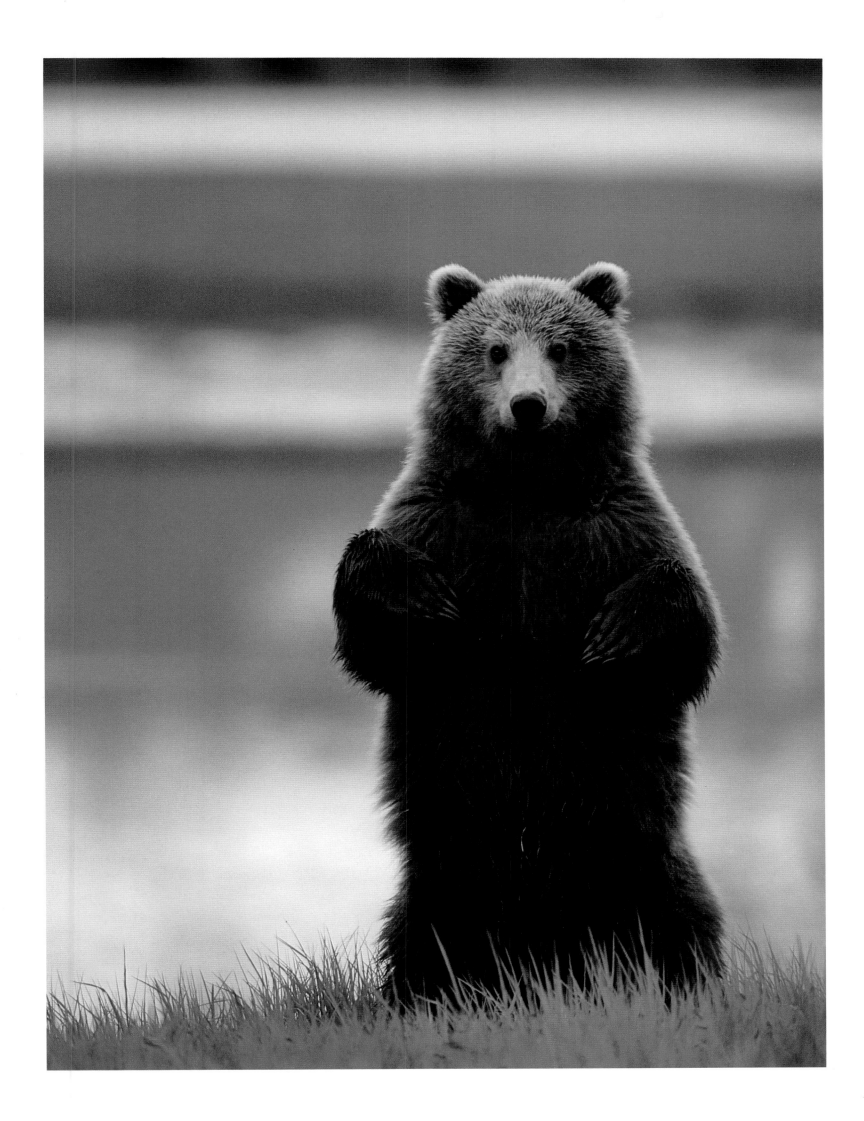

ALASKA'S WILDLIFE

BY TOM WALKER

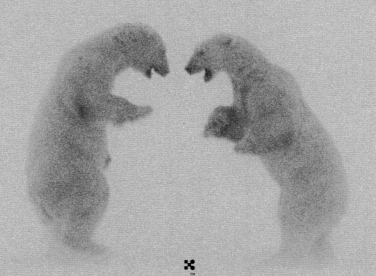

GRAPHIC ARTS CENTER PUBLISHING®

International Standard Book Number 1-55868-201-5
Library of Congress catalog number 94-73057
Text and Photographs © MCMXCV by Tom Walker
Published by Graphic Arts Center Publishing Company
P.O. Box 10306 • Portland, Oregon 97296-0306 • 503/226-2402
President • Charles M. Hopkins
Editor-in-Chief • Douglas A. Pfeiffer
Managing Editor • Jean Andrews
Designer • Robert Reynolds
Production • Richard L. Owsiany
Book Manufacturing • Lincoln & Allen Co.
Printed in the United States of America
Third Printing

In memory of
Helen and Cecil Rhode

TOM WALKER

□ Page One: *Endangered humpback whales migrate each spring from Hawaiian waters to the rich feeding grounds off Southeast Alaska.* □ Page Two: *Each autumn just prior to the rutting season, herds of caribou moving to winter ranges must cross mountains and broad rivers.* □ Page Three: *Brown bears, fresh from hibernation, congregate on tidal flats to gorge on new spring sedges.* □ Title Page: *Across the vast stretches of arctic ice, polar bears hunt seals and other marine mammals. The playful sparring of juveniles may be training for the more serious battles of adulthood.* □ Facing Page: *Normally active at night, lynx are sometimes seen during long spring and summer days. Many sightings occur in early morning of late March when Lynx are searching for mates.*

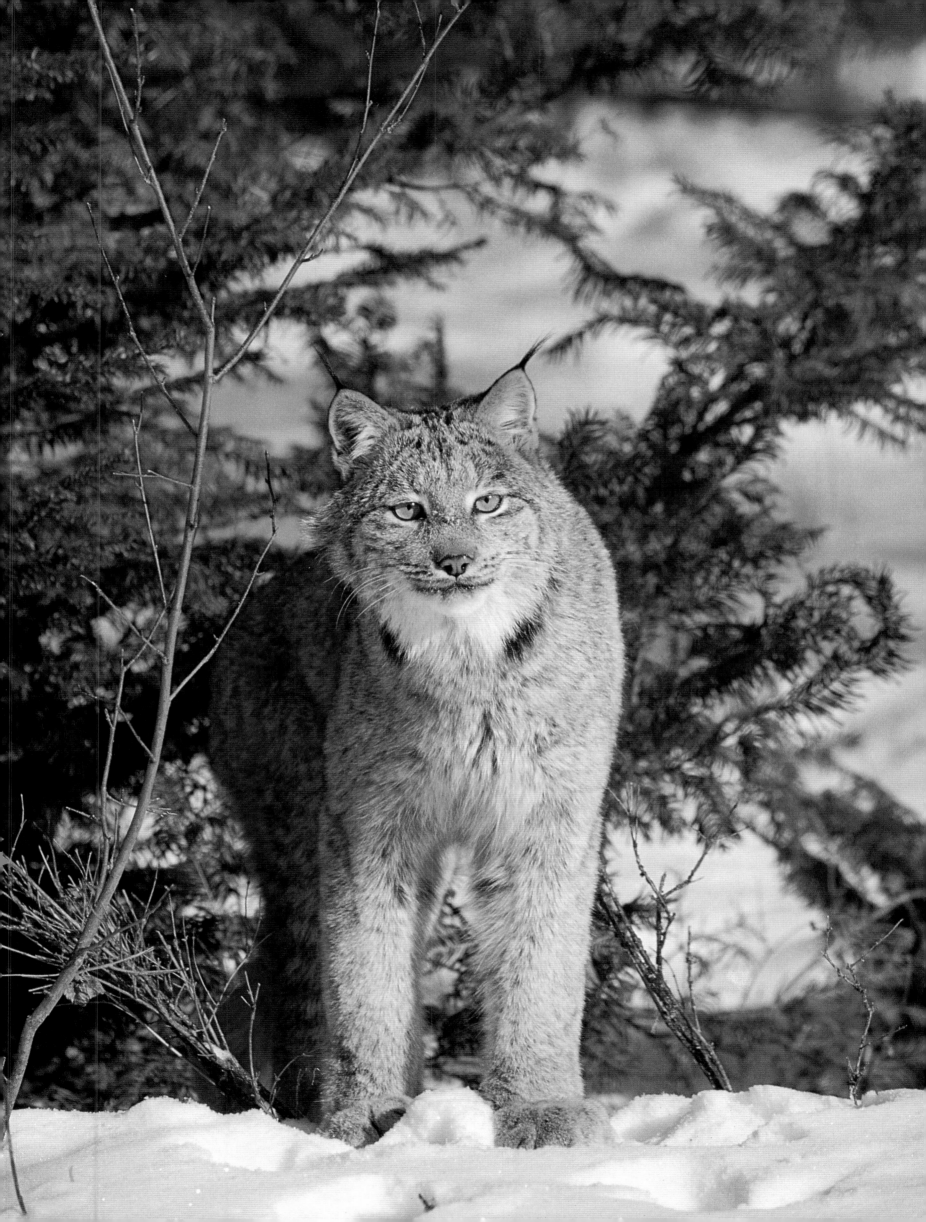

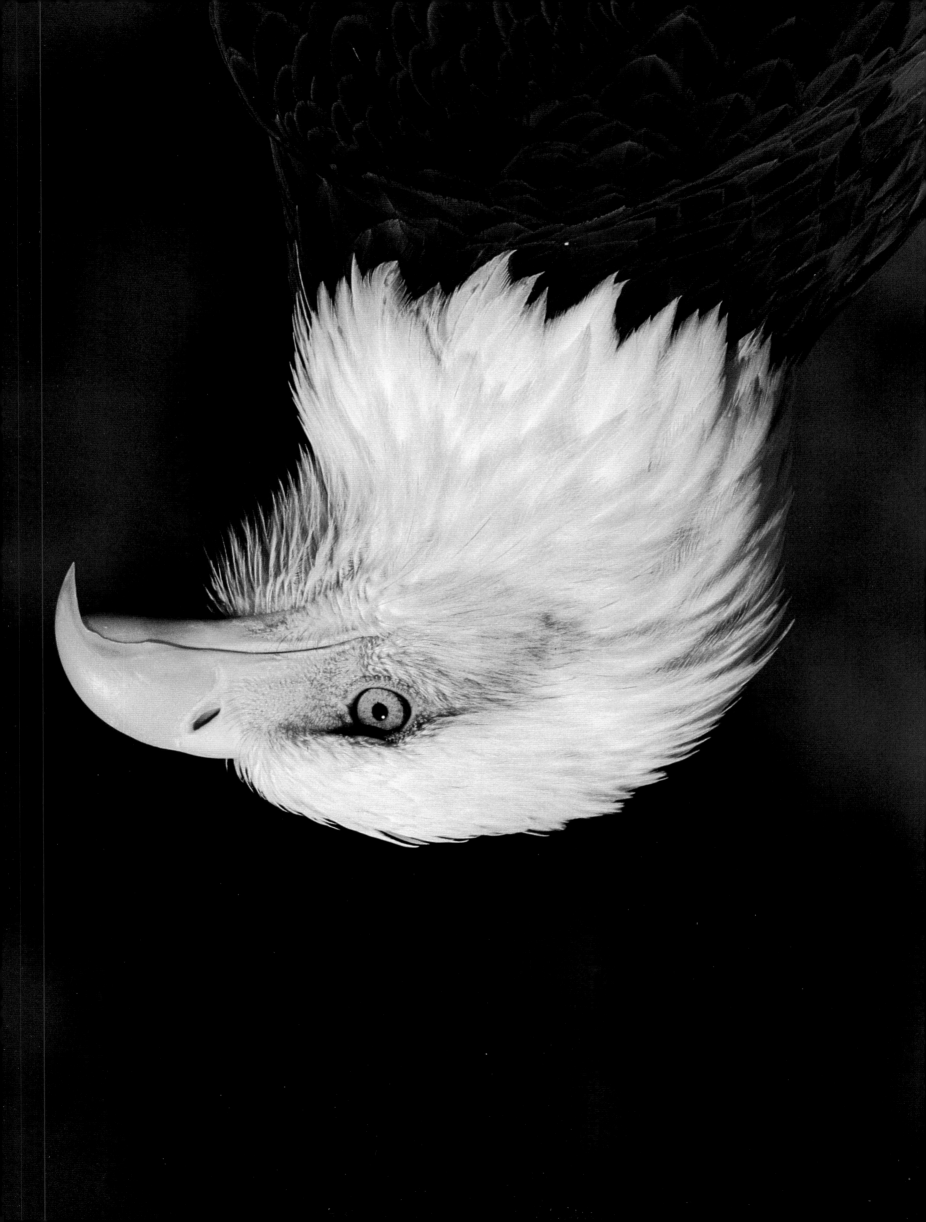

ice out

In the depth of Alaska winter, where the temperatures bottom out at a record minus 80 degrees Fahrenheit, it seems as if even *sound* can freeze. Except where the wind murmurs in the forest or shrieks across the tundra, silence is winter's anthem. Only the occasional quorking of a raven breaks the deafening silence.

By early April, midday temperatures regularly begin to approach, even surpass, freezing. The earth stirs beneath the snow and ice. The gurgle of running water and the drip-drip-drip of thaw become commonplace. On distant hills, coyotes yodel near their dens, while in the forest, owls hoot on their territories. On the tundra, ptarmigan, which have been mute for weeks, call from the willow coverts.

The forests of Southcentral Alaska welcome the first migrant songbirds. The burry whistle of the varied thrush echoes in the timber. The first small flocks of shorebirds, vanguard of millions, arrive on the tidal flats. Snow geese and Canada geese appear in estuaries and wetlands. The trumpeting of swans and the gossip of cranes add to the tumult. Bird song, the most notably missing element in winter forest and tundra, now enlivens the earth. Without question, winter is at an end.

Often *spring* in Alaska is more a state of mind than a season. Temperatures can still drop to minus 30, with biting winds that claw at exposed flesh. Yet each day, the sun rises higher and stays longer in the sky. After winter's long dark, when the April sun blasts the snowy slopes and plain, it is time to go out and record the lives of animals as they emerge from their great struggle. Though I long to see and hear the first migrating geese, in mid-April I want most to see how the resident wildlife has fared the winter.

Early spring, however, is a time for a wildlife photographer to move gently around animals. Although it may be easy to ski or snowshoe over the crusty snow, the grazers and browsers have survived long, difficult months of scant food and should not be disturbed. The real end of winter is still many long days away.

Dall sheep clothed in their winter raiment *look* huge in spring, but their weight is at its lowest with vital fat reserves depleted. Many ewes are pregnant and need all their energy to ensure both their own survival and that of their unborn lambs. The last thing these animals need is to be put to flight through deep snow by a photographer or hiker.

One spring, I traveled into the Chugach Mountains to photograph an immense ram that was frequenting the slopes of Pioneer Peak. The icy slopes and snow-filled gullies made climbing hazardous; it was a struggle to reach the ridge east of the peak where I camped. Small bands of sheep fed on exposed forage in the few places where solar heating and wind had shorn the slopes of snow. I eventually located the target ram grazing amid a band of smaller rams. The area was then open to hunting, and most rams were wary of humans. On another occasion here, I had approached a group of mature rams, and they had not spooked. I hoped these rams would behave the same way. *Wishful thinking!* The rams saw me at a distance edging across a snowy incline, and, to my dismay, they bolted up and over the ridge. In the ensuing days, I never caught sight of them again.

Looking back, I rue the youthful stubbornness that continued the pursuit. Those rams did not need to be challenged in their ancient spring haven. Contrast that inexperienced *faux pas* with a recent trip into another ram country.

☐ Facing Page: *The bald eagle is named for its conspicuous white head. This distinctive marking is not attained until birds are five or more years old. Juveniles have mottled head feathers.*

On the first day, I easily located a band of rams on their spring range. I did not try to sneak up on them, but, instead, hiked toward the sheep in open view. A ram snapped alert from grazing and stared in my direction. Cued by its posture, all the rams were soon watching me. To allow them to get used to me, I sat down on a rock and took out a frozen sandwich to gnaw on. These were not Denali National Park sheep that are tolerant of people, but neither were they as wary as those on Pioneer Peak. The last thing I wanted was to disrupt these rams. My goal was photography of *undisturbed* behavior. In time, the band returned to feeding, and I tired of chewing icy peanut butter. I stood up and took a slow step toward the sheep. Heads swivelled my way, but after awhile the sheep resumed feeding. It took over an hour to meander within camera range. My caution paid off. Later, the rams bedded down within fifty yards of where I sat on a rocky outcrop.

In late afternoon, I headed back to camp with a sense of satisfaction. My fingers were numb; my toes, wooden blocks. My cheeks stung with frost. The sheep continued to feed where I first encountered them. That alone made me happy. Oh, photographs? Not a one worth saving. But the next day . . . yes, the next day. . . .

wolf howls & caribou bones

A mile from where the wolves first trotted off the tundra ridge and down into the willows, they began to run. Following their tracks, I saw where they had left concealment and raced onto the frozen river. There, they turned south and ran out onto the open tundra. In the distance, I saw a magpie lift from a dark stain on the snow and fly off with a hoarse, scolding call.

Careful tracking unraveled the tale. A lone caribou had been pawing for lichens on the riverbank, and the wolves had given chase. Two ran together; the third circled wide. The pair beelined for the lone cow and rapidly gained ground. Pressed hard, the cow ran in an arcing trajectory. The lone wolf, angling in, cut the curve and made first contact. All that now remained of the caribou were gnawed bones, scattered hair, and a few scraps for the magpies and the lone red fox that had visited the kill.

It was impossible to determine when the kill had been made, but definitely since a storm three days before. The antlered skull evidenced the cow's pregnancy. Bulls shed their antlers in late October or early November. Non-pregnant cow caribou lose theirs later. Pregnant caribou shed their antlers either right at the time of calving, or shortly thereafter. It is late April and likely that two caribou died here.

This was not the first caribou I had found killed by wolves. Once I actually saw a wolf kill a calf caribou. It was in Sunset Pass in the Arctic National Wildlife Refuge.

Spring came to the high arctic in June—*late* June that year—and even that month was stormy. The majority of the Porcupine Caribou Herd calved in the mountains well away from the wintry plain. Thousands of caribou wandered through the pass in the two and one-half weeks I camped there. I also shared the valley with a dozen grizzlies and at least three different wolves, a black and two grays.

One sleety, overcast morning, I sat on a knoll near my camp watching a herd of two dozen cows and calves approach and wade the creek below me. The lead animals crossed without hesitation and trotted off across the tundra. After the entire herd crossed,

□ Left: *Bull moose fatten for the rigors of the rut and often enter winter with fat reserves depleted or suffering from wounds sustained in dominance battles. Winter mortality is high.*

a single cow detached to return to the cobblestone creek bed. She hurried to a calf struggling in the rocks. Somehow during the crossing, the two-week-old calf had broken a hind leg. Urged on by its circling mother, the calf limped a few feet across the rocks and onto the tundra.

The cow was frantic. The urge to move on was powerful, but so was her connection to her disabled calf. She ran back and forth between the calf and the herd until the herd went over a nearby ridge. The cow raced after them, leaving the calf alone on the river bank. The calf tried to follow but fell. Soon its mother came running back. Urging her calf on, the cow circled, head low, calling loudly. The calf managed to rise but could not walk. The plaintive grunts of the caribou carried well in the still, quiet morning. Once again, the urge to move on overpowered the cow's maternal instinct, and she again left the calf to follow the herd. Several minutes passed. Just when I thought the calf was abandoned, the whole herd raced back over the ridge. They stampeded away from the calf and ran by my tent. They kept going for more than half a mile before slowing. Several stopped to stare toward the talus above my camp. I expected to see a bear, but saw no cause for the commotion. The herd paused only a moment before continuing a mad dash up canyon. The calf took two feeble steps before faltering. I glassed the slope repeatedly, but saw no movement.

The herd ran the mile to the head of the canyon as if pursued and went out of sight around the bend. I put down my binoculars and looked back at the calf, which staggered toward the creek. A wolf raced downhill toward it. The "chase" was over in an instant. The wolf slammed into the calf, knocked it down, and took it by the neck.

I watched the wolf rip open the calf's abdomen and feed for less than ten minutes. When finished, it licked its muzzle and paws and then walked toward where I sat in plain view. The wolf's coloration blended so superbly with the sere tundra that I had difficulty following its progress across the tussock slope. The bloody-jowled wolf stopped to stare at me from less than thirty yards. I gazed into those yellow eyes for just a moment before the wolf turned and trotted down to the creek where it drank. It took one long look over its shoulder at me before fording the river. I lost sight of it far out on the tundra.

I walked to the calf's remains. The wolf had opened the carcass from throat to vent, neatly eviscerating it. Only the liver, kidneys, and heart had been eaten.

Looking down at the gore, I realized I had witnessed the "classic" predator-prey scenario in which the predator supposedly kills only the weak, sick, or lame. I was thankful for the sudden termination of the calf's suffering, but I knew wolves did not always kill so quickly. Wolves sometimes kill healthy calves as well as disadvantaged adults. In succeeding days, the wolf never returned to finish its kill. Jaegers, a golden eagle, and red foxes consumed the leftovers.

Tom Meier, a wildlife scientist then studying wolves in Denali National Park, was more than a little interested when I told him of the kill. He had seen similar incidents. The conversation turned to Dall sheep. Based on his field work, Meier said he doubted that sheep could ever make a stand against wolves. Unless safely perched on a cliff, he said, sheep would always panic into flight. Yet that very next fall, on the Alaska-Yukon border, I saw a band of sheep make a stand against wolves.

☐ Right: *Wolves are superb hunters of moose, caribou, deer, and Dall sheep. All wolves are opportunistic, feeding on any animals they can catch, including beaver, ptarmigan, hares, and ground squirrels.*

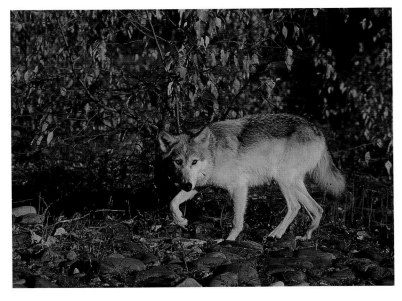

One sunny November day, I climbed a steep, snow-covered ridge toward sparring rams. While catching my breath halfway up the ridge (and questioning my sanity for being out at minus 20 on a neck-breaking, ice-encrusted cliff), I saw movement between me and the sheep.

A wolf was creeping toward the rams through the rocks. The rams saw the wolf almost at that same instant and dashed off the ridge down into the steep avalanche chute to my right. The wolf pursued them.

Proving my own dementia, I also climbed down into the couloir in an attempt to keep the chase in sight. At once, I was in trouble, the going steep and dangerous; all my attention was on finding hand- and footholds. I saw the rams climbing out of the couloir, but I did not see the wolf. Spurred on by visions of a wolf feasting on ram, I pushed as fast as I dared across and out of the chute. It took almost thirty minutes for me to cover the distance the rams had crossed in seconds.

On a bald knob in the center of the cirque to the east was a milling herd of sheep. Through my binoculars, I could see rams, ewes, and lambs, all crowded together, with *two* wolves approaching scant feet away.

A ewe stepped forward, head and horns lowered, and the herd *en masse* feinted at the wolves. Both dodged away. Three times the maneuver was repeated with the same result. Then the densely packed herd charged the wolves. One wolf bolted away, tail between its legs. Its companion tried an end run toward a lamb, but the herd turned toward it and drove it away, too. Astounded, I watched the wolves cross the cirque, climb the slope, and disappear over the ridge.

into the eyes of a grizzly

Snow had been falling for about two hours. Not a hard snow but a steady, persistent one. The tundra ground cover was already buried by just two inches of wet flakes. I was hunkered behind a three-foot-tall willow, the tallest *tree* around. The snow was not unwelcome; I don't mind watching animals in poor weather.

Caribou had been passing my camp for hours, at least since midmorning of the previous day, one of drizzle and low fog, with little light for photography. Now I could photograph the migration in summer snow. The spring movement to the North Slope calving grounds was over. The Porcupine Caribou Herd, perhaps 175 thousand strong, was headed through the Brooks Range on the long slow movement toward the winter range in central Yukon. Bulls, cows, and calves trooped by in small bunches and impressive herds. From behind my tree I had limited visibility, not because of the willow's luxuriant growth weighted with snow, but because of a low ridge jutting up before me. I could see the caribou moving on the ridge and on the slopes beyond, but I had no view to the north or of the swale behind the ridge. I had no wish to get closer. I wanted only to photograph the caribou.

The illusion of invisibility, the ability to observe animals without disturbing them in the slightest way, is joy. "The mouse on the tundra." In the last week, playing the part of the "mouse," I'd seen a peregrine make a stoop on some unseen prey; a grizzly chase caribou for two hours before finally killing a calf; and a golden plover tend its eggs laid in a lichen depression.

As the moisture slowly seeped in through my thin rain pants, then through my wool pants, I began to stiffen with cold. Except

☐ Left: *Female brown bears with cubs are drawn in spring to sedge flats favored by other bears, including large males. For protection, family groups stay close to cliffs or thick brush.*

for slight adjustments of position, I dared not move. The photographs were coming to me!

Just as the slope beyond the nearby ridge filled with caribou and a long line of them began to string out in the foreground—the very scene I had been waiting to photograph—the entire herd stampeded. I cursed under my breath. *Did they see me? Scent me?* My spirits sank. I scanned the higher slopes beyond the ridge. Nothing. The valley swiftly emptied of caribou. I struggled to my feet, but my knees refused to straighten. There was tightness in my back and shoulders, the cold deep in my body. I flailed my arms to warm up. *Why had the herd bolted?* There were no mosquitos, botflies, or other pests to torment them. There had to be a reason.

My first thought was of wolves. I thought it would be both lovely and exciting to see them make a hunt in the snow. But wolves would already have been in full chase. I turned around to study the slope behind me. Nothing.

I saw the bear as soon as I turned back. It was walking the ridge the caribou had vacated and was close. *Very close.*

The bear saw me at once and stopped stone-still. I was downhill from it in a shallow depression, a very bad position. The closest trees were hundreds of miles away. Climbable cliffs were too far to offer haven. There was literally nowhere to go. This was the moment I had long expected: unarmed, face to face with a grizzly on the open tundra.

In nearly thirty years in Alaska, I have encountered all sorts of bears in all sorts of circumstances, but never so close on open tundra. I have never felt more vulnerable. My mind raced through my options. I knew that to bears *size* is an important factor in establishing hierarchy. I wanted to trade places with the bear, be on the ridge looking down on it. I didn't want to look small and perhaps helpless. I dared not move or make a provocative gesture.

Complicating the matter, the wind blew south from the bear to me. It could not yet get my scent and identify me with certainty. Bears have good vision, but they do not trust their eyesight. I was making no sound the bear could fix on and ponder. Bears need the assurance of their sense of smell. I knew *my* scent would determine the outcome.

After a long, wrenching pause, the grizzly walked to its right, and to my left. It came down from the ridge into the depression, its gaze locked on me. With its second step, I began to walk toward the ridge. I circled like a wary prizefighter, acutely aware of the mismatch—the flyweight versus the heavyweight champion.

I was glad to gain the high ground. It was as open and devoid of safety as the depression, but I felt immeasurably better off. Now that the bear was somewhat below me, it looked smaller. I hoped I looked larger, more intimidating. We had traded positions almost exactly. The bear stood smelling my tracks, and the wind blew from me to him. He lifted his head and sniffed the breeze with quivering nostrils. I could hear a low grumble, a mutter.

As the bear evaluated the situation, I dared not move. Seconds, which seemed minutes, ticked away. Finally, the grizzly turned to walk away. Every few steps he looked back, to see, perhaps, if I was following or pulling a sneak attack. *Fat chance.* As he walked, he piddled and yawned often, body language signaling stress. Though this stress posed a threat to me, it was small comfort to know I was not the only one glad to see the contact end.

All at once I was aware of sound. The wind. The water dashing over the rocks. My own breathing. My field of view

□ Right: *Buoyant, hollow-hair coats and wide-splayed hooves aid caribou in swimming. Bull caribou readily take to the water during migration or to escape predators like wolves and bears.*

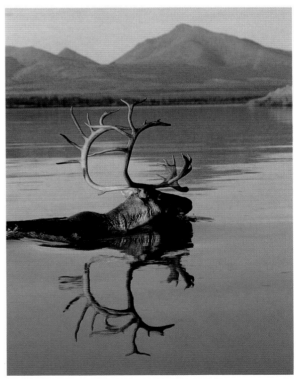

began to widen, and the world came into focus. The snowy tundra. The mountains beyond. The falling snow. I was also aware again of the smell of the rich wet earth.

I waited until the bear was long gone before I walked back to the willow bush for my pack. I took fifty steps to my pack, then another ten steps beyond to look down at the imprint of paws in the snow. I then shouldered my pack and backtracked toward camp. I had had enough "photography" for one day.

arctic loons & wolverines

The reality of wildlife photography is far different from popular perceptions. Upon viewing my photograph of a nesting red-throated loon, a woman remarked that she would love to have been there. I asked her to articulate the imagined circumstance. She described a warm summer evening in a blind by the side of a tranquil pond while enjoying the varied loon behaviors. When she finished her description, I could only wish that outdoor photography in Alaska was as pleasant as her conception.

To get that picture, I had waited for *days* not just *hours*. The wind blew across the tundra day after day without letup. Cold, snowy days alternated with sunny, warm ones filled with mosquito legions that turned the inside of the blind into a Dantesque hell. My food ran low, and I suffered from a miserable flu-like illness that kept me in my tent for three days. When the wind finally died one night, at about 2 A.M., it did so for only two or three hours. The sky was clear; the arctic sun, unobscured. As the wind faded and the water stilled, the loon dozed. Expecting the wind to pick up at any time, my tension level increased by the moment.

□ *Left: To attain flight, loons must first run a considerable distance across the water. Red-throated loons fly after a short run, which allows the use of small nesting ponds.*

Warm light, golden grass, a gorgeous bird, a marvelous reflection in the water. If only the bird would open its eyes, look alert.

Then it happened: an arctic fox sallied across the marsh. The loon's head popped up, eyes sparkling with a striking catch light, its head swiveling to follow the meandering fox. Once the fox passed by, the loon stirred and rose up to roll its eggs around before settling on them again. In those few moments, I forgot the cold, my fatigue, and the mosquitoes. Within an hour, the wind again began to blow, and the reflection disappeared in the roiled water.

Wildlife photography in true wilderness is often uncomfortable, and not without hazard. In reality, wildlife—bears, for example—pose the *least* risk to the photographer. Stream-crossings, boat and small plane transportation, storms, isolation, injury, hypothermia—all offer greater risk. At best, wildlife photography often means camping for days at a time in small tents and subsisting on almost unpalatable, freeze-dried foods. It requires rigorous hiking across difficult terrain, while burdened under the weight of an enormous pack full of absurdly expensive, high-tech equipment that must be protected from impact damage and the assault of the elements. Even good days usually mean being cold, tired, and hungry. Most of all, the craft requires more patience than was allotted to Job. Wildlife photography can be described as hours and hours of boredom interspersed with brief moments of joy.

Then why do it? Great wildlife photographers are often described as driven—or obsessed. And so it appears. I prefer, however, to think that most of us do what we do because we possess tremendous imaginations. We *fantasize* endlessly, imagining the perfect picture, or what lies around the next bend in the river. I could see in my mind's eye, for example, the loon picture well

□ Right: Red, or sockeye, salmon spend one to four years at sea before returning to spawn in their natal streams. Upon entering freshwater, bright silver-colored sockeyes turn red.

before the elements came together. No matter how pie-in-the-sky, I envision scenes I want to photograph: a wolverine digging squirrels; wolves pulling down a moose; a black bear with a bright red salmon in its mouth. Whenever my enthusiasm is squashed by physical toil, bad weather, or short rations, all I need is to get a glimpse of a prized subject and I'm off, ready to try again.

Some dreams are illusive. Over time, I have seen fourteen different wolverines roaming wild and free but have yet to get a picture of one. Other dreams come true with remarkable alacrity. Once, while sitting on a hillside in the Brooks Range enjoying the view of snow-capped Mount Chamberlin, I thought, *If only a herd of caribou would come into sight now. Less than half an hour later, a herd of caribou trotted over the ridge precisely where desired.*

In winter, I often daydream of photographing a moose or caribou on a scarlet sward, or against a backdrop of golden hills dominated by snow-tipped peaks. I awaken at night from images of thousand-pound bull moose jousting with one another, or of bears going at it with gaping jaws and swatting paws. Unlike many events in life, these visions are the residue of reality. Perhaps the one single reason why I persist, despite the hardships and solitude, is because, in the end, through the lens, dreams *do* come true.

salmon, talons, & teeth

Even after almost thirty years of tromping wild paths, I am often still surprised at how lifeless some habitats can appear. On a *per acre* basis, Alaska supports far fewer large terrestrial mammals than do smaller states in more temperate zones. At certain times of year, despite an overall statewide caribou population that surpasses one million, vast tracts of prime caribou habitat are empty. Caribou appear to be in almost perpetual migration. I have seen the tundra covered with thousands of animals one day, only to be barren the next. On the grand scale, caribou can form huge post-calving aggregations in astonishing numbers that help foil both predators and insect tormentors. Nearly one hundred thousand animals have been seen tightly grouped together on the edge of the Arctic Ocean.

Caribou are not the only animals that are so transient. Sometimes, ptarmigan flock by the hundreds to migrate to rich winter habitats. In Canada, movements of eight hundred miles have been documented. Waterfowl, shorebirds, raptors, and most songbirds migrate. Some travel alone; others migrate in huge flocks. Each year in October, the world's largest concentration of geese gathers near Cold Bay and Izembek Lagoon. When the right combination of wind, temperature—and perhaps whim—come together, tens of thousands of black brant, Canada geese, greater white-fronted geese, and emperor geese migrate south almost all at once. Aviation alerts are issued.

Although migrations offer the best examples of seasonal abundance, calving and breeding also produce temporary groupings. Herds of elk, moose, sheep, and caribou form during their annual rutting seasons, in some cases the sole time of year when the sexes mingle. Pockets of abundance more commonly develop in connection with seasonal food sources. All animals need food, water, and cover. These are the minimum requirements for establishing home ranges and territories. Brown bears normally avoid close contact with one another except during breeding season. After emerging from hibernation in spring, the need for sustenance is so great that bears are often found grazing together

on choice terrains. In autumn, bears also share lush berry patches. Mountain goats in early summer congregate at mineral licks and again in fall on snow-free cliffs above the sea. In winter, I have seen as many as ninety-nine moose at one time on a particular willow flat. Forage is not produced equally across all habitats. It is the richness of forage in summer, but more importantly in winter, that helps biologists determine the *carrying capacity*—the number of animals that can live off the land—of a particular habitat.

All five species of Pacific salmon—kings, silvers, chums, pinks, and reds—along with char and steelhead trout, return from the north Pacific to spawn in Alaskan waters. While few rivers support runs of all five species, several produce runs of three or more species. Pacific salmon, renowned for their migrations, navigate by "reading" the sun, stars, water temperature, earth's magnetism, and by olfactory clues—the "odor" of the chemical footprint of specific streams. Inexorably, salmon wend their way home to natal waters. These salmon runs also illustrate the powerful lure of abundant food. Salmon, however, do not migrate inland to forage; instead, they lure varied animals that feed on *them*.

In early May, with the return of king salmon (which may weigh over one hundred pounds), a migratory onslaught begins that lasts well into October and beyond. Almost with the appearance in spring of the first silvery fish at river mouths and in tidal estuaries, predators arrive for the banquet. Orcas, seals, and sea lions are the first to feed on the returning schools. Sea otters catch an occasional salmon inshore. Even as runs move upstream, some ocean predators follow. Beluga whales are common in the mouths of smaller rivers. In 1993, a pod of Belugas was seen in the Yukon River at Tanana, 750 miles upriver from the Bering Sea. At least one made it as far as Fort Yukon, almost *eight hundred miles* upriver. Harbor seals are not uncommon in fresh water.

While some animals wait for salmon to come to them, others move long distances to take advantage of this bounty of easily exploitable protein. Almost *everything* eats fish—land otters, red foxes, coyotes, wolves, black bears, and brown bears. The wolverine is the only large meat eater I have not seen dining on salmon, but no doubt some do. On a stream bank in Prince William Sound, I once saw a marten feeding on a pink salmon.

During the two to seven years that salmon species mature in the open sea, finned predators—fishes, toothed whales, seals, sea lions—and disease take a toll. Humans also claim a share. Of the billions of eggs laid each year on Alaskan spawning beds, only a fraction will mature and return to spawn. Young salmon are susceptible to predation, too. Gulls, terns, and resident fish species feast on migrating salmon smolt or over-wintering fry.

Pacific salmon and brown bear. The two are as synonymous as Alaska and winter. A bear wading from a frothy stream with a salmon in its mouth is the clichéd wildlife image of Alaska. Both Alaskan brown bears, *Ursus arctos,* and American black bears, *Ursus americanus,* catch and eat salmon, but rarely do the two species coexist on the same watercourse. Black bears enjoy exclusive use of only a few streams; most are dominated by their larger cousins. A brown bear may kill and eat any black bear it catches.

Like humans, not all bears are good at fishing. Some are more adept than others. One bear at McNeil River State Game Sanctuary once caught ninety-one salmon in one day, eating only a portion of each fish caught. During the peak of the run, a bear at McNeil will catch and eat about eight chum salmon a day. On this

☐ Left: *Black bears congregate along several salmon streams in Southeast Alaska and Prince William Sound. Because brown bears are a threat to their safety, black bears seldom stray far from the forest.*

largess a mature bear can gain over three hundred pounds during the summer. One bear on the Alaska Peninsula *doubled* its body weight—from 250 to 500 pounds—by fall.

Kodiak brown bears, giants in a race of giants, grow to their immense size (the record animal scaled at over fifteen hundred pounds) largely because of their seasonal diet of salmon. Salmon runs, however, are not always reliable. The living is easy when fish are abundant; tenuous, when fish are scarce. Reproductive success, as well as survival, is often tied to summer fishing. Winters are harsh, and hibernation in Alaska can last seven months. In years when both the salmon runs and berry crops fail, starving bears die in their dens. Malnourished females may not bear young, or their cubs die shortly after birth.

Brown bears sometimes gather at prime fishing locations in large numbers. I once saw *sixty-five* bears in the quarter-mile stretch of river above and below McNeil River Falls. The record is sixty-seven. Sanctuary manager Larry Aumiller estimated there were one hundred twenty-five bears in the surrounding one-mile area. These record concentrations are seasonal and do not reflect annual area population densities. Many bears may move long distances to take advantage of the chum salmon stacked up below McNeil Falls. Only a few bears live year-round within sanctuary boundaries. In part because of their rich salmon streams, Kodiak and Admiralty Islands support about one bear per square mile. An area on the Alaska Peninsula boasts an even higher density.

Like brown bears, bald eagles travel great distances and congregate along prime salmon streams. Eagles are commonplace in their preferred habitat of coastal old-growth forest. In summer and fall, they are also ubiquitous inland along salmon streams and lakeshores. Late-season runs attract large numbers of birds. In mid-winter, dozens of eagles collect along the Kenai River. In peak season, the Chilkat Bald Eagle Preserve's forty-eight thousand acres, near Haines, Alaska, support the world's largest gathering of eagles. A late-fall chum salmon run attracts birds from as far away as Washington State and Alaska's Prince William Sound. In November, up to four thousand eagles can be found along a five-mile stretch of river. The Chilkat Valley's year-round population of eagles is two hundred.

The preserve's peak numbers are particularly impressive considering that just thirty years ago the bald eagle was nearly extirpated over most of the contiguous United States. By 1963, bald eagles in the Lower 48 dwindled to an estimated low of 417 nesting pairs. A 1992 survey pegged the population at 3,747 pairs, prompting talk of its removal from endangered species status. Alaska's eagles, although once hunted for bounty, never declined as dramatically as the pesticide-plagued Lower 48 populations.

Reportedly, eagles can see a fish or other prey from over a mile away. Bald eagles not only rely on fish for sustenance, but occasionally kill waterfowl, gulls, and—rarely—small mammals. Carrion is an important diet item. Compared to smaller birds of prey, eagles are relatively slow flyers. Though they fly at thirty miles per hour, they can dive at one hundred. Ravens and hawks harass and taunt eagles in flight. Ravens swoop and spin circles around eagles, making eagles appear maladroit. Eagles are capable, however, of astonishing aerobatics. During courtship in April, eagles lock talons and dive in spectacular somersaults and loops. Off the Homer Spit, I have seen as many as sixteen eagles involved in the pursuit of an eagle clutching a herring. It is almost a game of

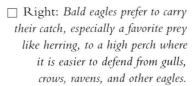 □ Right: *Bald eagles prefer to carry their catch, especially a favorite prey like herring, to a high perch where it is easier to defend from gulls, crows, ravens, and other eagles.*

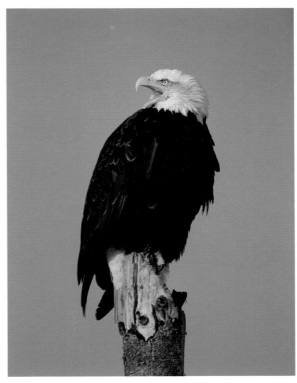

tag, rather than a feeding behavior. One eagle may snatch the fish from another's talons before, in turn, losing the fish to yet another eagle. Or the fish may fall free and be caught by an eagle twisting onto its back in midair to make the catch. The eagle with the fish becomes the pursued until either the herring falls into the sea or the hungry eagle makes off with it.

In part because of the abundance of fish, bald eagles in the wild can live over twenty-two years; captive birds have lived to almost forty. Like some waterfowl, bald eagles mate for life. In spring, the female usually lays two eggs, which hatch in May. Hatchlings are white. Immature eagles are mottled brown and white. An adult's head and tail turn all white in its fifth year. Adults average thirteen pounds, with females larger than males. Adult wingspans range from six to almost eight feet. An eagle captured recently on the Chilkat River had a wingspan of ninety inches.

Once, near Haines, on an unusually warm November morning, I saw over fifty eagles lazily circling on thermals rising from a south-facing peak. Perhaps *kettling,* as it is called, satisfies some ill-defined social function, but on such days the eagles appear to be ascending—sometimes high enough to be lost to sight—for the plain joy of flight. At such times, I wish I could join them.

flukes & spouts

Summer is brief—a time to be on the saltwater, a moment to savor views of the nearly thirty species of marine mammals that are resident or transient to Alaskan waters. Marine mammals are warm-blooded, air-breathing animals that live most of their lives in the sea. It is believed that most of them have evolved from terrestrial ancestors.

Cetaceans—whales, dolphins, and porpoises—are animals that inspire our imagination. Coastal Alaska is rich with seventeen species of cetaceans, ranging in size from the giant blue whale down to the common harbor porpoise.

One of the first whales to migrate north in spring is a "baleen" whale, the bowhead. Having no teeth, they consume tiny sea organisms by filtering them through jaws of hairy baleen. Bowheads can ram through ice one to two feet thick. Though still considered an endangered species, they are increasing in number. Northern Eskimos conduct limited subsistence whale hunts.

In summer, humpback whales are found in Southeast Alaska, where they filter-feed inshore on tiny shrimplike crustaceans and small fish, such as herring. In winter, humpbacks calve off Hawaii. This endangered whale is notable for its acrobatic behaviors such as breaching and tail-lopping. The sight of a *twenty-five ton* whale leaping from the sea is certainly awe-inspiring.

Gray whales, also an endangered species, have increased dramatically in recent years. In spring, they migrate almost five thousand miles from calving grounds off Baja to summer feeding zones in the Bering and Arctic Seas. They are the only whale that dredges the mud of the ocean floor to filter out amphipods and crustaceans. A few years ago, two gray whales were trapped in the ice off Barrow, sparking an international rescue effort.

Belugas are white whales about twelve to fourteen feet in length and weighing three thousand to thirty-three hundred pounds. They find their food with highly-developed sonar. Their broad audio repertoire has earned them the nickname "canaries of the sea." Common in northern and western coastal waters, they congregate near river mouths during salmon migrations.

☐ Left: *Female humpback whales average twenty-five tons; males, thirty-five tons. Despite their bulk, humpbacks are quite acrobatic; breaching, spyhopping, and lobtailing are common behaviors. Males are renowned singers.*

Male Orca whales can weigh eight tons and measure twenty-six feet long. Females are somewhat smaller. They are highly social, traveling in pods of up to fifty animals. Like humpbacks, Orcas can be quite acrobatic. Cooperative hunting is a trait that has earned them special notice. These toothed whales feed on fish, squid, and other marine mammals, even at times attacking larger whales. Their population is stable.

The black and white Dall's porpoise is a bow-wake rider that delights mariners. These three-hundred-pound mammals can hurtle through the water at speeds approaching twenty knots, ranking them among the swiftest of all cetaceans. They are seasonally common in Alaska waters.

Pinnipeds—"fin-footed" carnivores adapted to the sea—include seals, sea lions, and walrus. All have four webbed flippers, hair, and are insulated with blubber. They are adapted for diving, some capable of staying down two hours with the ability to descend to *forty-five hundred feet*. All are opportunistic feeders, consuming a wide variety of fish and invertebrates.

Steller sea lions weigh up to fifteen hundred pounds and often gather in large groups on haulouts or rookeries. They have a variety of vocalizations, but roar rather than bark like the common California sea lion. Stellers are declining and threatened.

Northern fur seals are depleted but still number almost 1.5 million. Fur seals are pelagic and rarely come ashore outside their breeding grounds in the Pribilof Islands. Commercial harvests of fur seals, which have one of the densest, warmest furs known to man, ended in 1984, although some are still killed for subsistence.

Harbor seals are common coastal residents. They can dive to depths of six hundred feet, submerging for up to twenty-five minutes at a time. Underwater, they are agile and swift enough to catch salmon.

Ribbon, bearded, and ringed seals are "ice seals," those associated with the pack ice. Ringed seals stay with the ice year-round, bearing their pups in excavations in snow. Pups wean quickly on milk with 40 to 50 percent fat content. Ringed seals may live forty years.

The scientific name of the walrus, *Obodenus,* means "tooth-walker," and the name is apt. Walrus, which can weigh over two tons, use their elongated canines both for protection and to haul themselves up onto the ice or onto beach haulouts. They do not use their tusks for digging as was once thought, but rather dive to the bottom of the sea and root through the mud with their *vibrissae,* or "whiskers," for mollusks, whereupon walrus suck the meat from the shells. Walrus are gregarious; groupings into the thousands are common. Their population is either stable at around 240 thousand or slowly declining.

Polar bears and sea otters are also considered marine mammals. The former is a bear, of course, while the latter is a member of the weasel family. The polar bear is the least adapted to an aquatic existence, but is a highly adapted ice hunter. Polar bears are protected from the cold by heavy layers of fat and thick fur. They normally stay with the pack ice through summer, but also ride slabs of drifting ice. Bears rest, mate, and birth on the ice, although some populations den ashore. In recent years, they have been found inland where previously unrecorded. A polar bear was shot sixty miles from the coast as it was raiding an Inupiaq fishing site. Polar bears eat ringed and bearded seals, other mammals, eggs, plants, carrion, and—uncommonly—belugas and walrus.

☐ Right: *Humpbacks employ a variety of feeding techniques. Lunge feeding is simply a giant gulp through massed prey—either euphausids (tiny shrimp-like creatures) or small fish (like herring).*

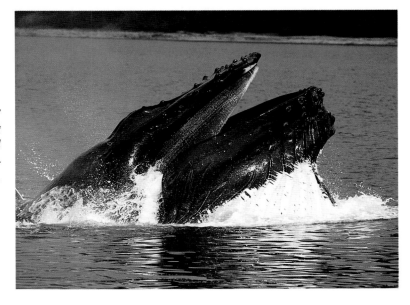

Sea otters are common all the way from the Aleutians south to California. They spend little time ashore, since they rest, mate, feed, and nurse their pups in the water. Alaskan otters are larger and more at home on land than are their southern cousins. Sea otters sport a coat of thick fur, the densest among all mammals. Old animals have white heads and can weigh up to seventy pounds. Otters use tools—rocks—to open bivalves. They dive for up to four minutes at a time to depths of three hundred feet. Otters burrow deep into the sea mud for crustaceans. They eat clams, mussels, urchins, crabs, and fish. Because otters consume 20 to 25 percent of their body weight *each day,* they are quite capable of impacting the size and abundance of their prey. Some 160 thousand otters live along the Alaska coast, with rafts of up to one thousand not uncommon. Both polar bears and sea otters are increasing.

It is one thing to know all these facts about Alaska's more common marine mammals; it is entirely another to see them in their natural habitat. Off Admiralty Island, I have observed Orca whales interacting with other marine mammals. Following is a narrative pulled from my field notes.

Some distance off the starboard bow, dozens of black and white Dall's porpoises surface in slow rolls. They appear not to be traveling together so much as just feeding and moving in the same general locale. We seem to be passing well to the port of them. We do not alter course or our speed of ten to twelve knots.

"Here they come!" yells the captain, throttling up to his maximum safe speed of fifteen knots. Four or five porpoises just visible under the surface are angling in at great speed toward the bow. Before they reach us, they break water three times for breath.

"Bow riders!" I rush to the bow. Porpoises are taking turns surfing the wake. The crystalline water reveals their every motion. I can see the powerful propelling sweep of their flukes. They hold in place with slight effort and seem capable of much more speed. When one porpoise peels away from the wake, another swoops in to take its place. I can see how the blowhole slams shut when the porpoise submerges, and on surfacing how it snaps open for inhalation. Each breath is accompanied by a sound like a shot.

Porpoises veer in and out from the bow with amazing agility. Several times they cross from side to side in one pass. Once, a porpoise zooms across the bow, only to reverse direction with a 180-degree backflip with no apparent loss of speed. One porpoise lines up directly in front of the bow, in essence "breaking trail" for us. It positions itself just eight to ten inches in front of the keel. Now and again, it drops back ever so slightly until its flukes almost touch the bow. With only the slight, rhythmic sweep of its fluke, it hangs in place for minutes, changing depth only for a breath, apparently judging position by the water pressure off the bow. After fifteen minutes of play, they veer away. We will see others.

Another day, we are again heading south, when off to port we see five Orcas paralleling us, two females with calves and a mature male. They are on a slightly intersecting course. Again we continue at standard speed. They soon close to within a hundred yards, seemingly unaffected by our convergence. Their travel is a series of rhythmic surfacings and submergings. Each animal rises, blows, inhales, and dives. A fin breaking the water is the first clue to the direction of travel. The tip slowly breaks the surface, inexorably followed by the entire dorsal. The male's five- to six-foot-long fin slicing out of the water is quite ominous.

□ Left: *The breach of a humpback whale calf may be a location signal to its mother, or simply play. Lobtailing, or tail slaps, is another universal form of communication.*

Lulled by the whales' leisurely pace, we are shocked after an hour's travel to see them rocket ahead with a burst of speed. With only half its dorsal fin exposed, the male torpedoes forward at a rate apparently double ours.

"Porpoises panicking up ahead!" shouts the skipper as he guns the throttle. A quarter-mile ahead, dozens of Dall's porpoises race in all directions. Even at our fifteen knots, the Orcas race away from us. We see the short, hurried spouts of the racing females, but the male has submerged. We scan anxiously for him.

"Breach!" the skipper shouts. Far ahead the male arcs out of the water in a tremendous leap. Where he hits the water, two porpoises jet out of the water at right angles. Just ahead of the splash several more porpoises break water. Some circle our way. A female Orca and her calf move to intercept them. Again the male breaches. Again a porpoise squirts away from his point of contact. Then a female breaches—a breathtaking leap *twenty feet* high. Several porpoises are obviously being driven before the bull.

We power down, then stop. Close by, there is a tremendous splash and whirl of water. A cow, a calf at her side, yanks something under. Another whirl, and the cow surfaces. The water about her is crimson with blood. The calf pushes in close, appears to slash at something in her mouth. Together they submerge. Now only the tip of a cow's dorsal shows above the water.

My attention shifts. The male bears down on the struggle, *and* at us. He appears to be homing in to share in the kill. Then, just before making contact with the pair, he stops, and rises out of the water in a spyhop, his eye fixed on *us.*

He holds the spyhop for a long second before slipping back into the water. Then he is gone. And so too, are cow and calf.

Some time later we see all three surfacing at a distance, again heading south. Later we spot the other cow and calf far ahead of them. Eventually all mingle.

Several days later, traveling north and into port, we cross paths with a pod of thirty to forty Orcas. The radio tells us that two days before, a super-pod of fifty-seven Orcas was seen near here. Perhaps the southward migration has already begun, or a pod from British Columbia has made it this far north.

We idle down to watch the activity. After a bit, we see two Steller sea lions swimming some distance away. There are three Orcas quartering past them. While the Orcas are still several hundred yards away, the sea lions assume a curious position. They stretch out full length on the surface with their hind flippers touching, heads pointing in opposite directions. When I look back from the sea lions, the whales have submerged.

After an eternity, just when the whales appear long gone, an Orca breaches right where the sea lions lie on the surface. A huge splash accompanies reentry. The sea lions are struggling in the froth. All three Orcas soon surface and swim away. Despite the sea lions' obvious distress, there are no visible wounds on them or blood in the water. The sea lions roll and twist on the surface much like any dying or drowning animal. Perhaps the Orca smashed into them with its head like bottle-nosed dolphins do to drive away sharks. By the time we left, one sea lion was still struggling on the surface, the other had disappeared.

Late that afternoon, we witnessed yet another curious sight. Well ahead of a large pod of Orcas, we spotted a number of Dall 's porpoises. "Orca food dead ahead," quipped the skipper. What came next was inexplicable. These porpoises did not panic at the

□ Right: *Solitary in the water, harbor seals often haul out on land in groups, perhaps as added protection from predators. These seals are often found following migrating salmon far up rivers.*

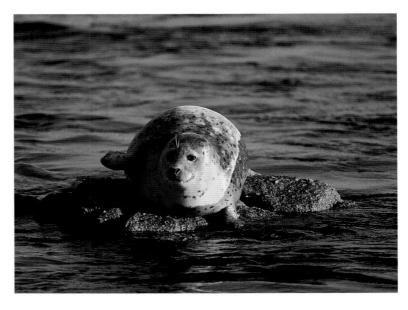

approach of the pod, nor did the Orcas speed up or initiate a chase. I saw porpoises swimming amid the whales. It seemed suicidal. Then I saw a large male surface nearby. A porpoise was crossing directly in front of it! Again and again the two crossed paths. *The porpoise was playing in the Orca bow wake!*

Later, I learned there are two types of Orcas: residents, which eat fish; and transients, which feed primarily on marine mammals. How other cetaceans communicate danger from Orcas or recognize threat from them is unclear. Sharing the water with an animal that can either be benign or deadly dangerous is risky.

On another trip, I saw Orcas hunting white-winged scoters, a small sea duck. A raft of scoters bobbed gently along on the surface, when suddenly a swirl of water and the lunging jaws of an Orca dragged one down. Minutes later, the injured scoter popped to the surface and attempted to escape. Time and again, the scoter was dragged under and held there, sometimes for several minutes, then released to the surface. Eventually the bird was pulled under, never to appear again. The killing was analogous to the way in which lynx sometimes play with voles or mice. In this case, however, there was nowhere to hide.

return of ice & stars

The alarm rattles to life. Four A.M. *Again.* The fifth morning in a row. I pull one arm from my sleeping bag and grapple for the alarm in the cold, dark tent. I unzip my bag and dress against the chill. No time to dawdle or for breakfast. I must hurry to be in position at first light. Six days ago upon flying in, I saw a scene I wanted to photograph but blew my chance. Since then I'd been struggling for another. From the air, I had seen a lake filled with thousands of geese. The pilot landed me on the Innoko River and promised to come back in six days. I had established camp in twilight, but I was keyed up and unable to sleep. I had been in the Innoko National Wildlife Refuge years before, but this was my first trip to photograph its numerous greater white-fronted geese.

That first morning, I was underway at five, heading across frozen marshes toward the lake. I hurried to stay warm. Partially blinded by the rising sun, I blundered on a small lake packed with geese. I saw them too late. Hundreds of wings slapped air as rising geese blotted out the sun. All I could do was watch, my camera buried in my pack.

Since that morning, I had been haunted by the memory of geese silhouetted against the rising sun. In my dreams, I heard their cacophonous exodus and felt the rush of wings. I awoke earlier the second morning and stalked the chill marsh, hoping to surprise the geese. The pond was empty. The geese were there on the third morning, but a heavy ground fog obscured the sun. I heard the multitude rise but saw little. Yesterday, the sky was again clear and there was no fog, but only a fraction of the big flock dappled the pond. I had consoled myself with a shot of a dozen birds flying overhead.

This is my last chance; the plane comes this afternoon. Upon awakening I check the sky. *Clear!* A remarkable fifth day in a row. My walk is electric, charged with optimism, blessed by the weather. The photographs I have made on this trip will not pay my expenses, but I have enjoyed the solitude of this remote location. However, I do want this *one* photo . . . truly one-in-a-lifetime.

☐ Left: *Only about two hundred pairs of lesser snow geese nest in Alaska, but thousands pass through on their way to and from nesting grounds on Russia's Wrangell Island and in Canada.*

□ **Right:** *Hardy lesser Canada geese that overwinter along Alaska's Southeast coast must endure low temperatures, rain, sleet, and snow. Goose down is well known for its insulative properties.*

I cross the marsh in darkness, avoiding the now well-known sloughs and oxbows. The sky has lightened considerably, the peaks stark against a light-blue sky that fades into the star-sparkled dome. In the distance, I hear the gossip of dabbling ducks, pintails mostly, and the nervous talking of geese. It seems to be coming from the pond. A quarter-mile away, I stop to get out my camera. With it, I meter the light on the horizon and make preliminary settings. I want the rising birds to be ink black against the colored sky.

I want to be in the same position as on the first day, with the sun just topping the mountains. Judging the sunrise and the time it will take to reach the pond, I move, but with as much stealth as the crunch of frozen plants will allow.

Finally, I am in position. The pond is alive with talking geese. Any second, there will be an explosion of water, wings, and sound. Again I read the light and make final adjustments. The sun begins to creep over the distant mountains. With each passing moment, the geese get louder. Then, with the sun less than half its diameter above the peaks, the thin wisps of clouds around it streaked with scarlet and yellow, hundreds of geese leap upward.

Wild cries and powerful wingbeats. Silhouettes against the dawn. I am keyed tight but caution myself. *Careful. Careful. Now compose. Steady, Steady,* I begin to shoot. At first, everything looks as I had remembered. With the second shutter release, I know something is awry. After the second shot, I stop shooting. The geese are splitting right and left after liftoff, not ascending against the sun. In a photograph, they will be invisible against the black mountains.

In seconds, it is over. Skeins of geese depart north and south, their cries fading against the dawn breeze. My spirits crash. The pond, empty and still, is now unremarkable.

Dejected, I circle the pond and walk toward the big lake. Perhaps I will still get a few pictures of wedges of flying geese. Small consolation. In my mind's eye is that scene from the first morning: geese obscuring the sun, a sight from a time when such scenes were commonplace to wetlands all over the continent—one I would have liked to share, through pictures, with as many people as possible. *Oh, well,* I whisper, *I'll get another chance. There'll be another time.* But I know it is not true.

new year light

New Year's Eve, 1993. Today is the first clear, cold day in two weeks. It is minus 4 degrees—almost toasty for Interior Alaska. Some years on this date it is minus 40, or worse. Days are still short here in the Nenana River Canyon on the border of Denali National Park. The sun's first light hit my cabin at 11:30 A.M. It was not quite 2:00 P.M. when the sun had set to the south behind the peaks of the Alaska Range. For awhile, availing myself of the warm day, I attempted to photograph chickadees feeding in the willows, but there was not enough light. Maybe next month.

Birds are few and far between now. The annual Christmas Bird Count was conducted December 26. On my better-than-four-mile walk I saw just four species—ravens, gray jays, black-billed magpies, and boreal chickadees. Even so, the local record was broken: eleven different species. (Compare winter's record with summer's 160 species.) Almost as many *mammals* live around my log cabin now—ermine, snowshoe hares, red-backed voles,

red squirrels, moose, coyotes, and a red fox. Winter in Interior Alaska is not difficult solely because of cold and darkness, but rather in part because of the lack of bird songs. Just past the solstice, we already gain a minute of light a day as we slip toward spring days of twenty hours of daylight. The birds *will* be back.

By 2:45 P.M., the snow peaks of Healy Ridge turned the sherbet colors of alpenglow, and the first stars were visible in the eastern sky. By 6:00 P.M., the ebon queen had cast a sea of stars above the tops of the hoarfrost-draped trees. To the west, Orion's brandished sword guarded the approaches to Denali. I saw the Great Bear, and Cassiopea. And, overhead, *straight up*, Polaris, the North Star.

Now, it is 8:00 P.M., and I come downstairs for tea, tired of reading by lamplight. I reach up to fire the propane light, but I pause. *Why is it so bright?* Moonrise is still two hours away. Outside, I see the snow glowing green. I look up. Cast to earth by solar winds, three giant arcs of diaphanous light sweep across from mountain horizon to horizon. The taiga is lighted as under a full moon. I see trees on the distant slopes; crenelated peaks backlighted by the aurora.

Reading can wait. I hurry to dress, get my camera, film, and tripod. Layers upon layers later, encumbered with snowshoes and all the camera gadgetry at my disposal, I head toward the back side of the hill and the familiar vantage point overlooking the confluence of the Yanert and Nenana Rivers. The lights are so intense I do not need my headlamp; I snowshoe as easily as in day.

From the lookout, the aurora is stunning. Four great bands now pulse across the sky, whipsawing arcs of green, orange, and red. Here, a segment writhes slowly, then fades away. There, another snaps with growing intensity. A small dot of red near Polaris enlarges, appearing to rush earthward at astonishing speed; like a giant Fourth of July rocket, it explodes in a dazzle of light.

For two hours, the aurora dominates the mountain amphitheater. The display does not end, but rather is muted by the waning full moon rising above the summits. The valley floods with light, the snow reflecting facets of the jewel moon.

The muted roar of a jet coming from the south breaks the spell. Only then am I aware of the depth of silence. Until now, nothing. Not a car, truck, or distant train. It is nearly 11 P.M. on New Year's Eve, and few are traveling. The lone plane is an intrusion into what had been as unsullied a spectacle as can be found on the planet today.

I look up. The lights of the plane, obviously beginning its slow, gradual descent into Fairbanks, are clear. But I am startled to see the jet's vapor trail lit and glowing with moonlight.

My attempts at photography over for this night, I start back toward the cabin but hesitate with another thought. Perhaps I will try howling to see if a wolf will answer. I cup my hand, lift my head, and howl. I stop, wait, and listen. Nothing. *Too phony,* I think. But I always sound that way. I never really expect wolves to answer, but sometimes they do. I try again. Still nothing. In the stillness, in this place, with the aurora overhead, the moon gliding ever higher, the cold deepening, my howl seems somehow blasphemous. So I quit.

I turn to leave. But stop. *What was that? There! There it is again.* Louder. Something singing in the dark. No, not wolves. Coyotes. Several, raising their night anthem. Tonight, it is a lengthy song, one worthy of an encore. When they stop, the night again is glowing, cold, and silent—and the year is just minutes old.

□ Right: *Long after the rut and during migration to wintering grounds, two small bull caribou, irritated by their proximity to one another, spar on the frozen headwaters of the Tanana River.*

□ Left: *Arctic foxes in winter are solitary except when congregating at animal carcasses. Some foxes wander out onto the ice pack to eat scraps of seals killed by polar bears.*

Gray wolf with arctic ground squirrel

Sitka black-tailed deer fawn

Willow ptarmigan cock in spring plumage

calves, cubs, & wolf pups

Spring is a time of challenge, a time of renewal. Reluctantly, winter eases its grip on the land. One day it is snowing and cold; the next, sunny and mild. Each day, the sun rises higher in the sky and stays longer. Many animals, their reserves of energy and strength depleted, totter on the brink of survival. Late winter storms kill many adults as well as newborns. At last, the sun defeats the snow and cold. Willow buds emerge, and life-giving shoots nudge through the warming soil. New growth banishes malnutrition.

Increasing daylight triggers pelage and plumage changes in animals that vary in color; encourages migrations of birds, fish, and mammals; and stirs hibernators. Weasels, hares, ptarmigan, collared lemmings, and arctic foxes begin to turn from white to brown. Birds arrive from as far away as Africa and Antarctica, waterfowl wing toward arctic nesting grounds, and millions of shorebirds gather on tidal flats. Bears, marmots, and ground squirrels blink in the sun after long winter sleeps. Moose calves wobble in spruce thickets, Dall lambs traverse rocky cliffs, and bear cubs follow their mothers across the tundra. Timing is crucial. Birthing and hatching are concentrated, both to foil predators as well as to take best advantage of the short, four-month growing season. Foxes, coyotes, wolves, and lynx raise litters. Owls, hawks, and eagles feed nestlings. *Spring,* the beginning of the brief respite from winter, has begun.

☐ Facing Page: *Two-year-old brown bear cubs begin to venture on short forays away from their protective mothers.*
☐ Overleaf: *Cubs usually separate from their mothers in spring of their third year.*

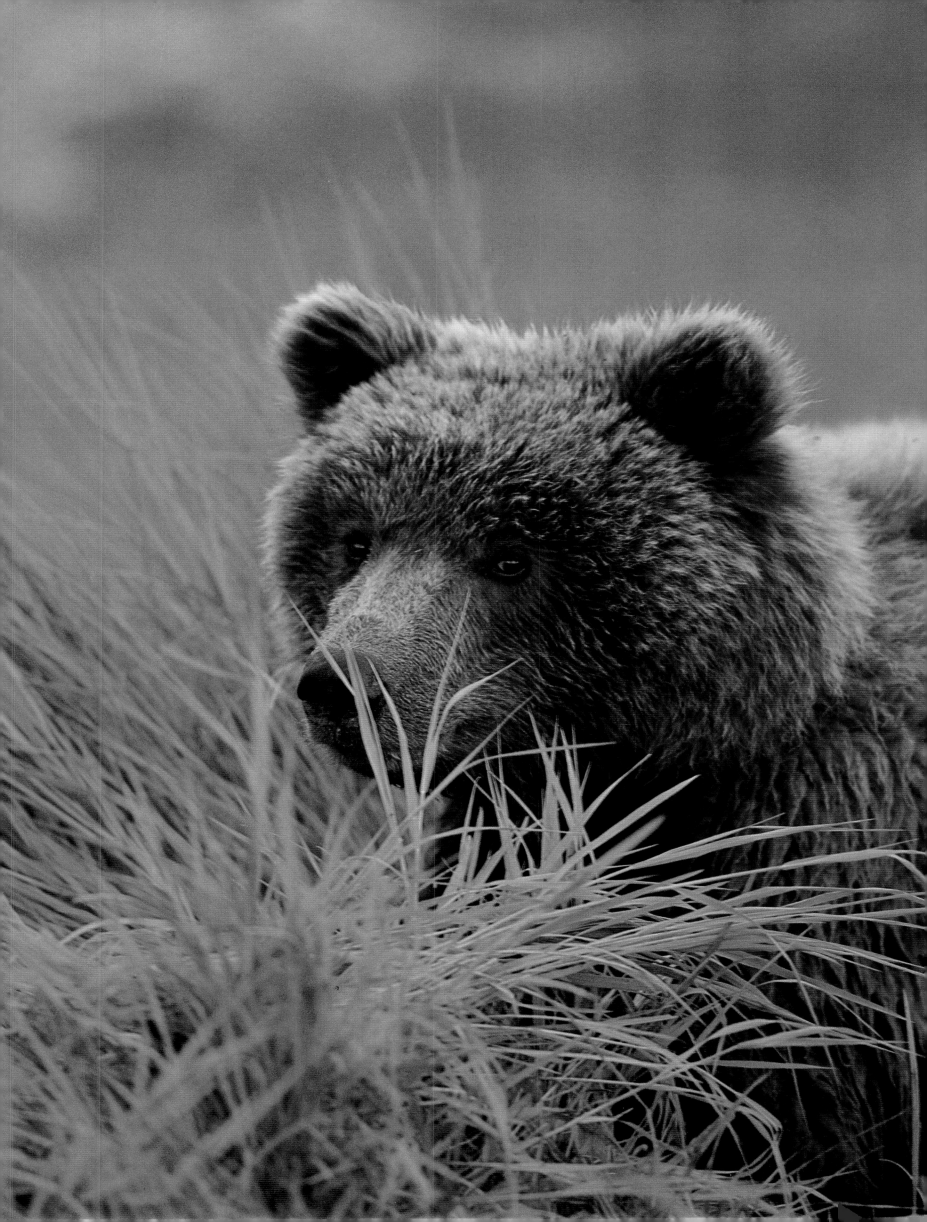

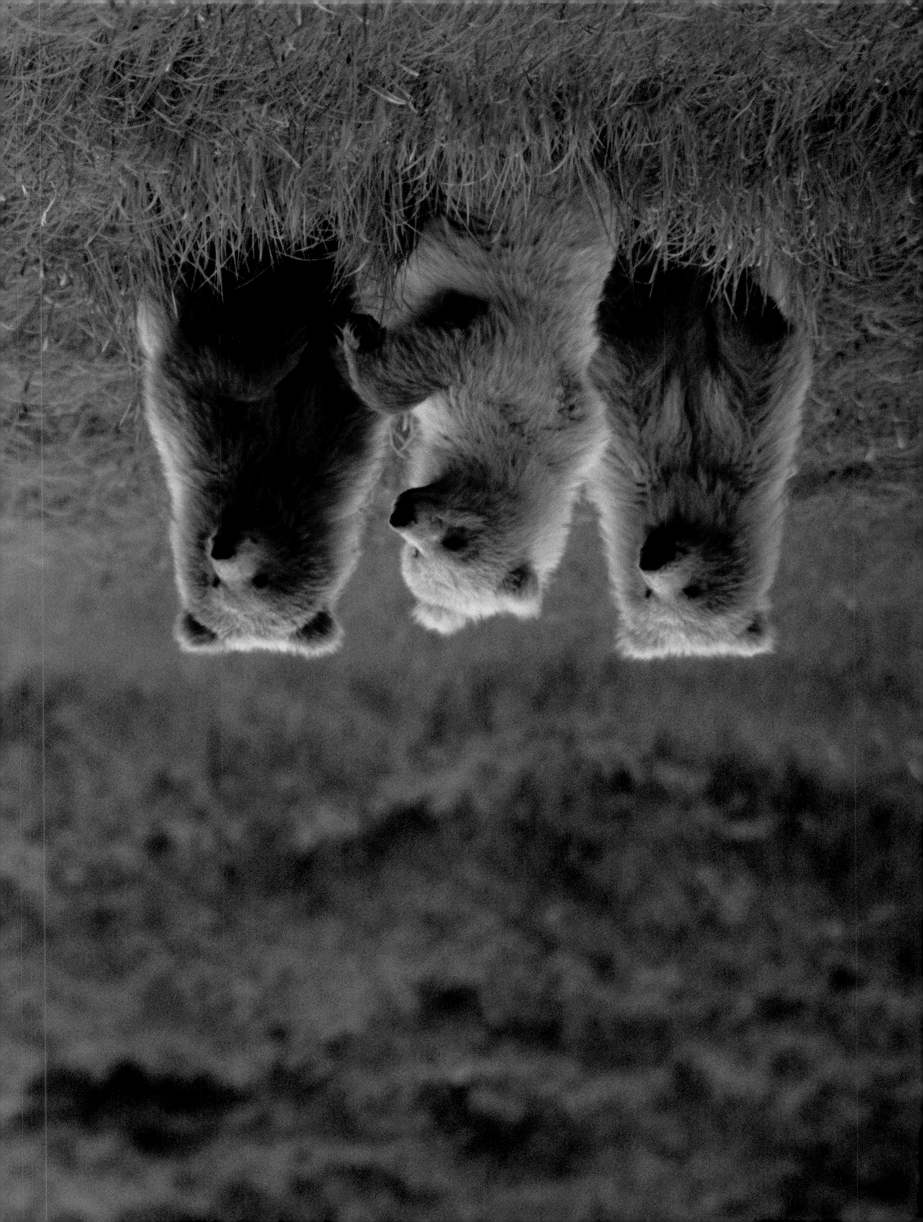

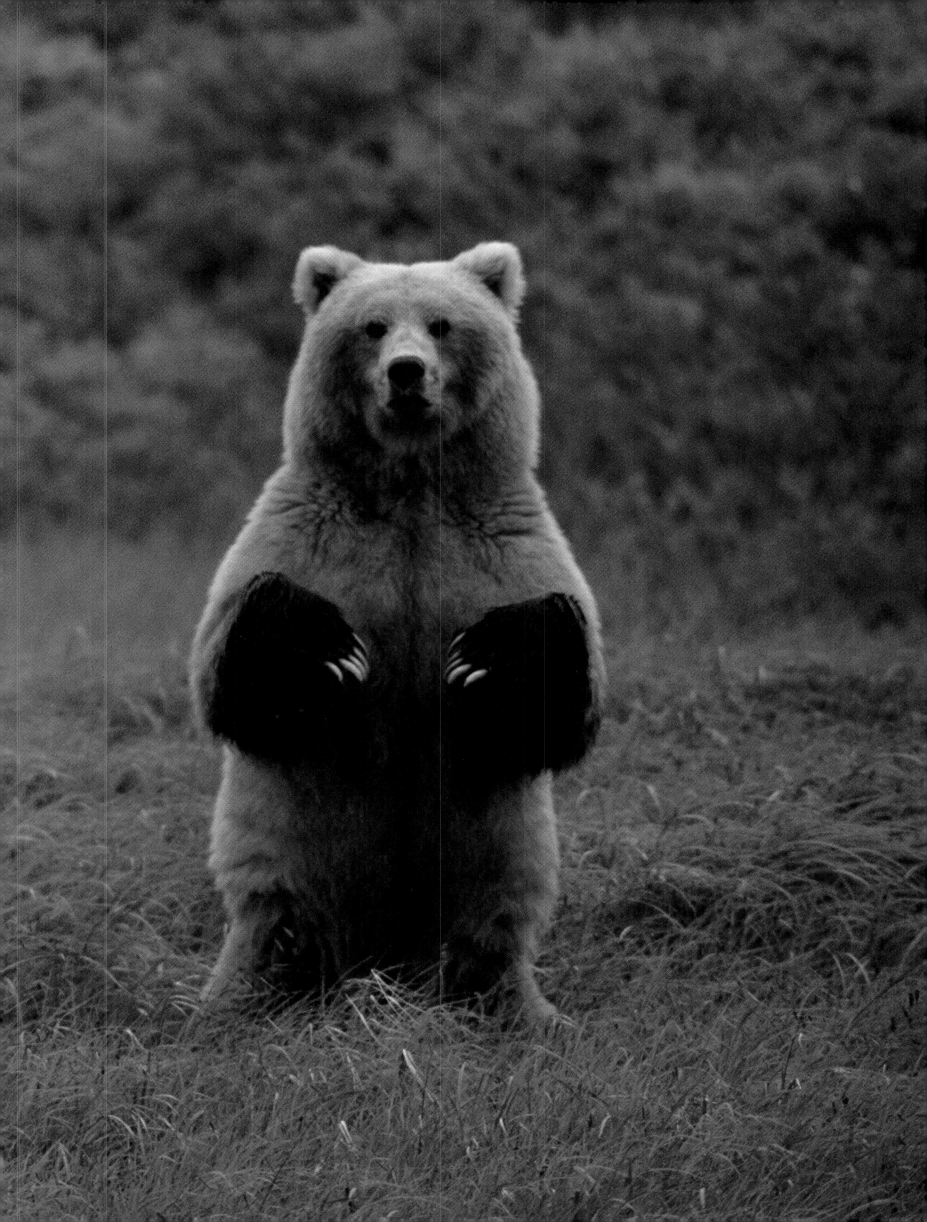

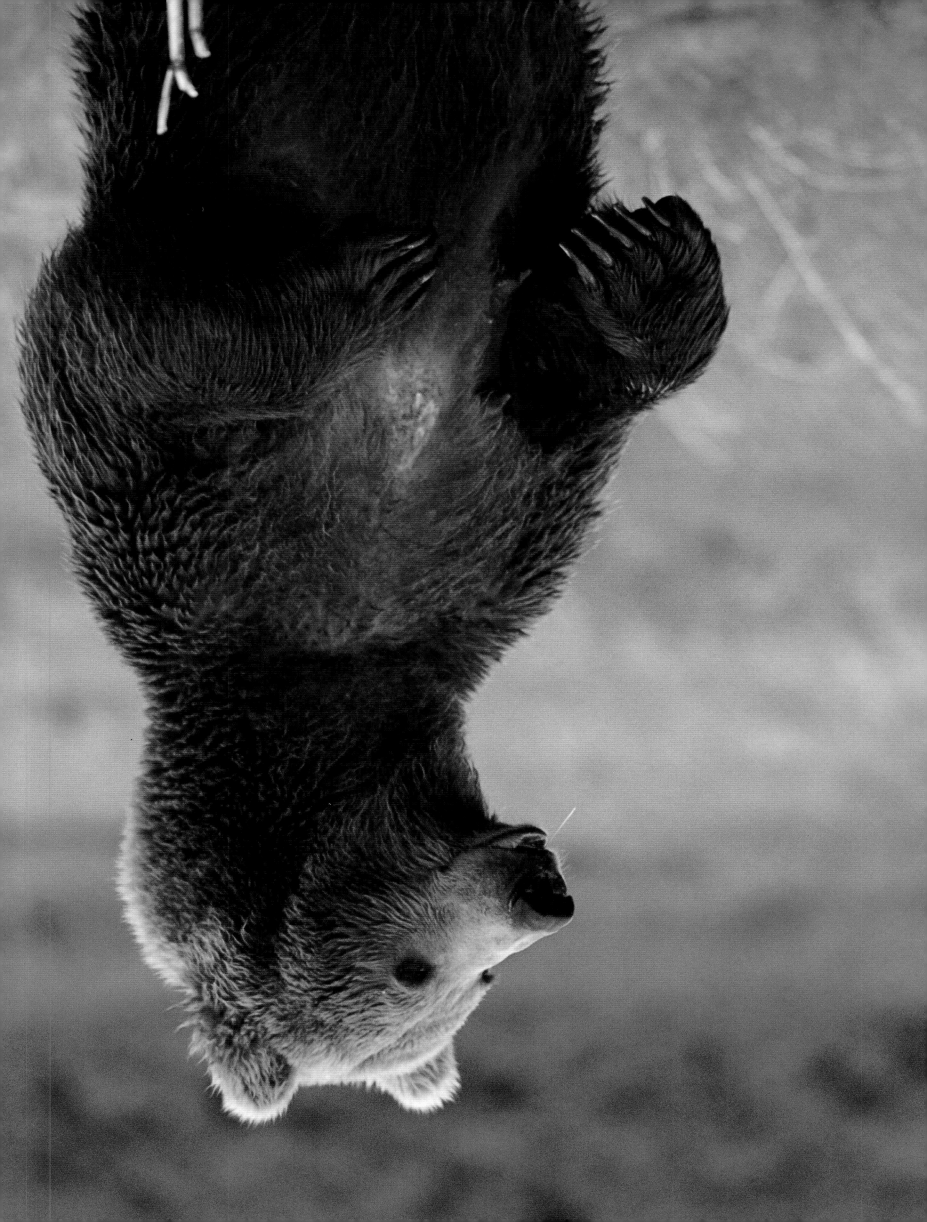

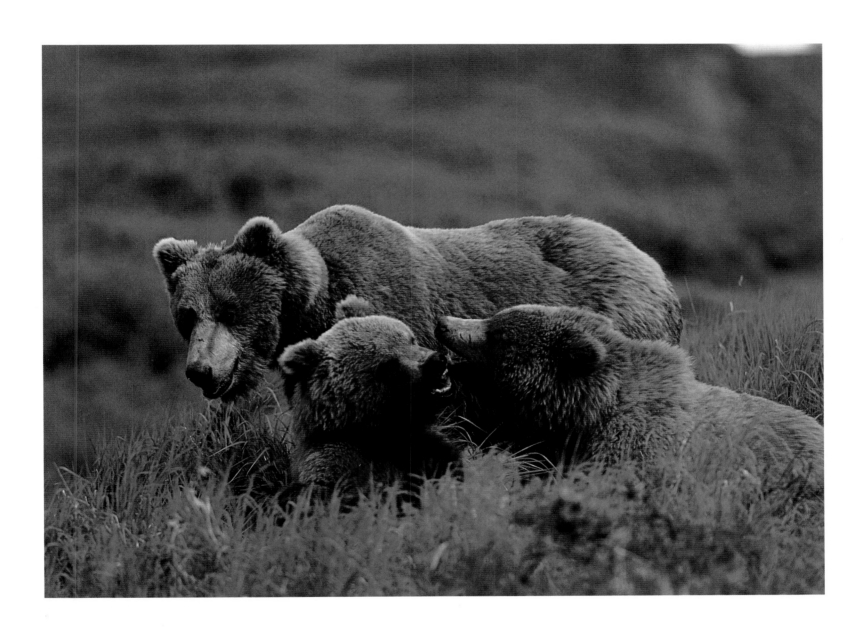

☐ Facing Page: *A female brown bear with cubs grows anxious with the approach of other bears. Observers have seen both male and female brown bears kill cubs of other bears. Family groups prefer to flee from the close approach of bears and humans.* ☐ Above: *Before venturing into the water, a female and her two cubs wait for a large male to vacate a prized spring salmon fishing site.* ☐ Left: *A two-year-old cub watches as its mother wades into a nearby fishing hole. Although bears depend on their sense of smell, they often stand on their hind legs to obtain a better view of their surroundings.*

31

□ Above: Calf moose are born from mid-May to early June. Twinning is common; triplets are not. Multiple births indicate habitat quality. Cow moose vigorously protect their calves from black bears, wolves, and humans. □ Right: Calves weigh about thirty-five pounds at birth and grow quickly, weighing over three hundred pounds by winter. □ Facing Page: In some areas, such as the Kenai Peninsula, black bears are predators of moose calves in spring. Bears scent-mark alders by walking over them or standing to rub against and bite them. This behavior is sometimes preceded by stylized pacing.

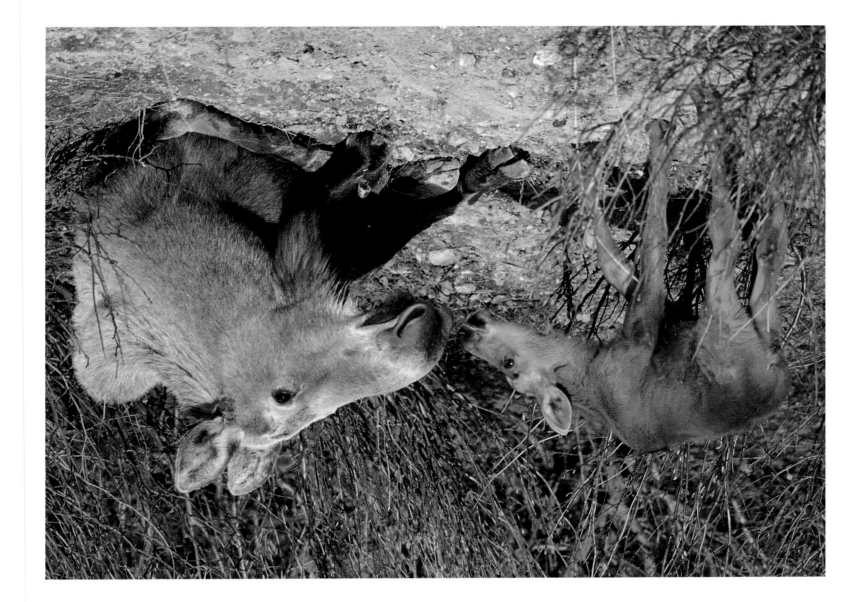

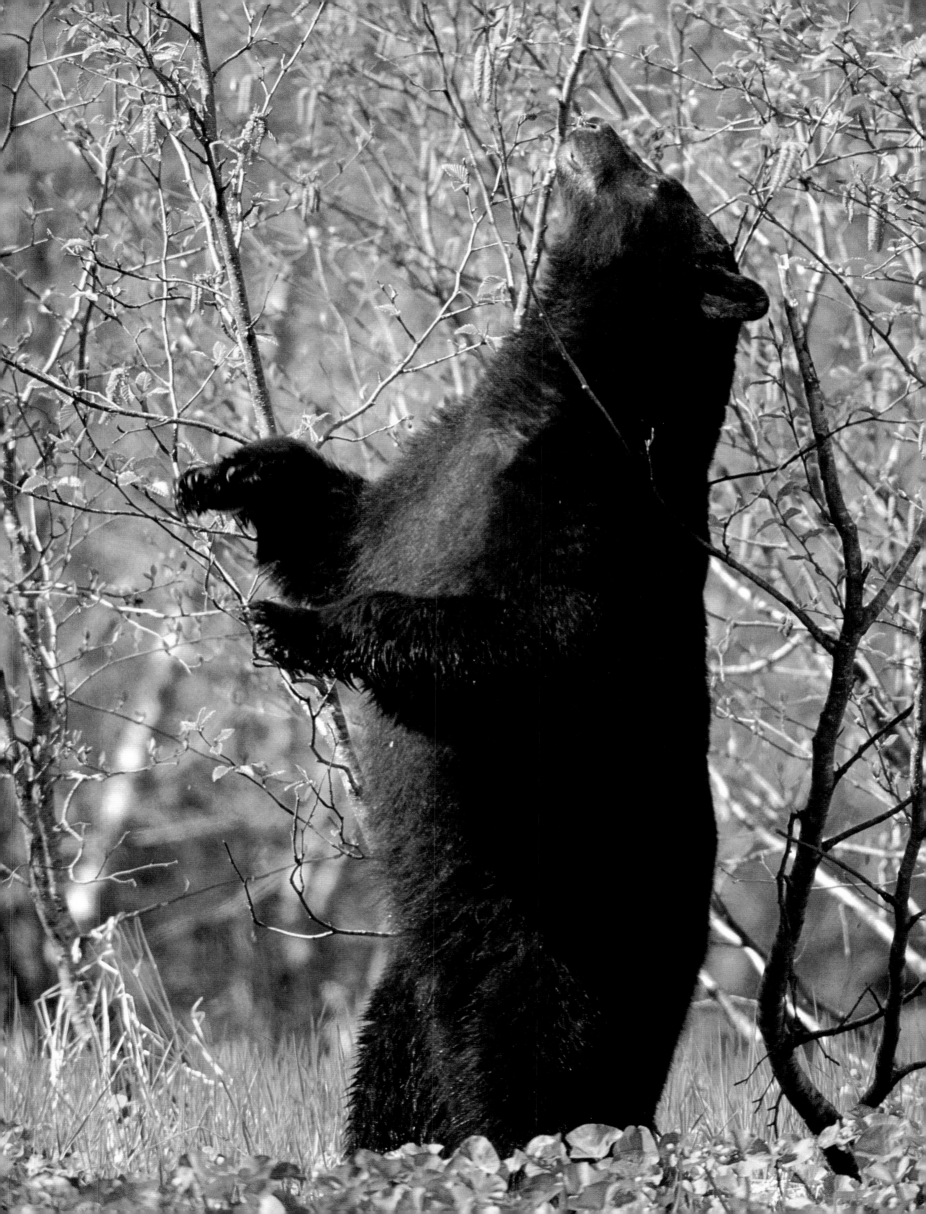

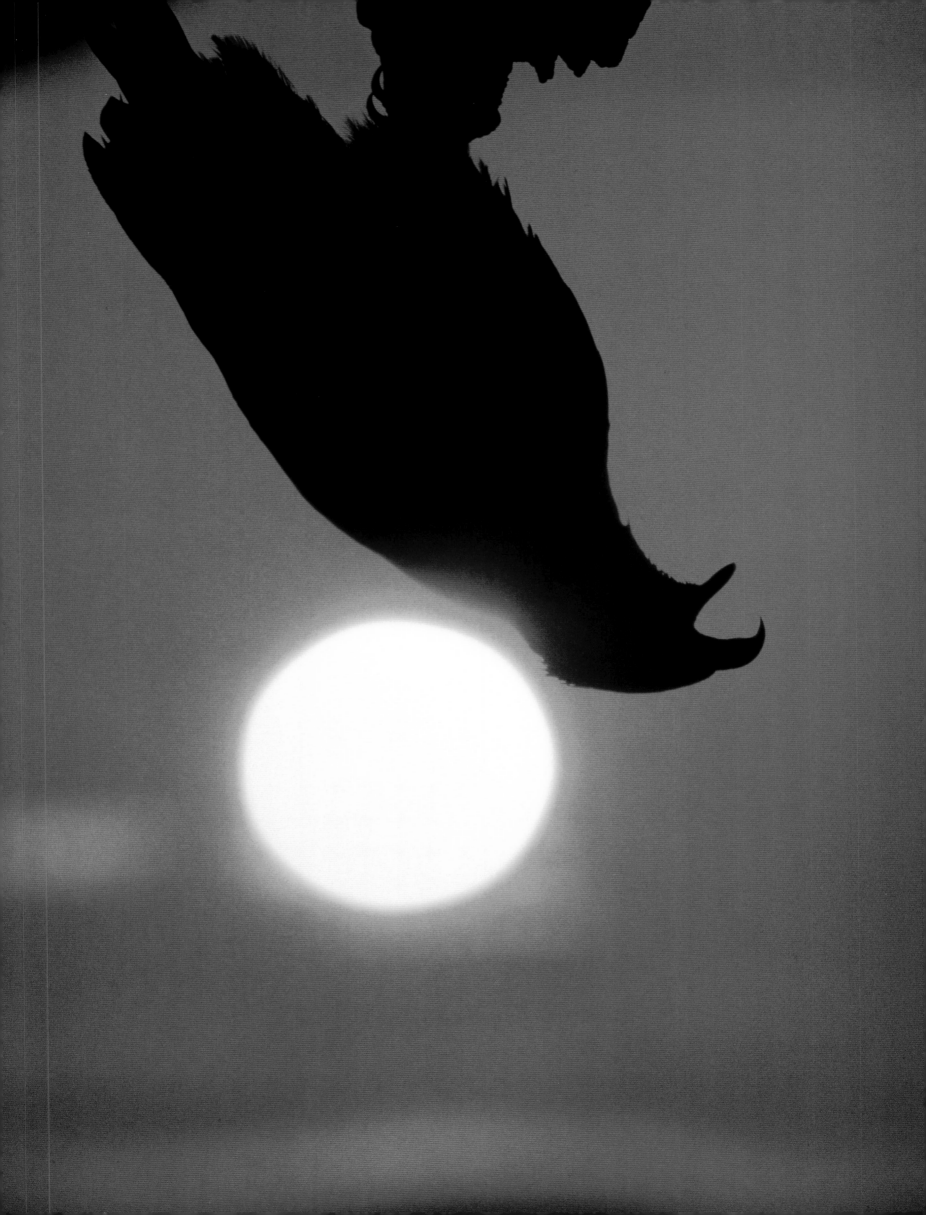

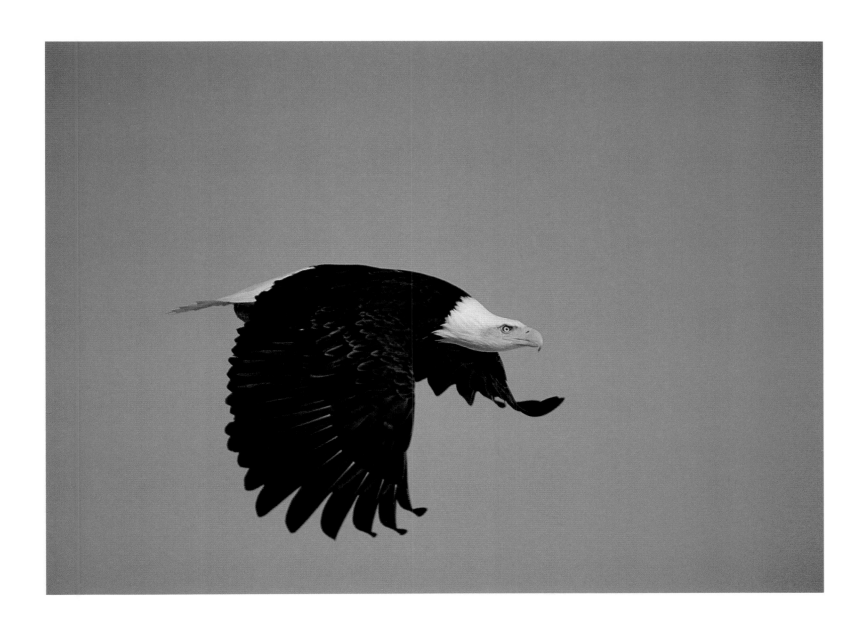

□ Facing Page: *As the sun rises over the Kenai Mountains, a mature bald eagle, the nation's symbol, voices its cry. The call is often a response to violation of individual space. Eagles are aggressive and protective of food.* □ Above: *Bald eagles fly about thirty miles an hour and dive up to a hundred miles an hour, an asset when swooping on a fish sighted from altitude. They eat dead or spawned-out salmon as readily as live ones. When fish are scarce, eagles prey on waterfowl, seabirds, crustaceans, and small mammals. They can spot food from over a mile, sometimes stealing prey of sea and land otters.*

□ Above: *Sea otters eat up to 25 percent of their body weight daily; males weigh up to one hundred pounds. These members of the weasel family prey on fish, mollusks, crustaceans, and octopi. On the sea bottom, they burrow into the mud to gather clams. Unlike other marine mammals, sea otters do not have thick blubber for insulation. To survive in arctic waters, an otter must keep its dense, insulating fur clean.* □ Facing Page: *Northern pintails, the most abundant duck in Alaska, can travel at speeds up to sixty-five miles per hour. They reach underwater for seeds, choice plants, and aquatic invertebrates.*

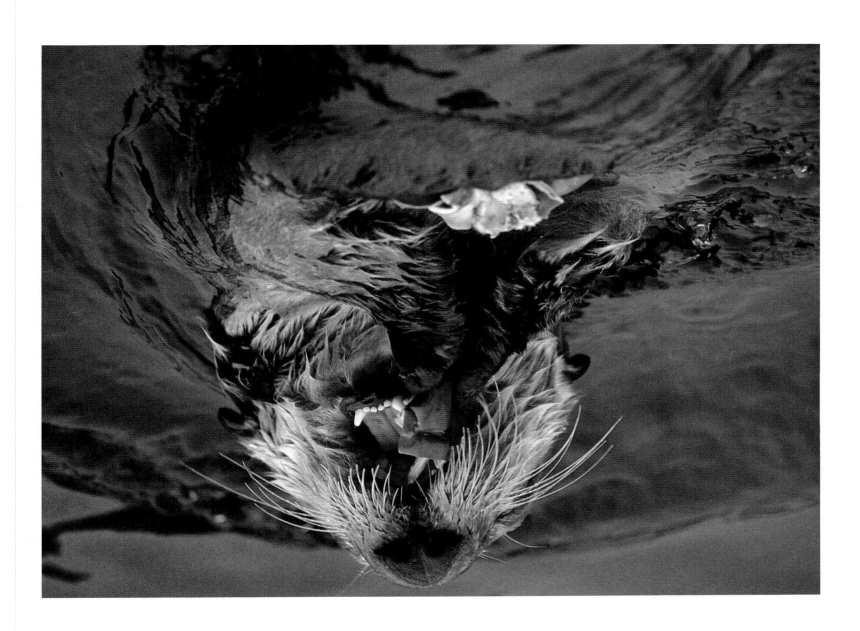

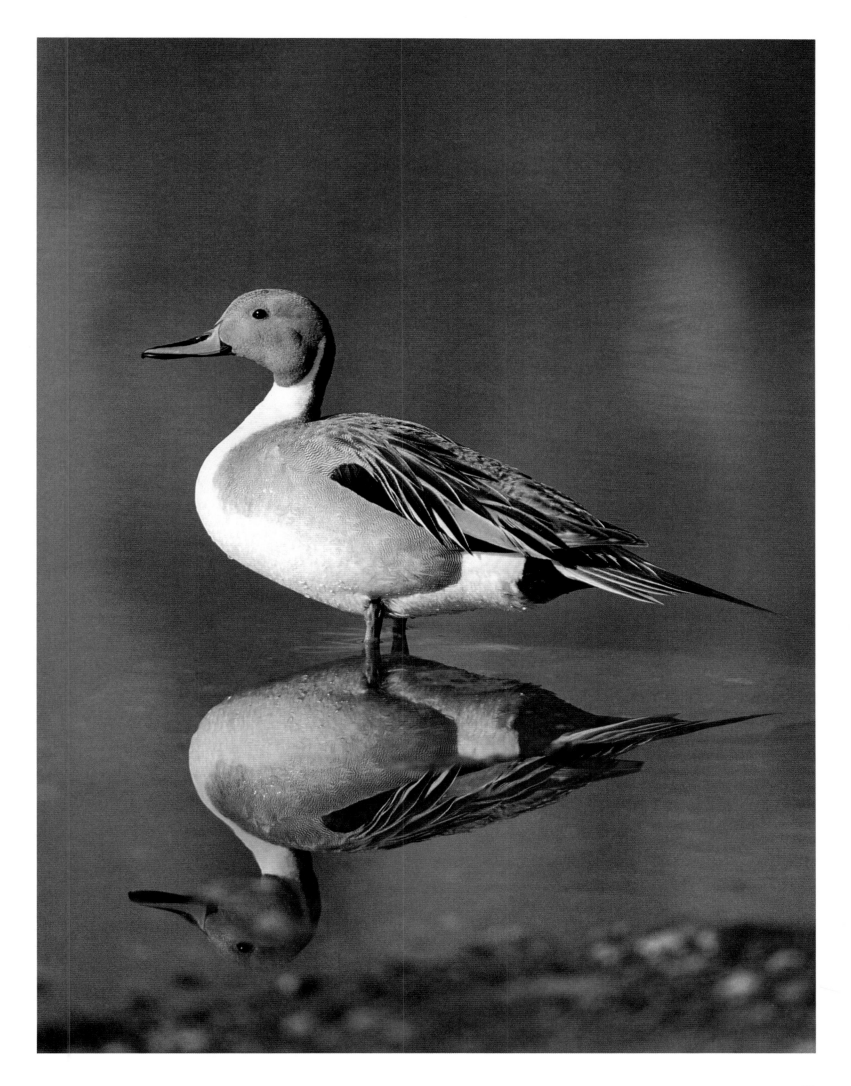

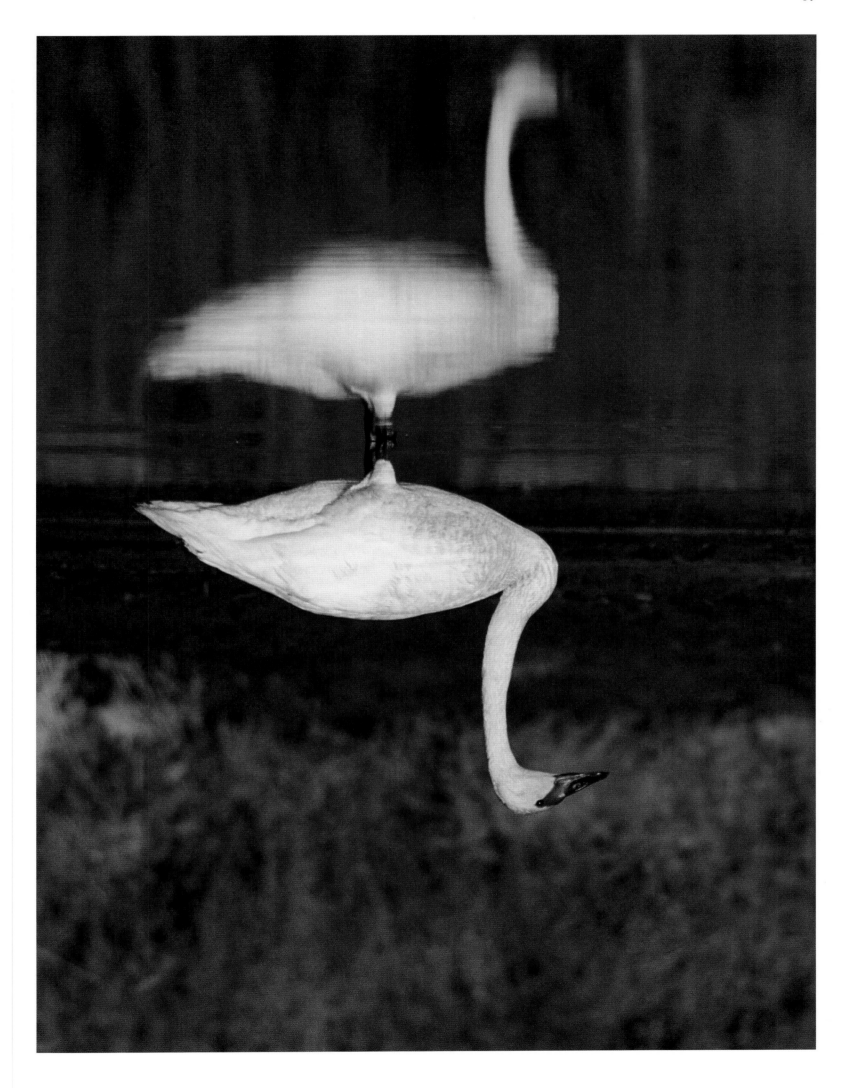

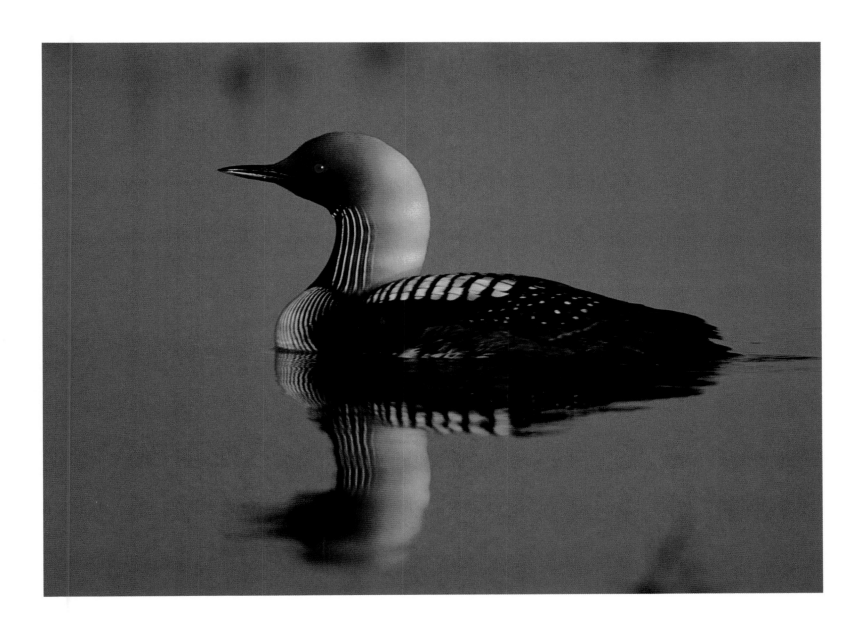

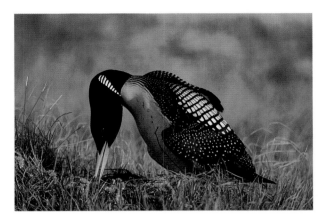

□ Facing Page: *Perhaps 80 percent of the world's population of trumpeter swans nest on Alaska's boreal forest lakes.* □ Above: *Pacific loons, Gavia pacifica, are widely distributed, with as many as five nesting pairs per square mile in some areas. Loons dive to 240 feet and remain submerged up to three minutes.* □ Left: *Loons, like this rare yellow-billed, Gavia adamsii, mate for life. In winter, all loons fade to dark brown with white undersides.* □ Overleaf: *Loons lay two eggs, which are incubated by both adults. A red-throated loon, Gavia stellata, rolls its eggs to ensure uniform warming.*

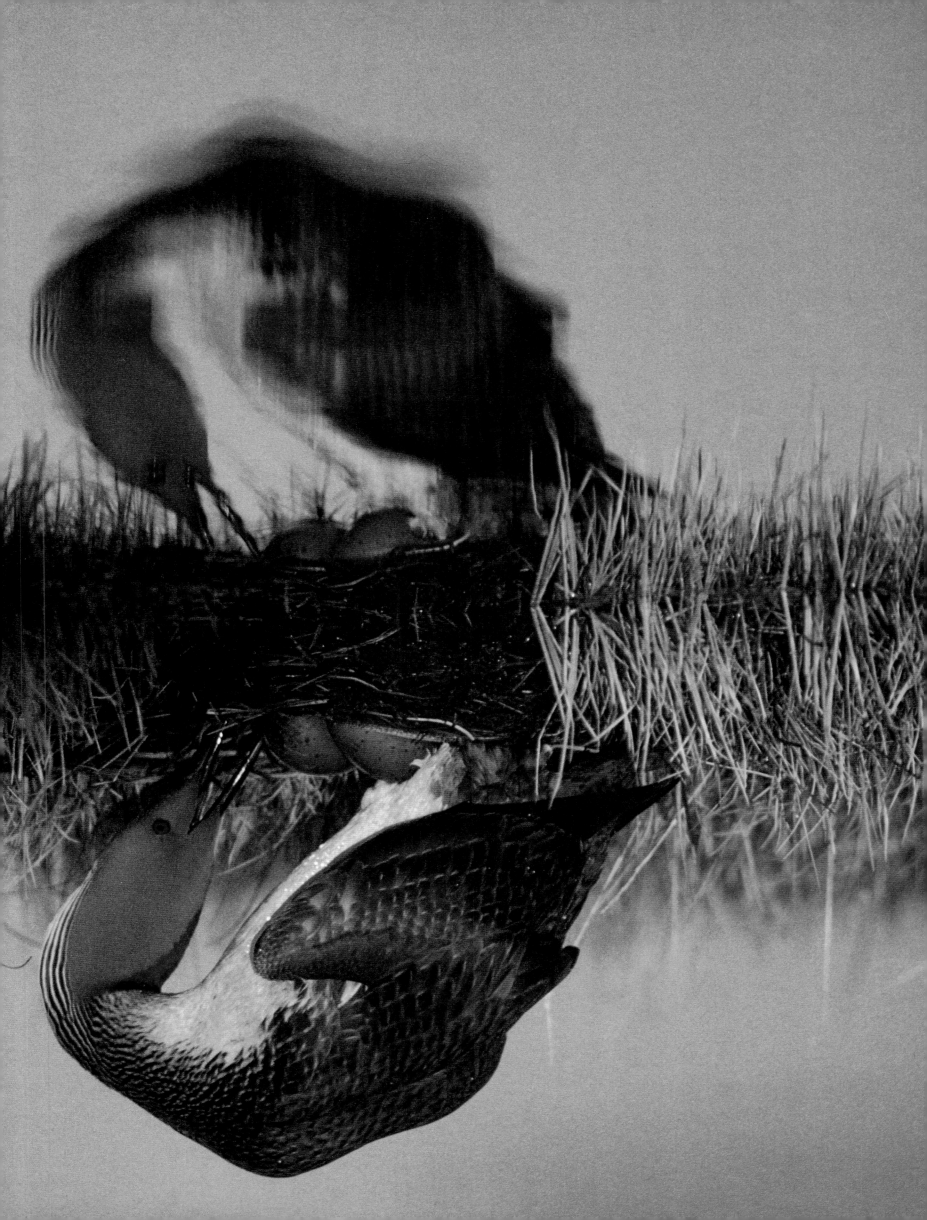

□ Above: A male lesser Canada geese protects its mate and nesting territory. A gander may challenge other waterfowl, as well as predators many times its size, with an aggressive, hissing attack. Sightings of geese attacking moose that are too close to the nest are not unknown. □ Right: Pairs mate for life and share in protecting their brood. Adults are flight-less during the three to four weeks of summer molt. □ Facing Page: One of six subspecies of Canada geese found in Alaska, the lesser Canada is the most widespread. Some geese overwinter, but most migrate along the Pacific flyway to Oregon and California.

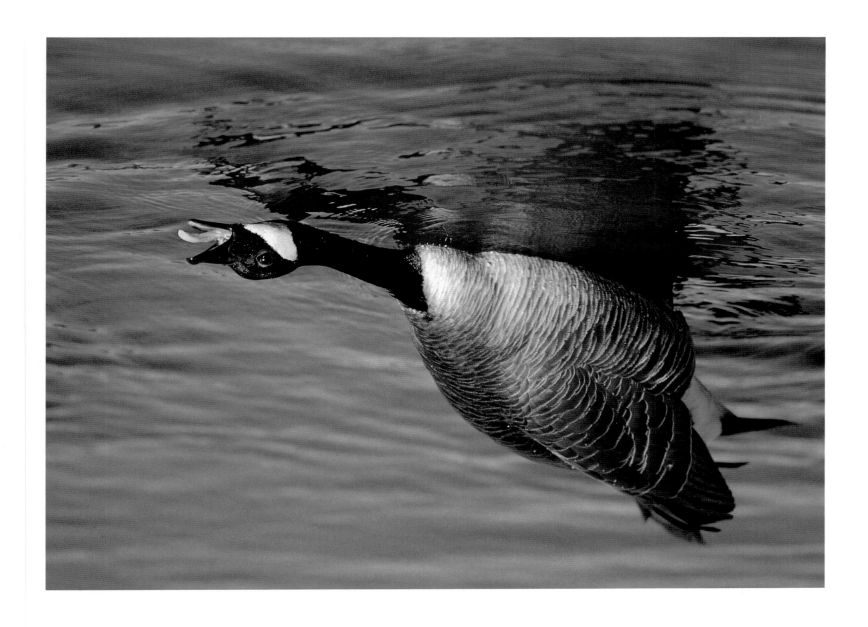

42

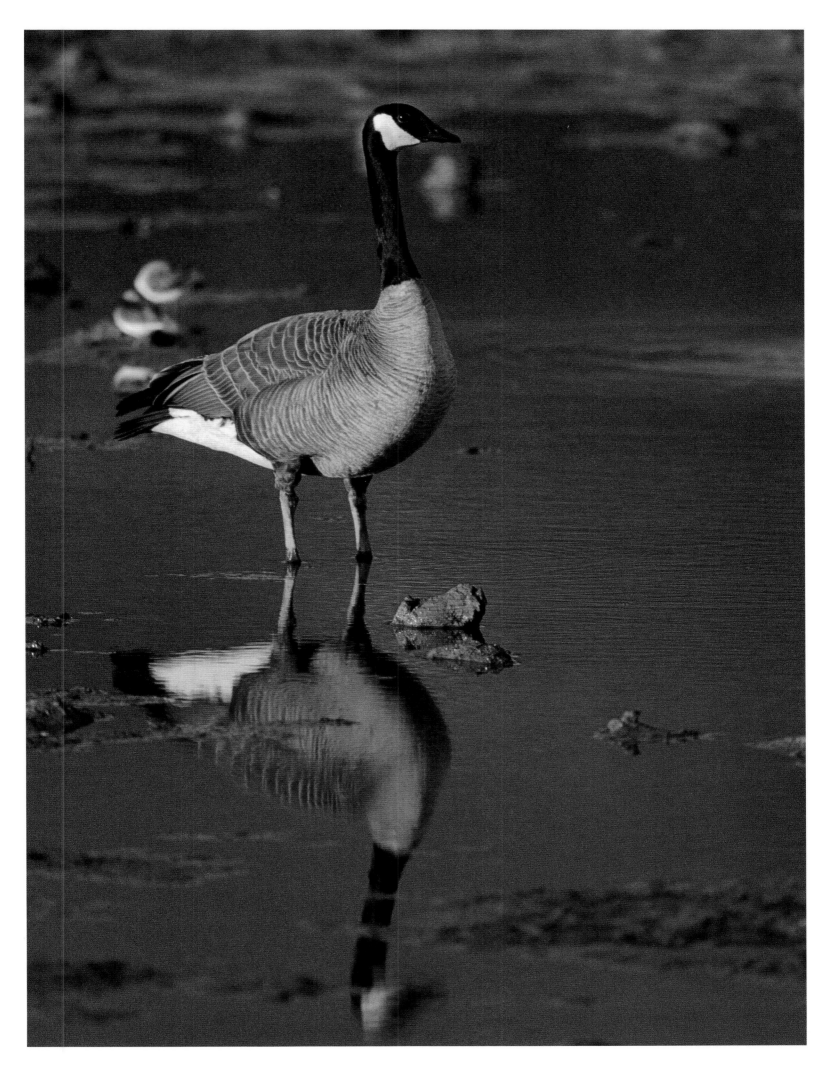

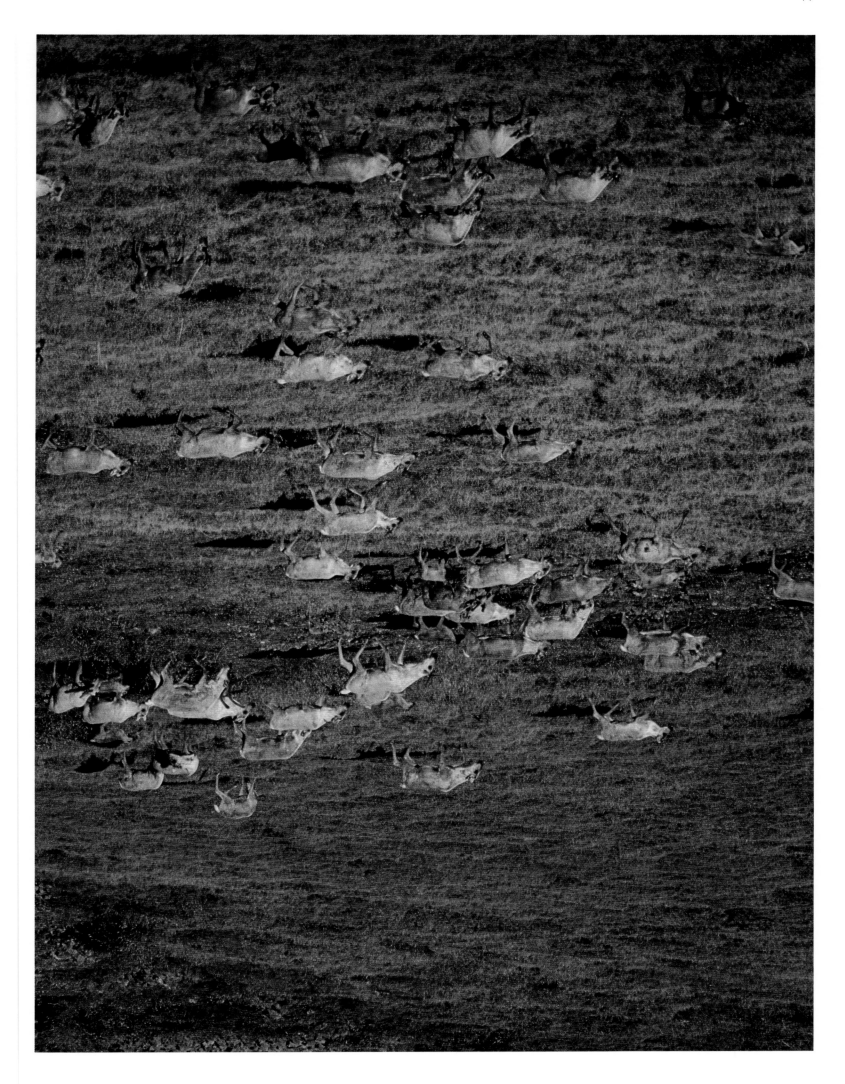

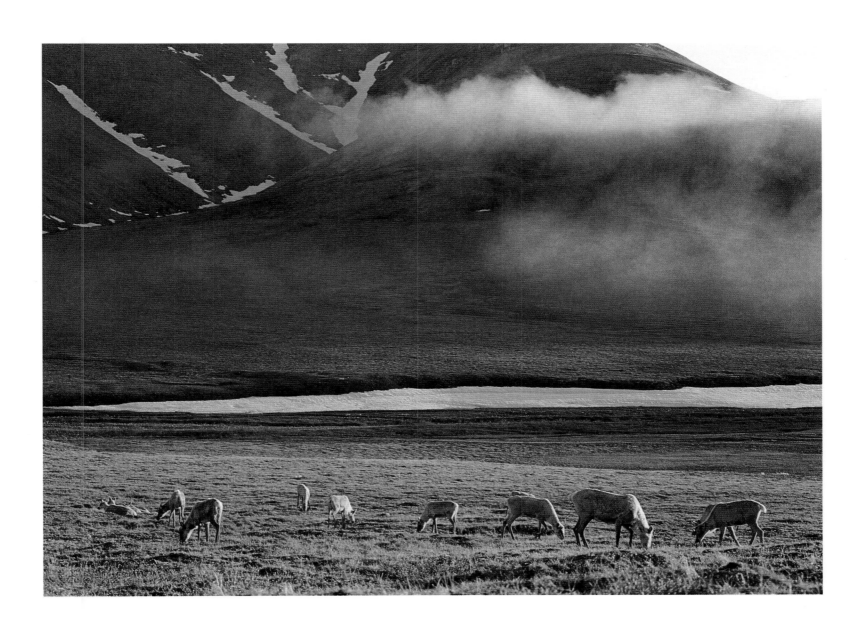

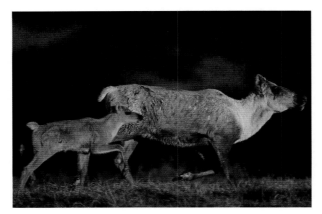

☐ Facing Page: *Caribou seem to be in perpetual motion. In spring, arctic herds move north toward the coast from southern wintering grounds long before the land is snow-free. Migrations are perilous to young and old.* ☐ Above: *Brooks Range valleys and slopes are warmer and snow-free weeks before the North Slope. Herds sometimes linger.* ☐ Left: *Calves average thirteen pounds at birth and walk within an hour. Shortly, they can keep pace with their mothers and in a few days can outrun predators and swim broad rivers. Fortified by a rich milk, calves double their weight in about twenty days.*

☐ Above: *At lambing in late May, solitary Dall sheep ewes move into rugged cliffs. The summits and cliffs offer protection from most predators. Averaging eight pounds at birth, lambs are soon able to follow their mothers across steep, rocky slopes.* ☐ Right: *Once they are three years old, most ewes annually bear a single lamb, with twins rare. Groups of lambs often gather in "nurseries" apart from their mothers.* ☐ Facing Page: *A female lamb will likely live out its life near its mother and in the band of its birth. Ewes and lambs live most of the year apart from mature rams, the sexes mingling during the fall rut.*

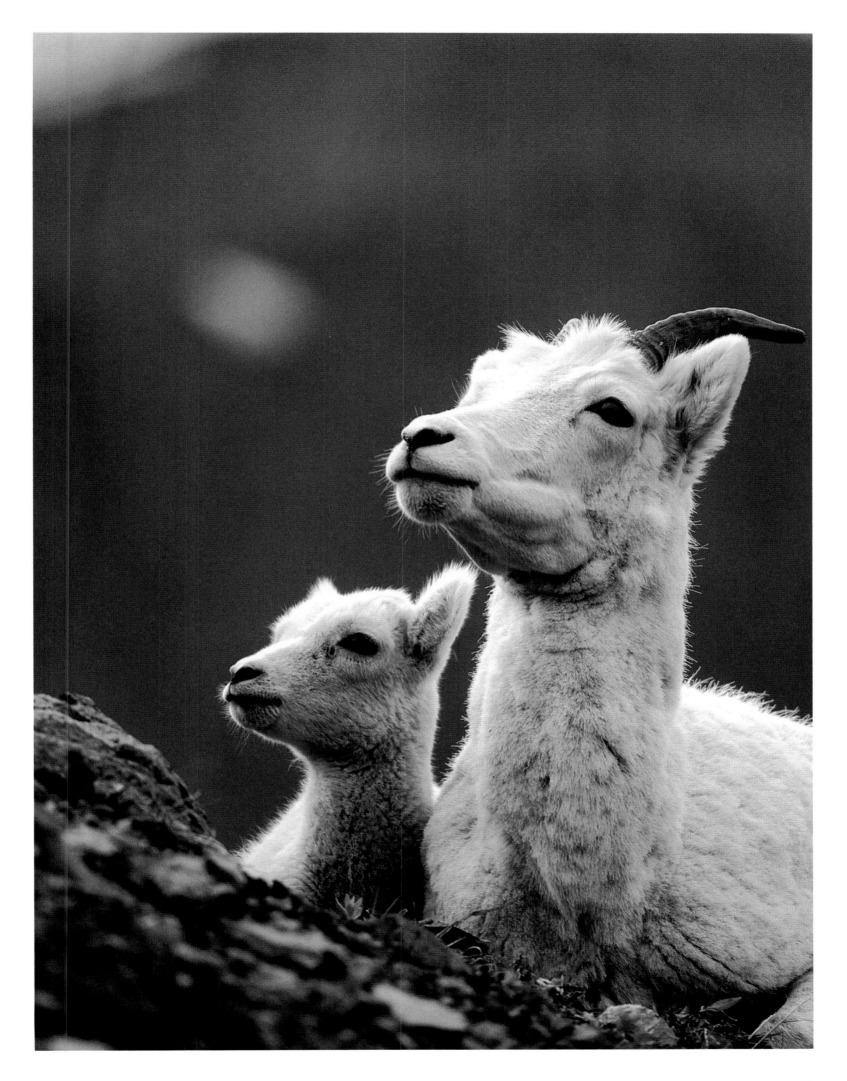

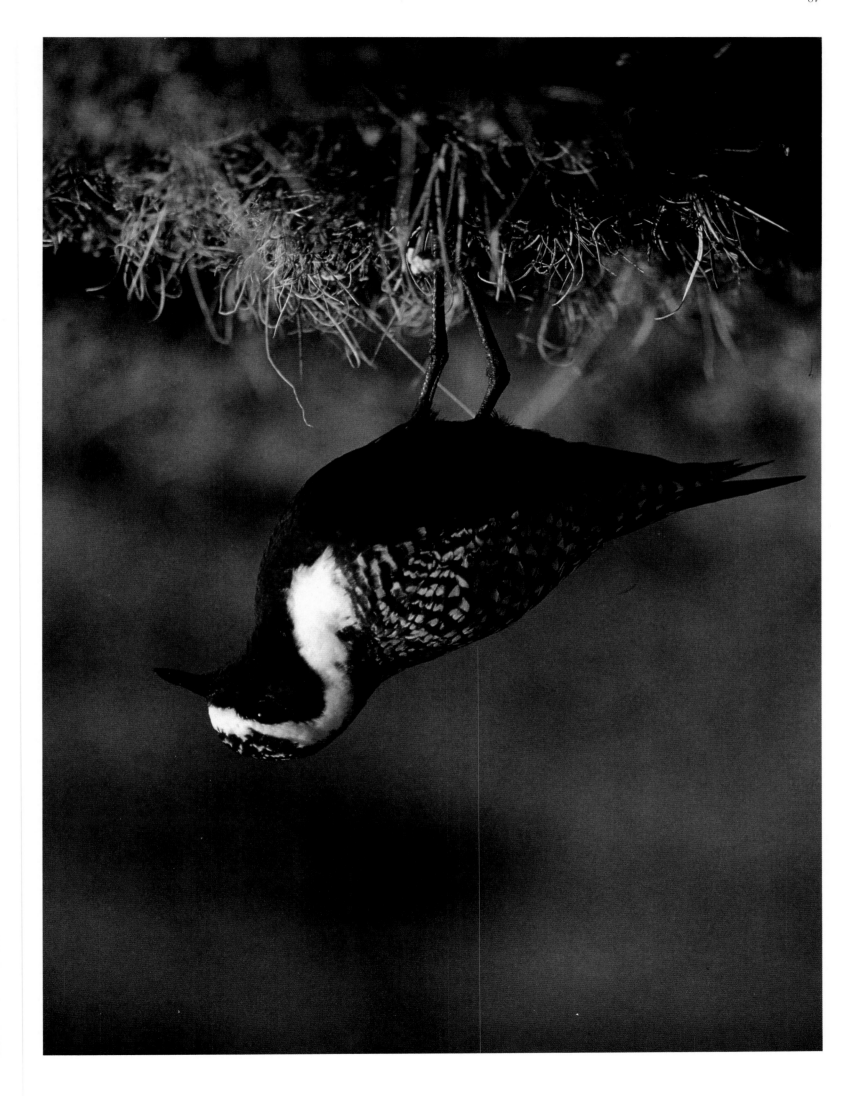

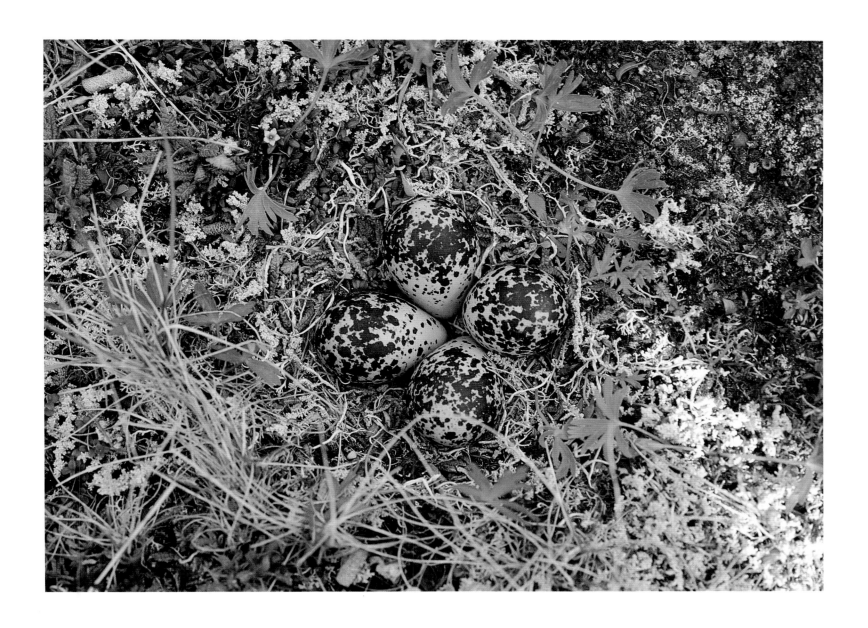

☐ Facing Page: *Summer coloration of American golden plovers—which winter in South America, Hawaii, and Polynesia—resembles nesting terrain, usually dry, or alpine, tundra. On southern winter beaches, plovers are much lighter colored. Migration routes include long, over-ocean legs, which they traverse at seventy miles per hour.* ☐ Above: *A plover nest is a simple depression in the lichens and grasses; four speckled eggs blend perfectly. Both sexes incubate the eggs. Golden plovers lure predators, like red foxes, away from their nests with masterful renditions of the injured bird, or "broken-wing" trick.*

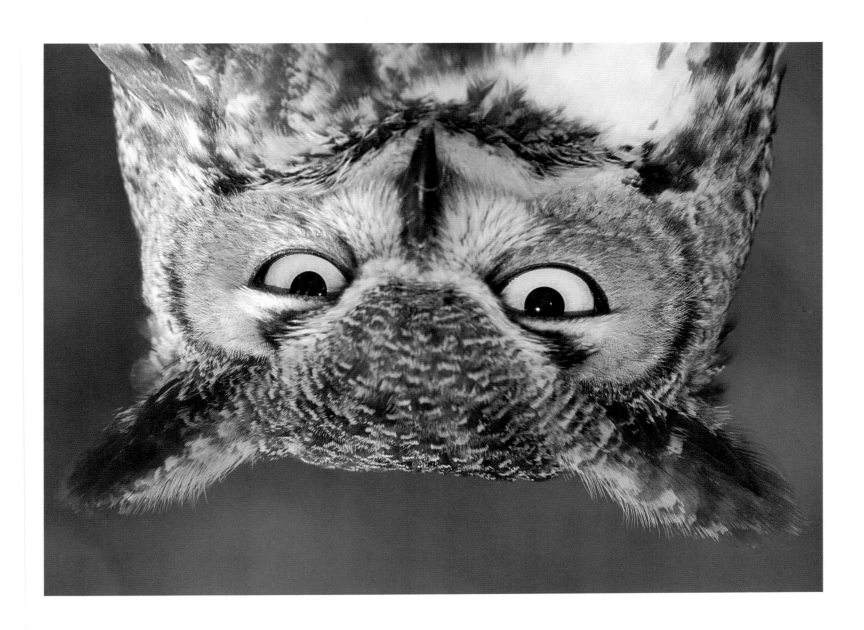

□ Above: *Great horned owls have excellent night vision, but often their acute hearing attracts them to their prey. Large facial disks and feathery "horns" concentrate sound. Owls can locate prey, sometimes as small as a shrew, without seeing it. On silent wings, owls glide in on their unsuspecting victims.*
□ *Facing Page: Savannah sparrows migrate north in spring from their wintering habitats on the Pacific Coast. Many migrate at night, their passage unseen. Four to five eggs are laid in a hidden ground nest in open terrain. Males watch over their territories from prominent perches. They eat seeds and insects.*

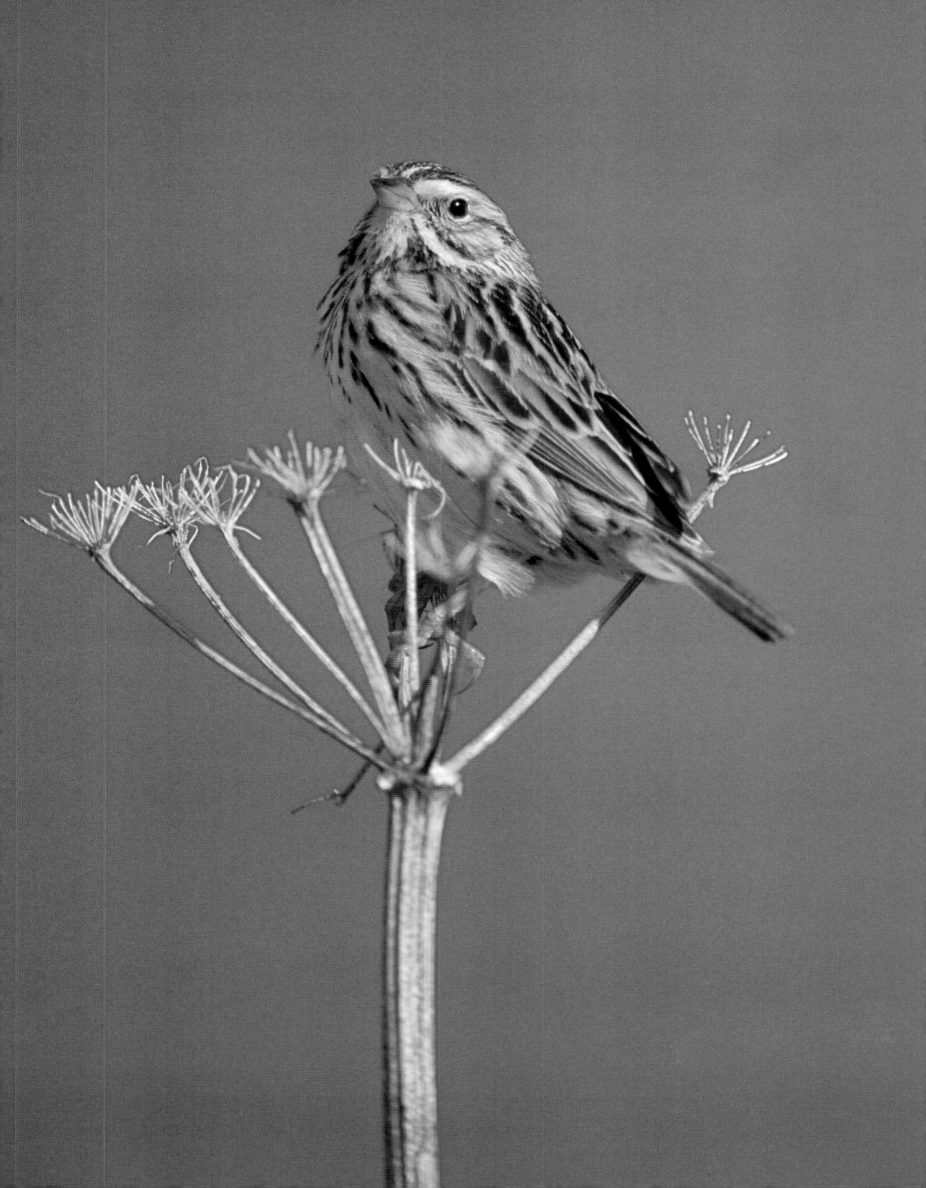

Cow moose eating aquatic plants

Orcas, or killer whales

American black bear

fire, sun, & thunder storms

In summer, the arctic sun does not set for weeks. In the sub-arctic, the sun sets briefly, and temperatures soar to 100° Fahrenheit. Lush summer thickets blanket the land. Plants seem to mature overnight, and biting insects torment almost every living creature. Bogs and muskeg are splendid hatcheries for *twenty-seven* mosquito species. There is even a specialized mosquito that lives off Interior's only amphibian, the tiny wood frog. Tempest and tumult brew above the mountains, and lightning fires scorch the land. Fire is a gift. No large mammal can survive solely in mature forests. Fire is a creative force, rapidly recycling critical nutrients.

With rain and warmth, summer appears to be an easy time of year, but it is deceptive. Predators, disease, and accident claim young and old. Some animals even die from insect harassment. Moose take to the water to feed on aquatic plants as well as to escape legions of bugs. Caribou bolt madly across the tundra to escape mosquitos and biting flies. On calm days, Dall sheep seek exposed summits looking for wind. There, they stand and endure. Life goes on. Yukon River salmon migrate fifty miles each day, some traveling as much as eighteen hundred miles from saltwater. Spawners fill streams, in death providing life to their own species as well as myriad other creatures. Everything lives, grows, and survives at the expense of others. Now, unlike winter, there is almost enough to go around.

☐ Facing Page: *Great horned owls hunt the boreal forest for red squirrels, snowshoe hares, and various rodents. The hooting of owls is a welcome sound from late winter into spring.*

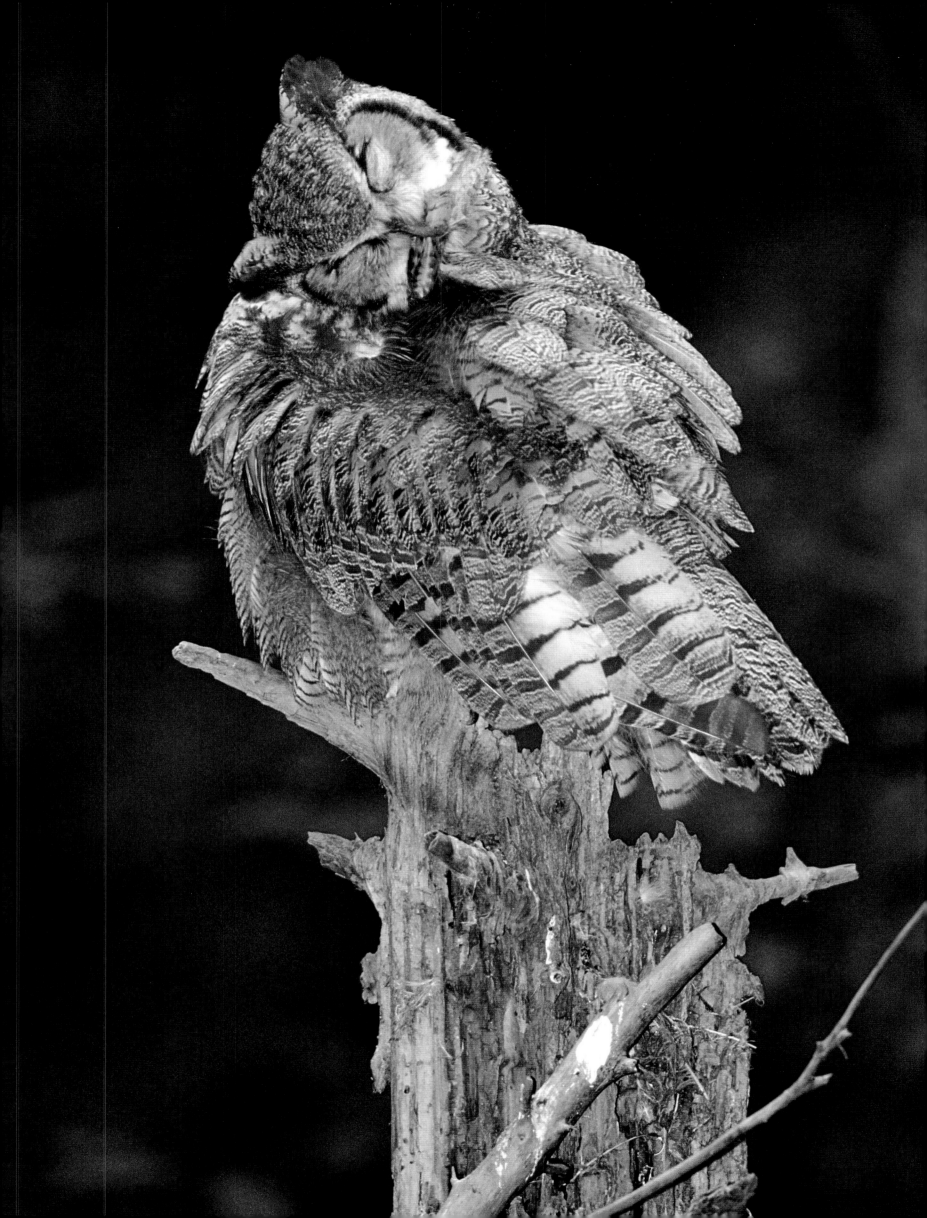

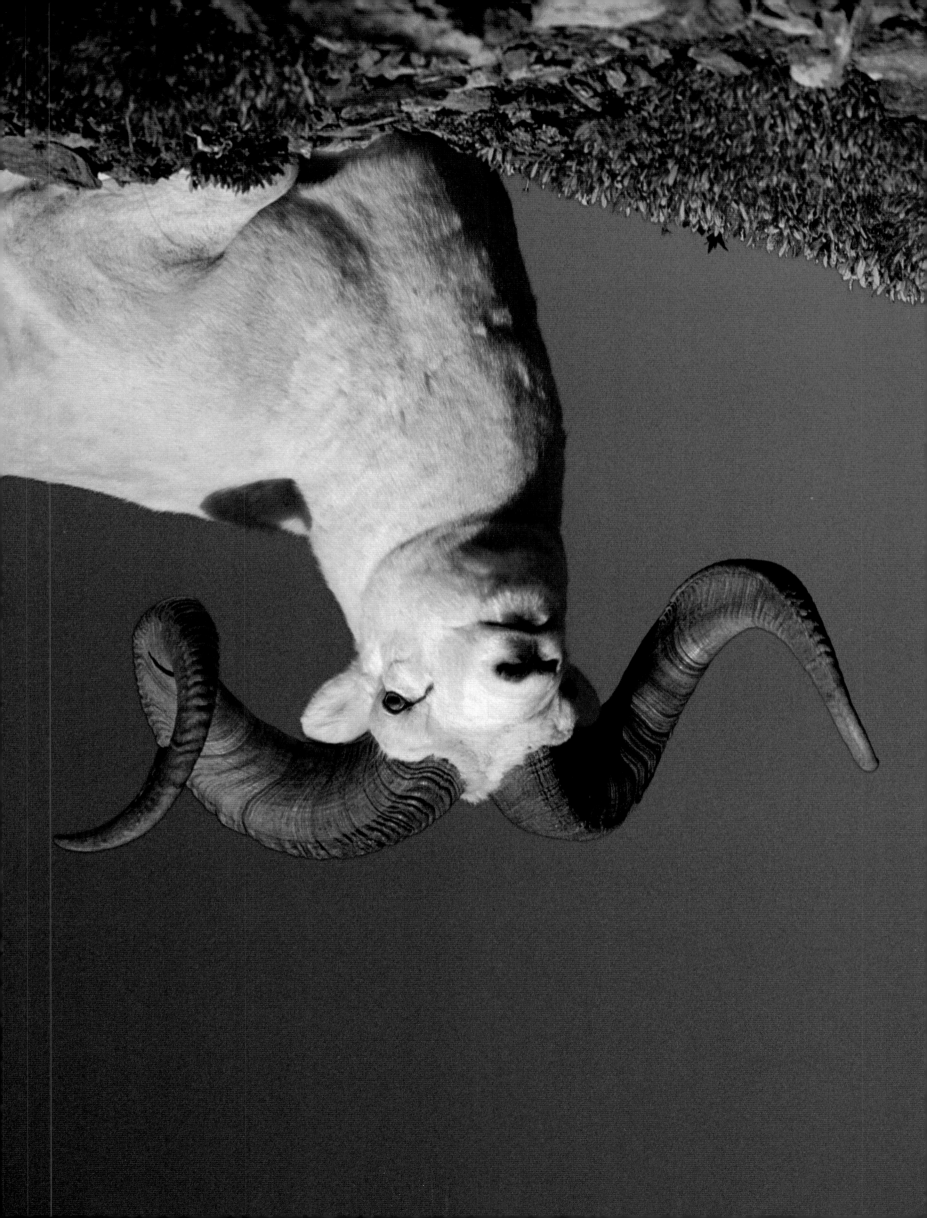

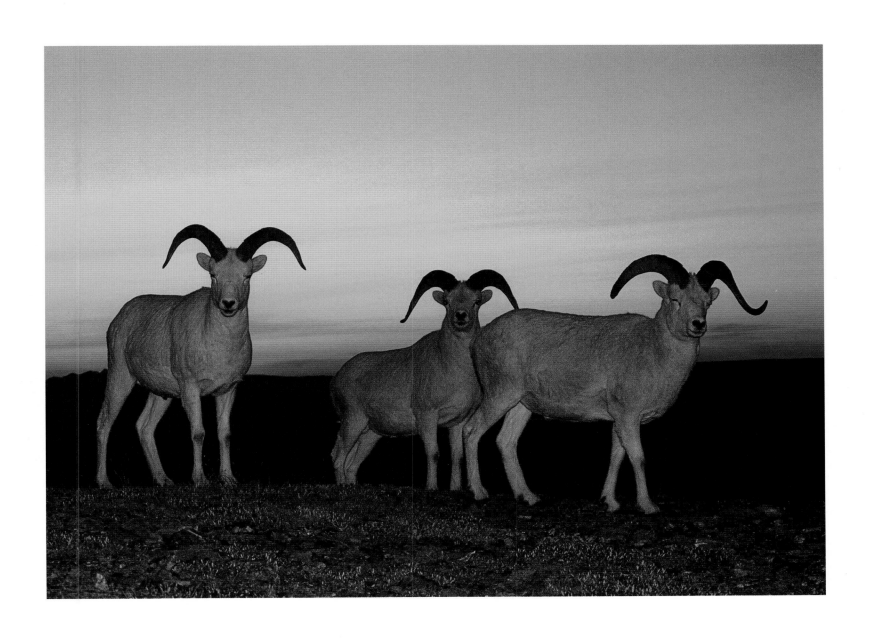

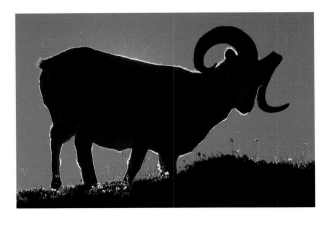

☐ Facing Page: *Unusually large ram horns are the product of quality forage, soil minerals, genetics, and longevity. Horns, emblems of rank and dominance, may break in combat or in falls. Unlike antlers, which are shed each year and regrown, horns grow throughout a sheep's life. Both sexes grow horns.*
☐ Above: *A ram trio fed through the less than four hours of twilight that passes for Interior's "night."*
☐ Left: *Silhouetted against the late afternoon sun, a ram benefits from a breeze that foils mosquitos.*
☐ Overleaf: *Moose wade into and feed on aquatic plants of lakes in view of Denali, "the high one."*

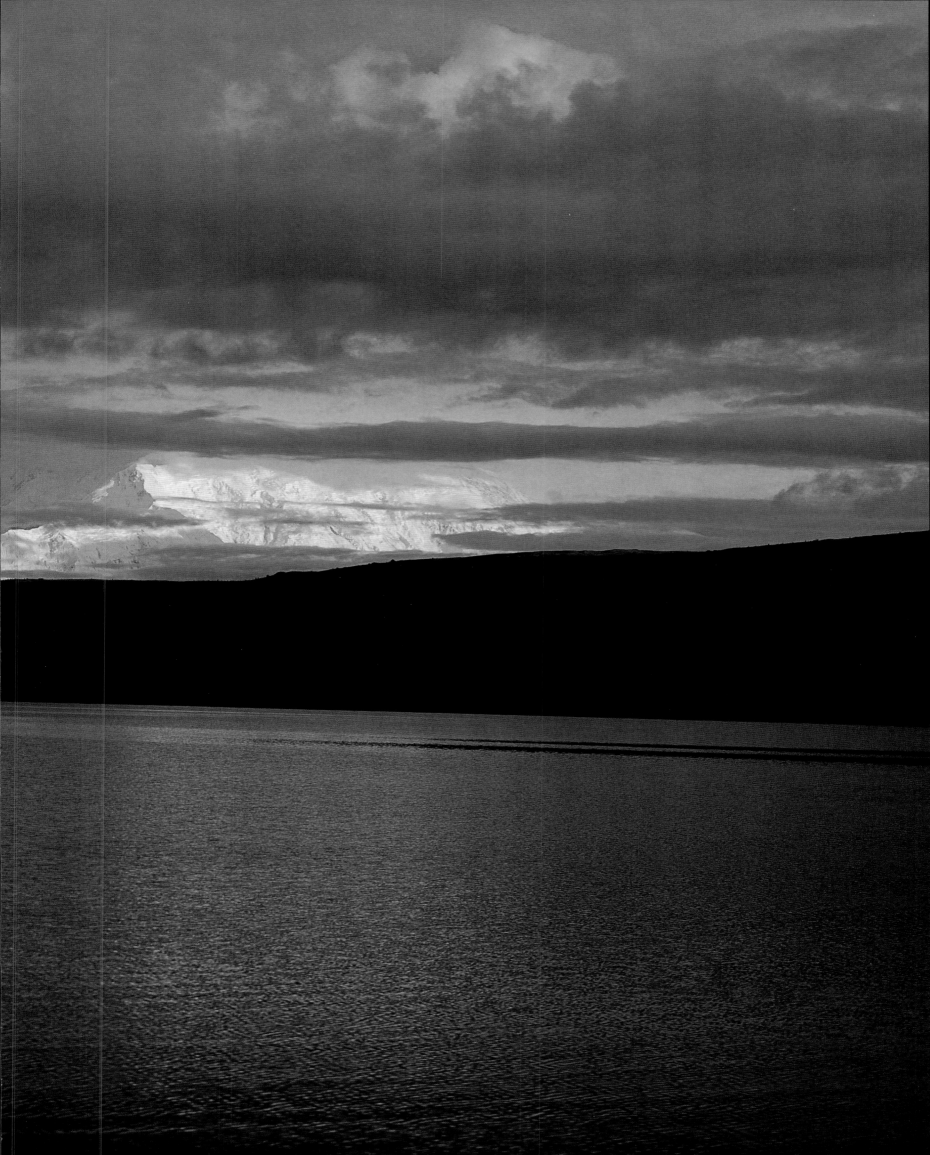

□ *Above: Wading from a salmon stream, a brown bear turns its curious glance on observers at McNeil River Falls.* □ *Right: Because they are the imprint of weaponry and play to human imagination, bear tracks at times are more provocative than an encounter with their maker.* □ *Facing Page: Large males command the best fishing locations and catch fish with economy of effort. During peak runs at McNeil River, bears prefer the nutritious skin and egg sacs of chum salmon.* □ *Overleaf: Red salmon spawn in streams flowing from lakes. They build nests, "redds," in stream or lakeshore gravels.*

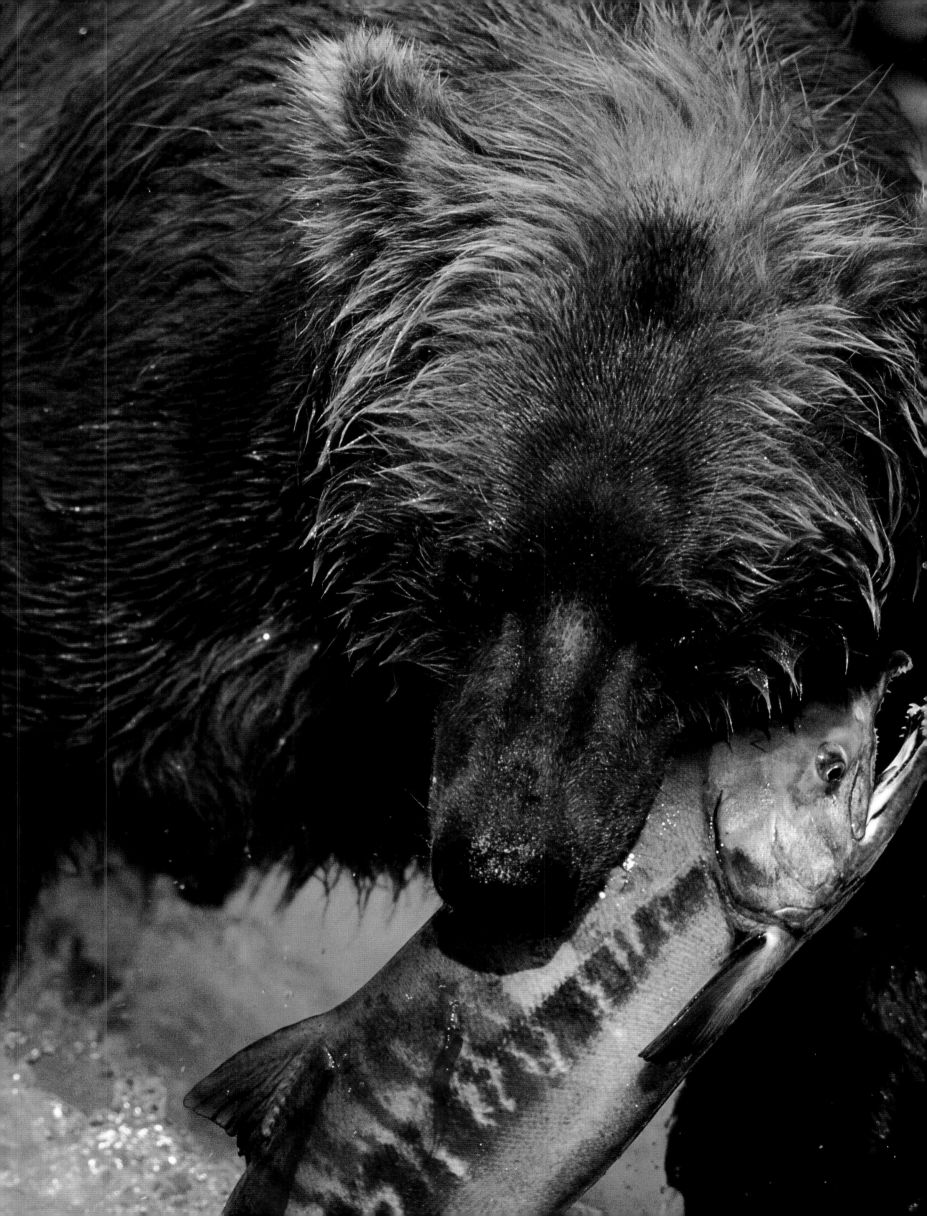

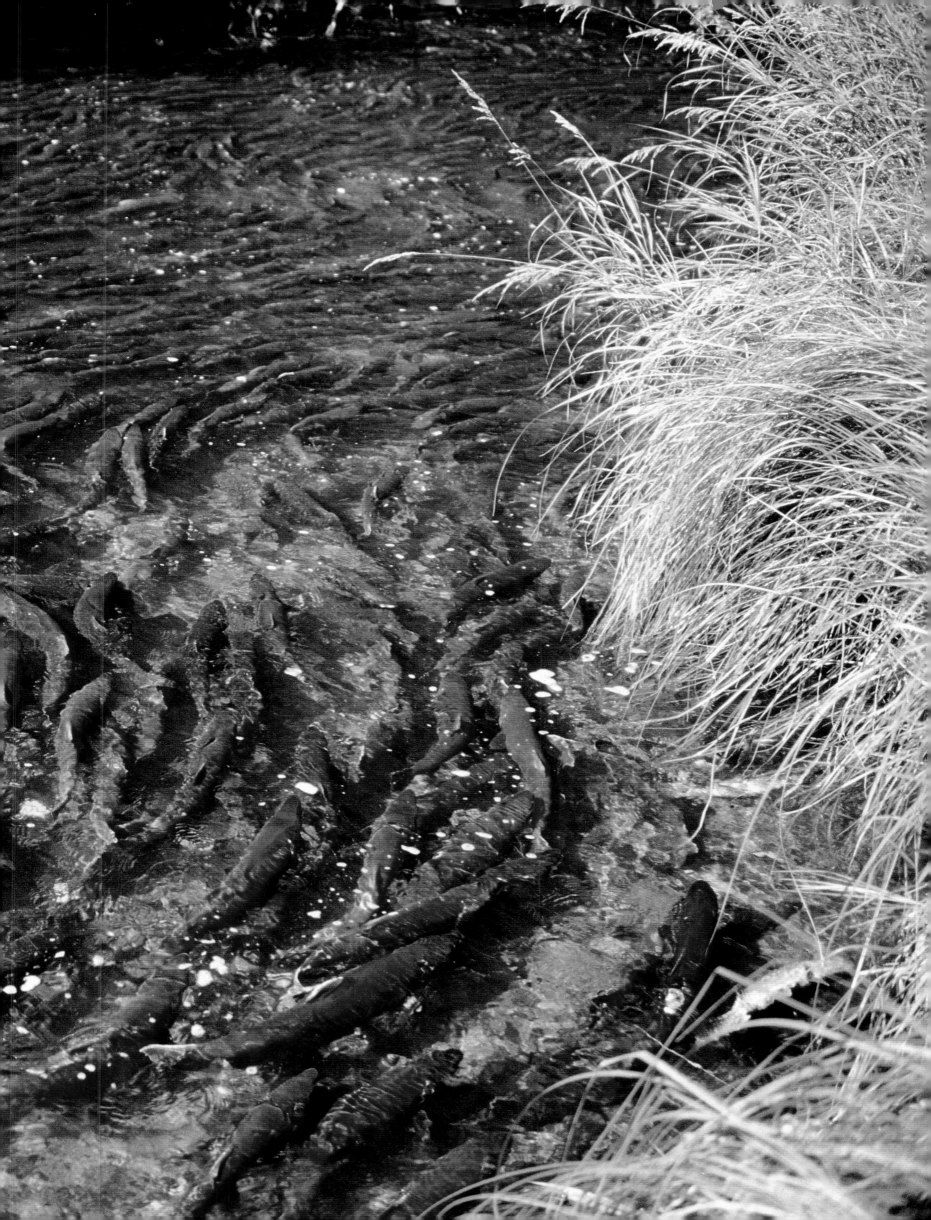

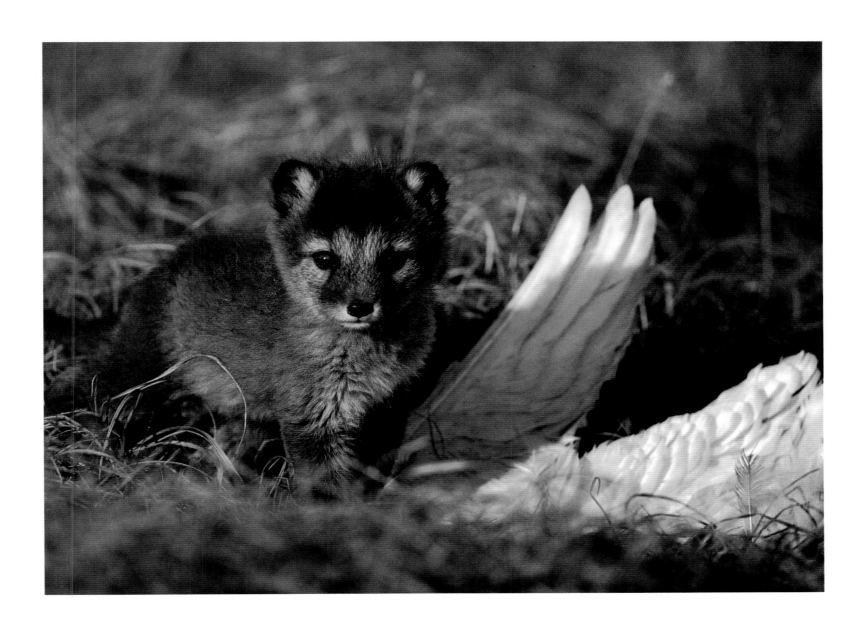

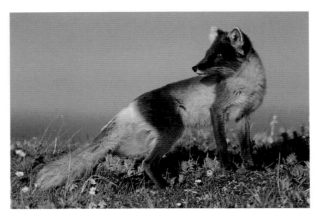

□ Facing Page: *Red foxes are predators of small mammals and ground nesting birds. Transplants to offshore islands have decimated some nesting seabird colonies.* □ Above: *When small rodents, such as lemmings, are scarce, arctic foxes feed on birds and eggs. Adults carry kills, like seagulls, to their pups. Litters from seven to fifteen pups require a lot of food. Pup mortality is predictably high, with most starving in early winter.* □ Left: *Two-toned in summer, arctic foxes turn white in winter. In either camouflage, arctic foxes are superb lemming hunters, pouncing on them through the snow or in the grass.*

☐ Above: *Rocky slopes are home to pikas, four- to six-inch-long animals that are related to hares and rabbits. They dry and store plants for winter forage. Weasels and eagles are their principle predators.*

☐ Right: *Golden eagles are mountain and tundra hunters. In rugged aeyries, eaglets are fed ground squirrels, pikas, ptarmigan, and other small animals. The juvenile mortality is high, about 75 percent.*

☐ Facing Page: *A red squirrel pauses to eat seeds. Squirrels aggressively defend their territories, which range in size up to about three acres. Predators, including martens and owls, kill few squirrels.*

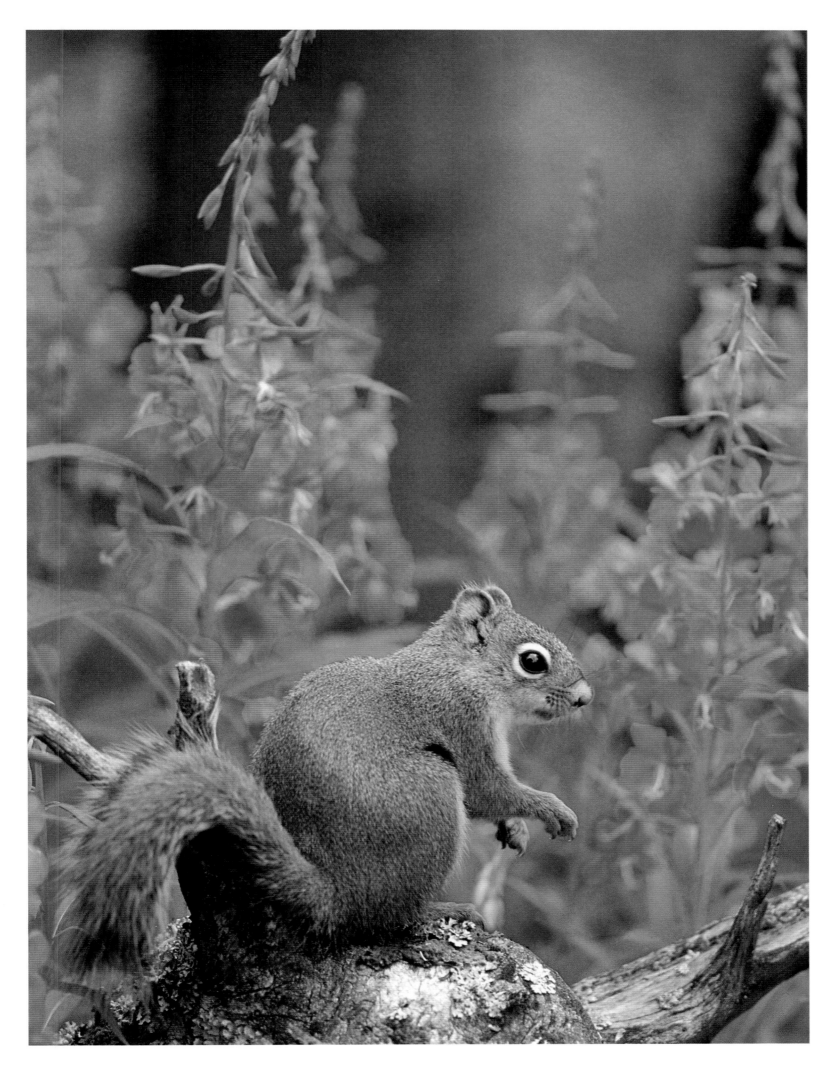

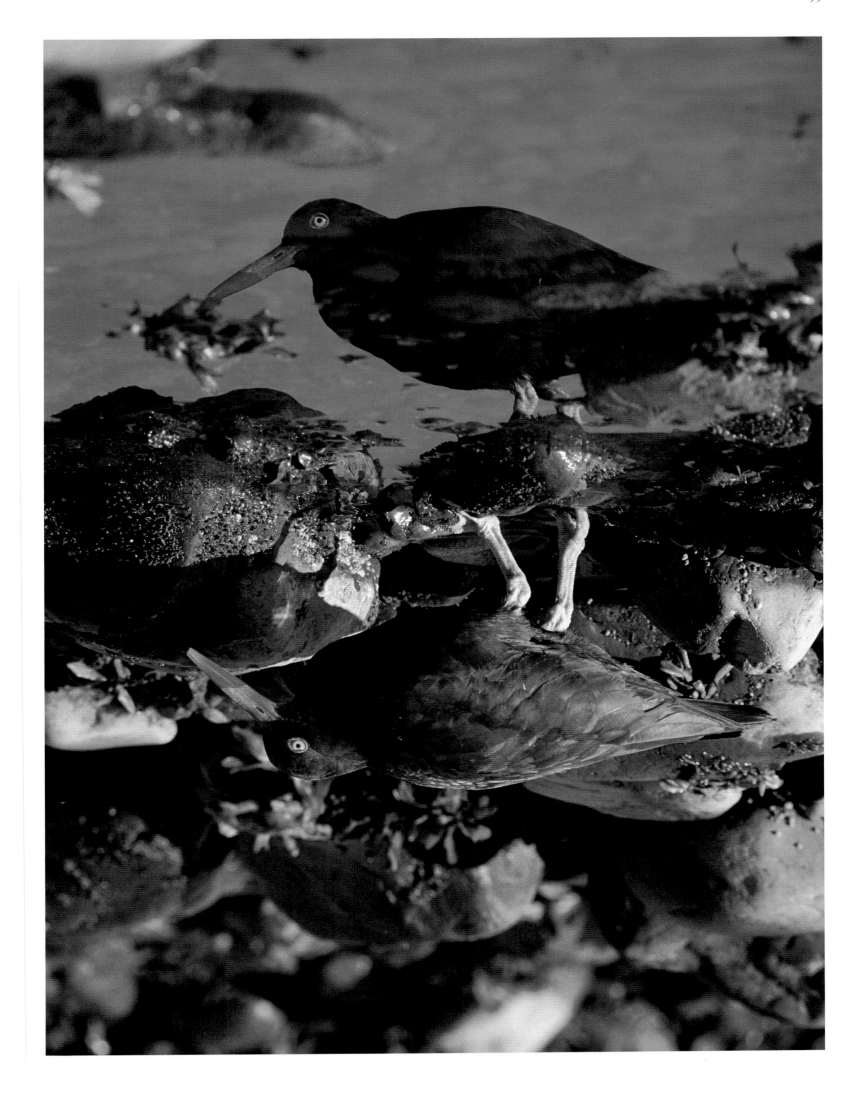

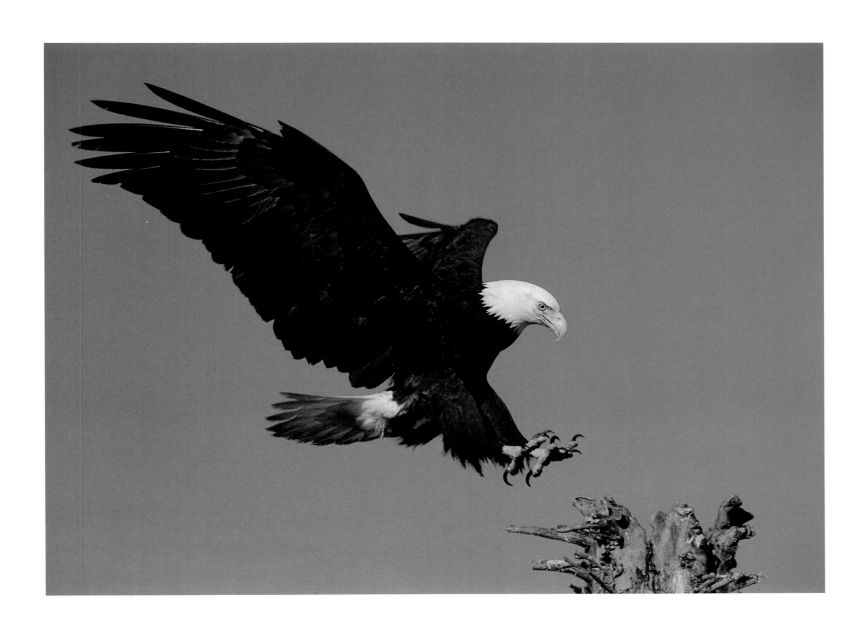

□ Facing page: *About eight thousand black oyster-catchers, 60 percent of the world's population, breed in Alaska. Oystercatchers feed on a variety of small mollusks and invertebrates. The unique bill is used to puncture or pry open bivalves. This shorebird nests in beach gravels not far from tidal feeding areas. Two eggs are deposited and cared for by both adults. Juveniles learn specialized feeding techniques by watching adults.* □ Above: *The scientific name for the bald eagle,* Haliaeetus leucocephalus, *affords a vivid description: the Greek* haliatos *means "sea eagle";* leukos *is "white"; and* kephale *means "head."*

□ Above: All birds, even a seabird like the tufted puffin, clean their plumage. Puffin bills are colorful in summer nesting season. In late summer, both puffin species shed the outer covering of the bill. □ Facing Page: Horned puffins arrive at breeding colonies in late May. Islets and coastal headlands are prime seabird nesting sites. Both tufted and horned puffins, like many seabirds, nest underground. Both species lay a single egg in a burrow on a sparse grass nest atop the rocks or soil. Both adults share in incubating the egg. While one sits on the egg, the other feeds at sea. Both adults feed the hatchling.

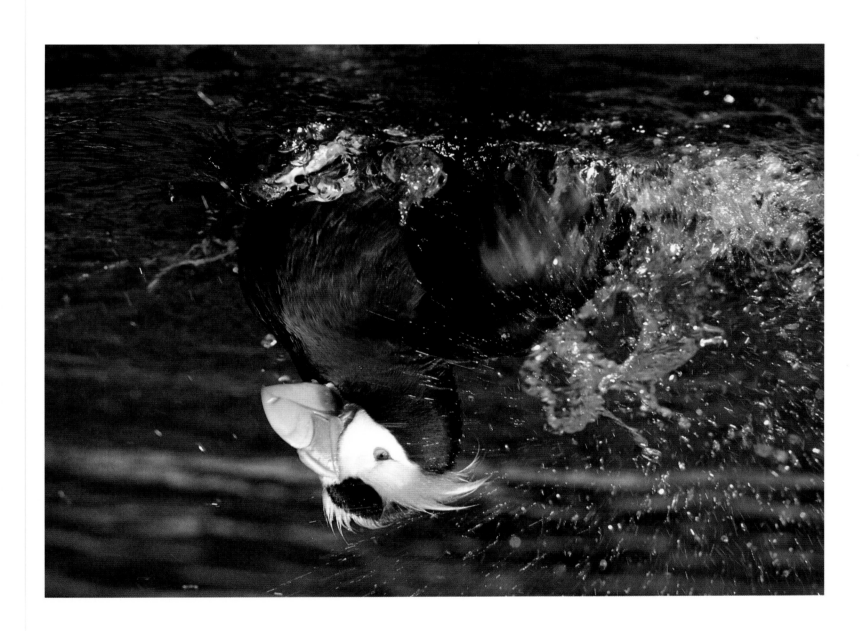

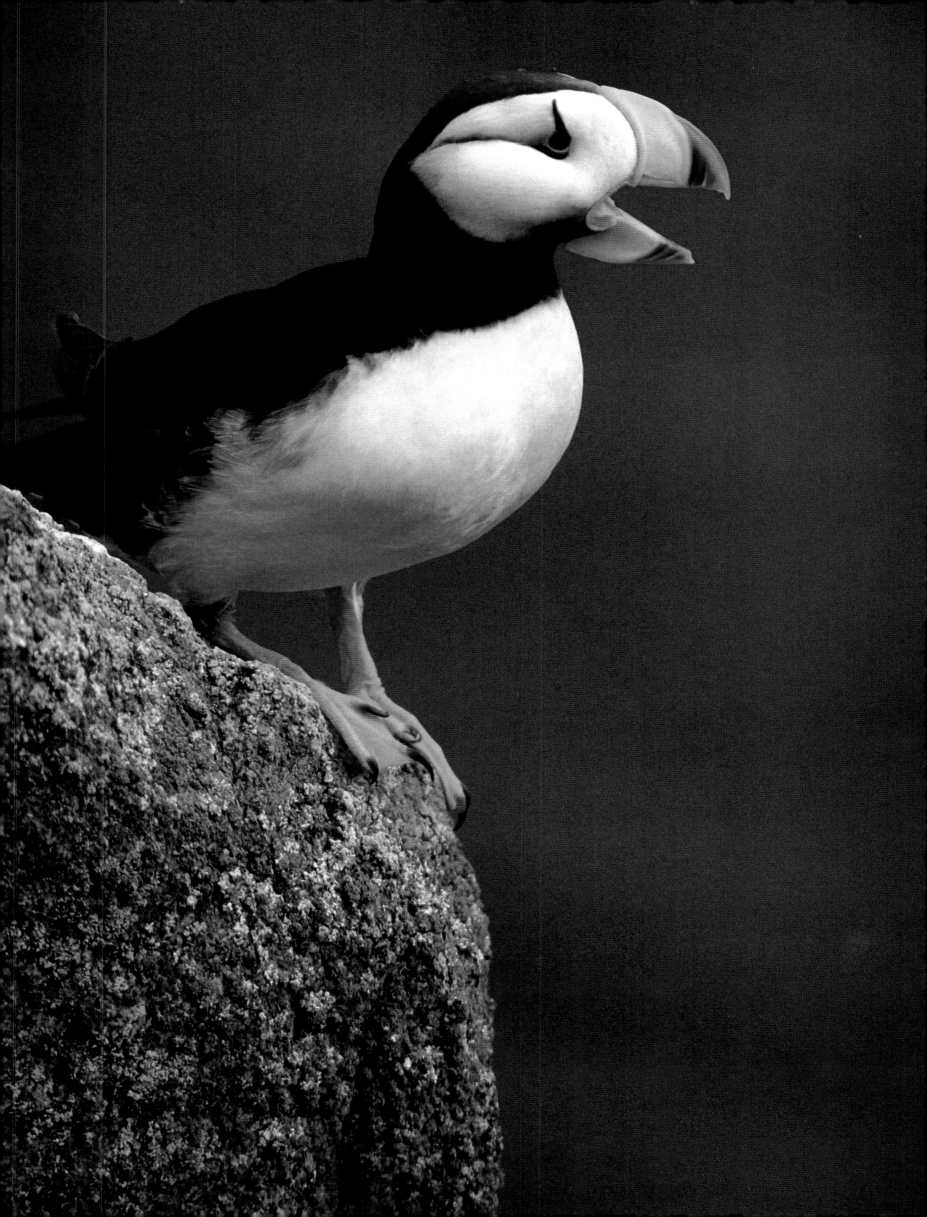

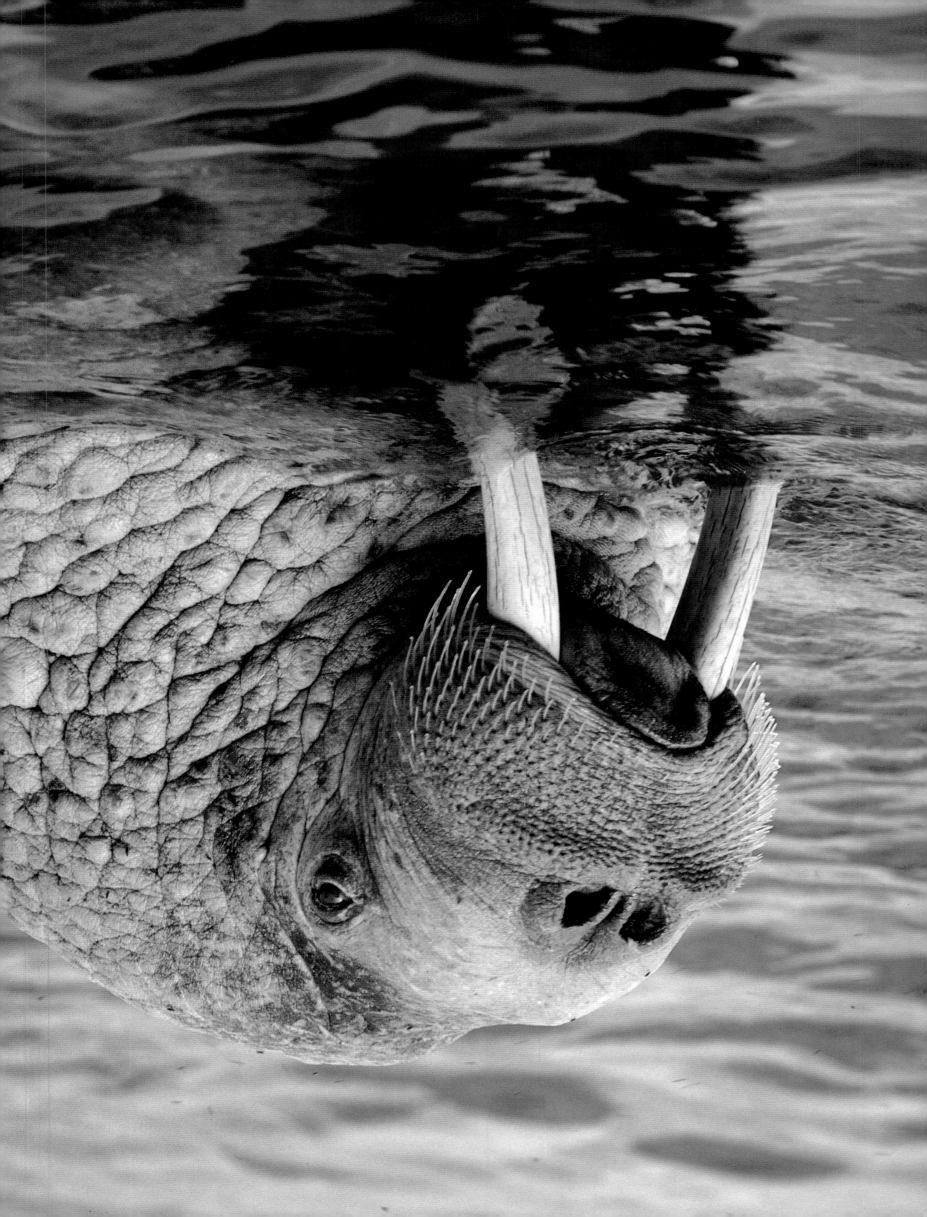

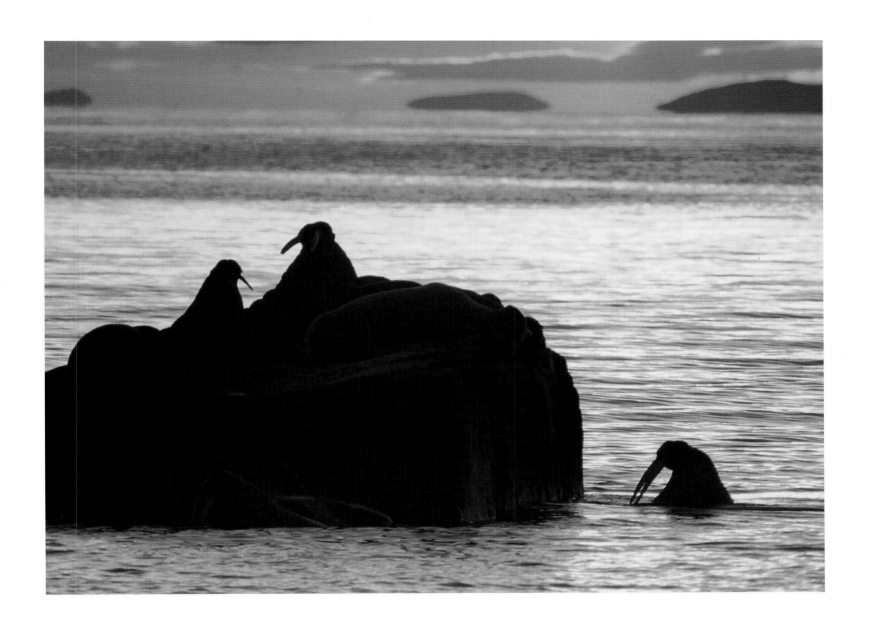

☐ Facing Page: *Awkward on land, walruses are agile swimmers. Searching for food, they dive for six to ten minutes to depths of 30 to 150 feet. Using their whiskers, called* vibrissae, *walruses root in the mud for bivalves. They suck the meat from the shells.* ☐ Above: *Gregarious walrus gather on ice floes or rocky shores. Land "haul-outs," though uncommon, are important sites.* ☐ Overleaf: *Walrus haul-out in part to regulate body temperature. When first ashore, walruses are white or bright pink, slowly turning brown as they warm. Adult males can weigh over two tons and sport tusks almost three feet long.*

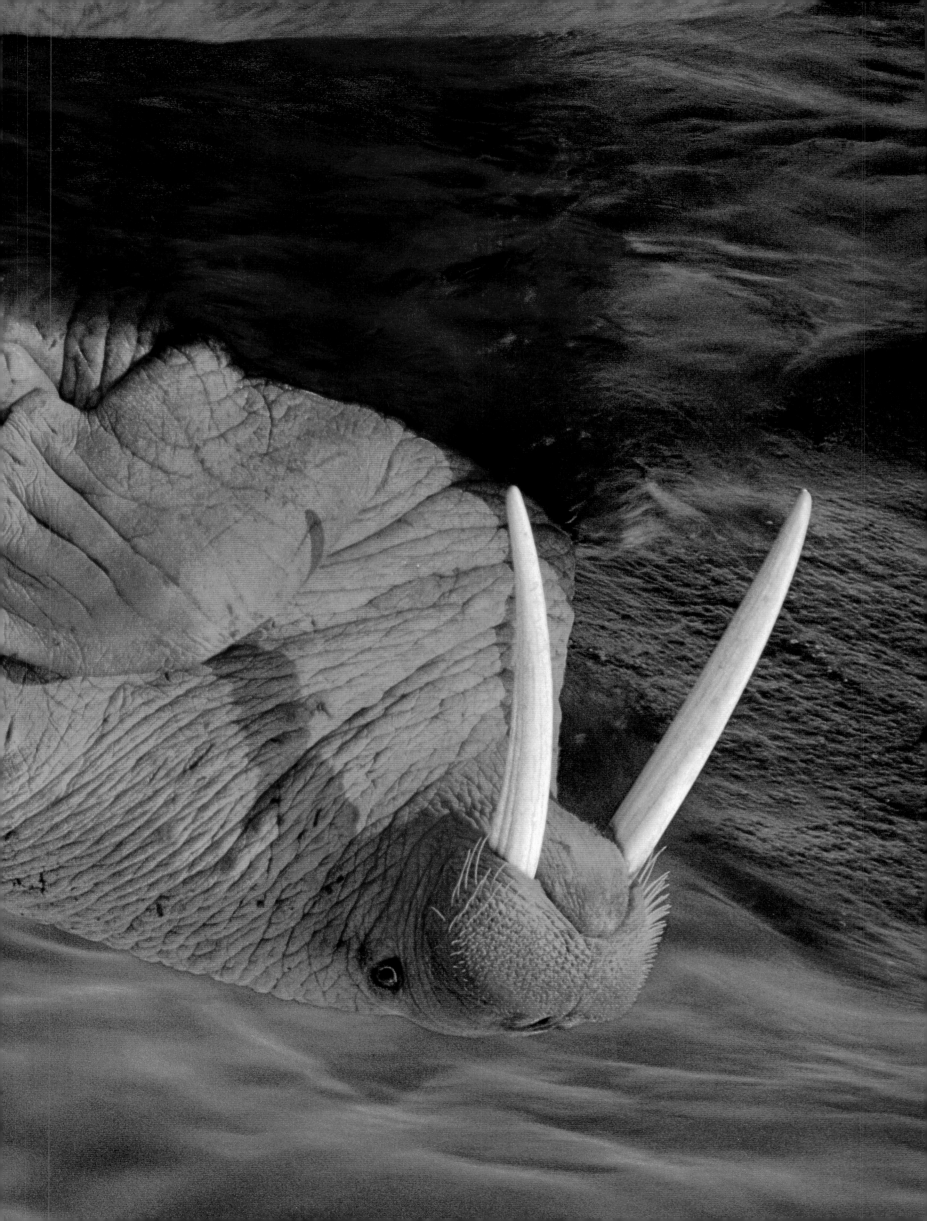

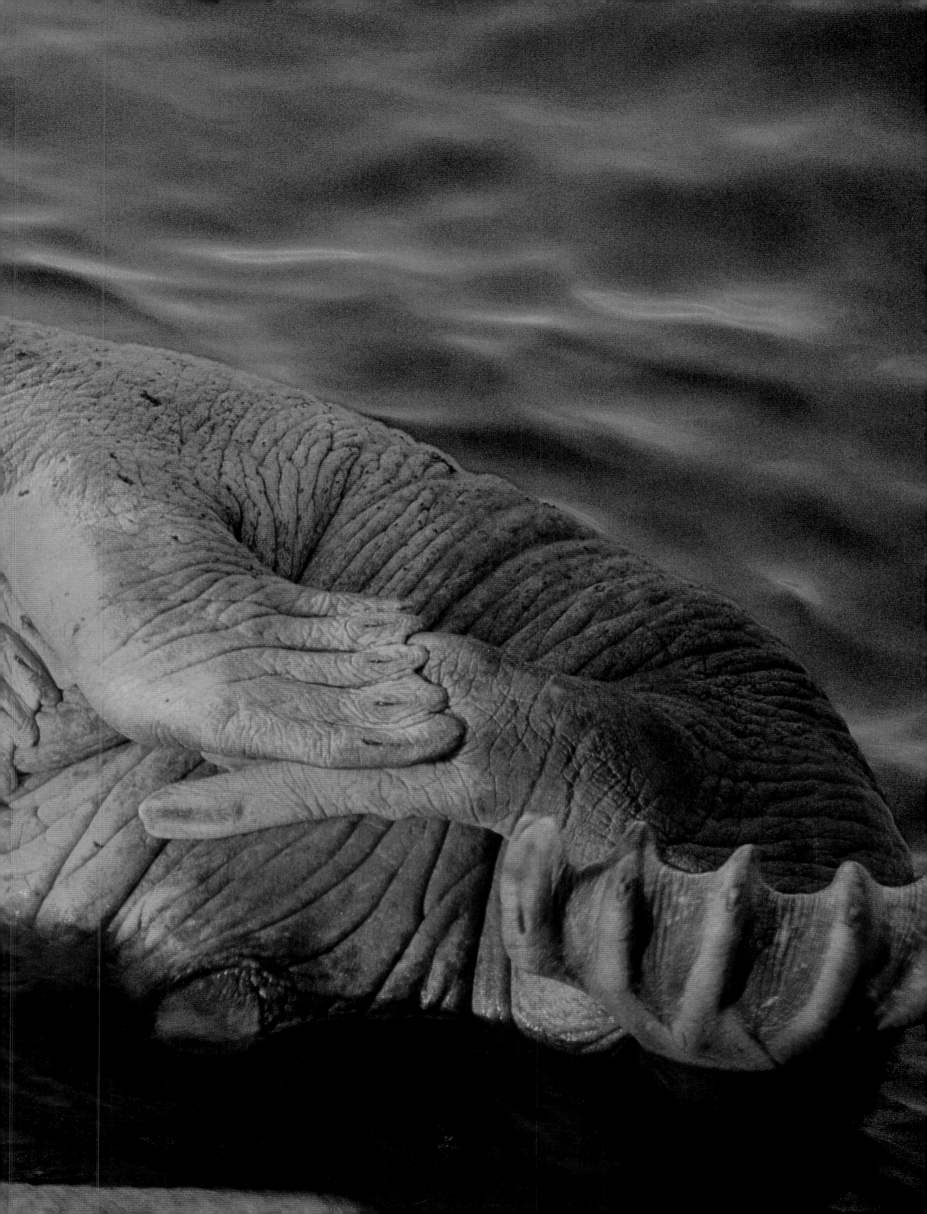

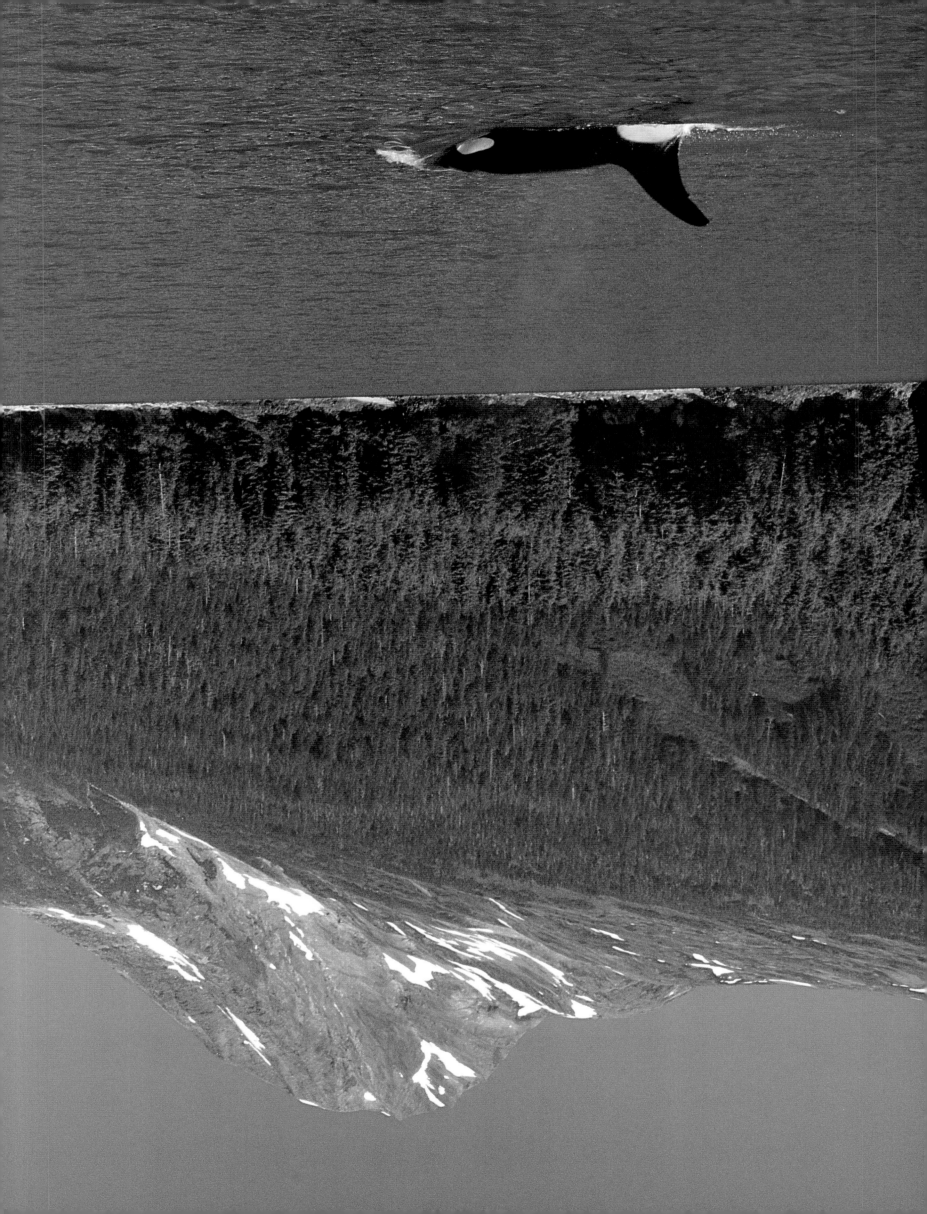

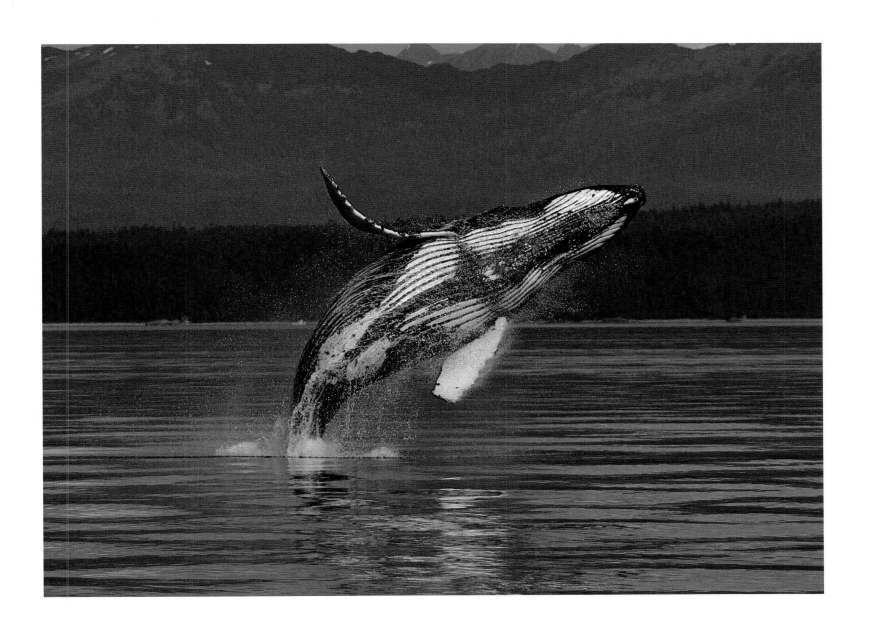

□ Facing Page: *Sometimes called "killer whales," orcas in Alaska number about four hundred. Two distinct groups, transients and residents, have different habits, dialects, and social structure. Transients eat marine mammals such as seals, porpoises, sea lions, and even other whales; residents eat fish, not marine mammals.* □ Above and Overleaf: *The humpback whale derives its name from its arching dive pattern. The scientific name in part means "big-winged," referring to pectoral fins about one-third the body length. Endangered humpbacks, numbering 12,500 worldwide, live forty to seventy years.*

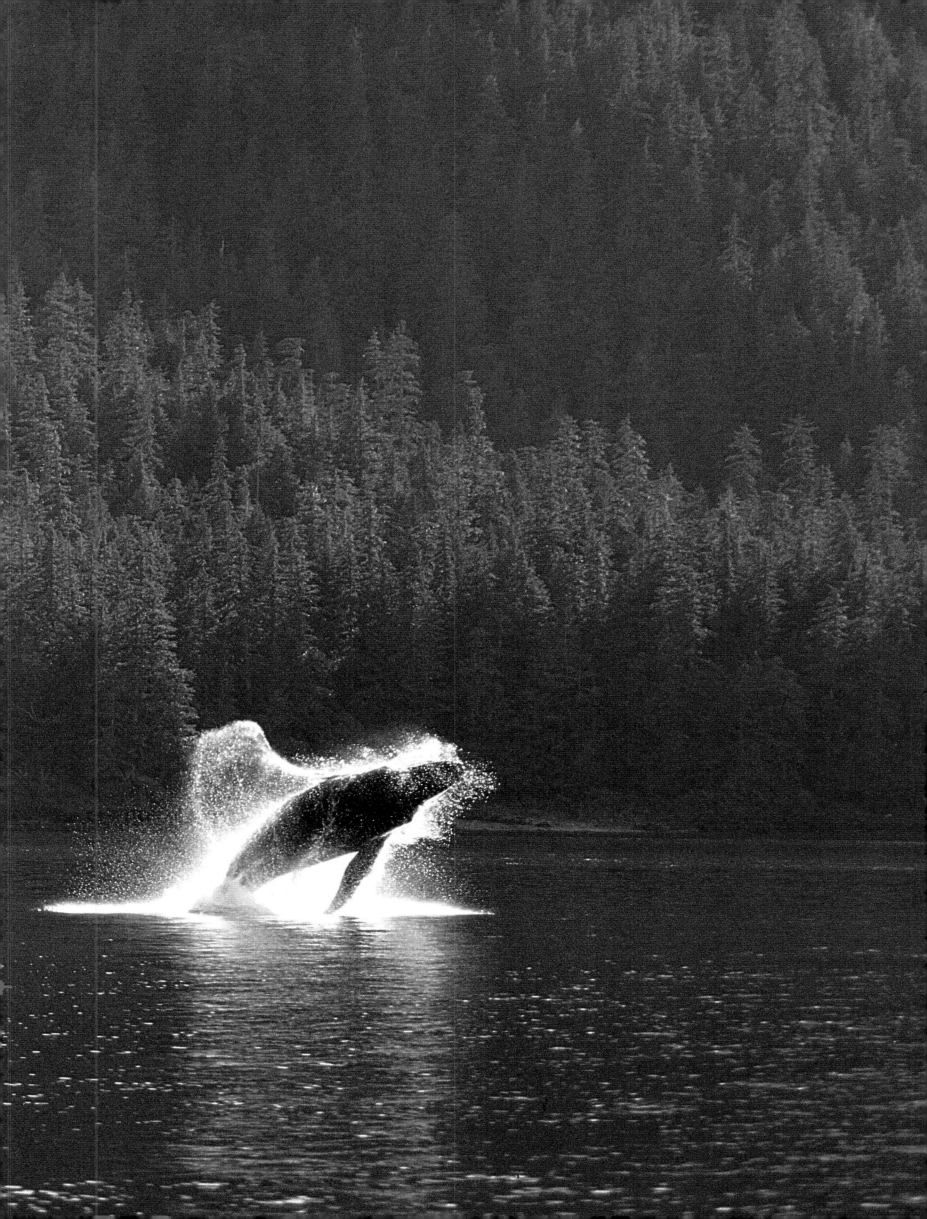

□ Above: Humpback whales have no teeth; their jaws, instead, are lined with hairy baleen. Lunge feeding, singly or in a group, is an open-mouthed pass through prey. A feeding humpback can take in almost five hundred gallons of water in a single gulp, using the baleen to filter out as much as one hundred pounds of food. In summer, a humpback consumes as much as two tons of food each day. Humpbacks also feed by "fin-flicking," fin slaps that stun fish. □ Facing Page: Black-legged kittiwakes, common murres, and horned and tufted puffins share nesting cliffs, which protect them from foxes on the islands.

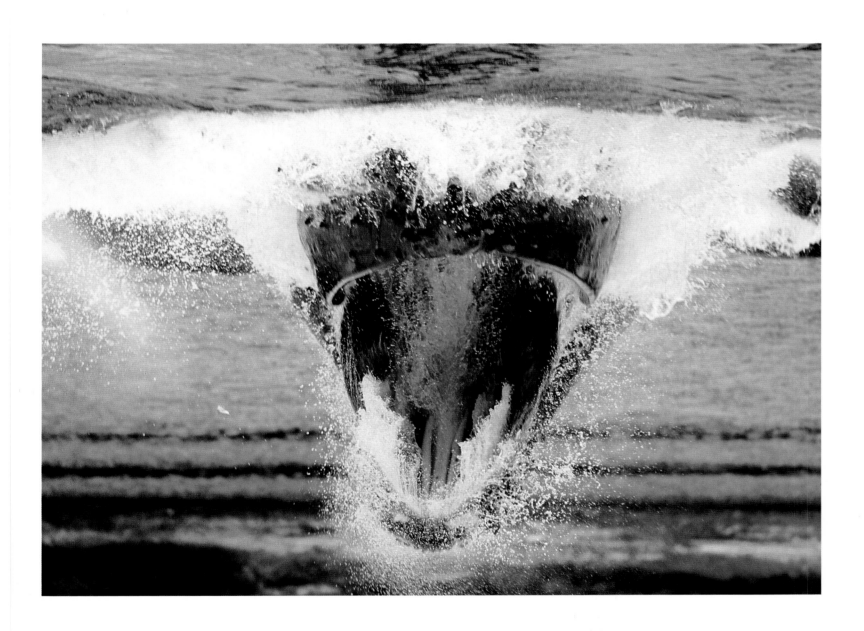

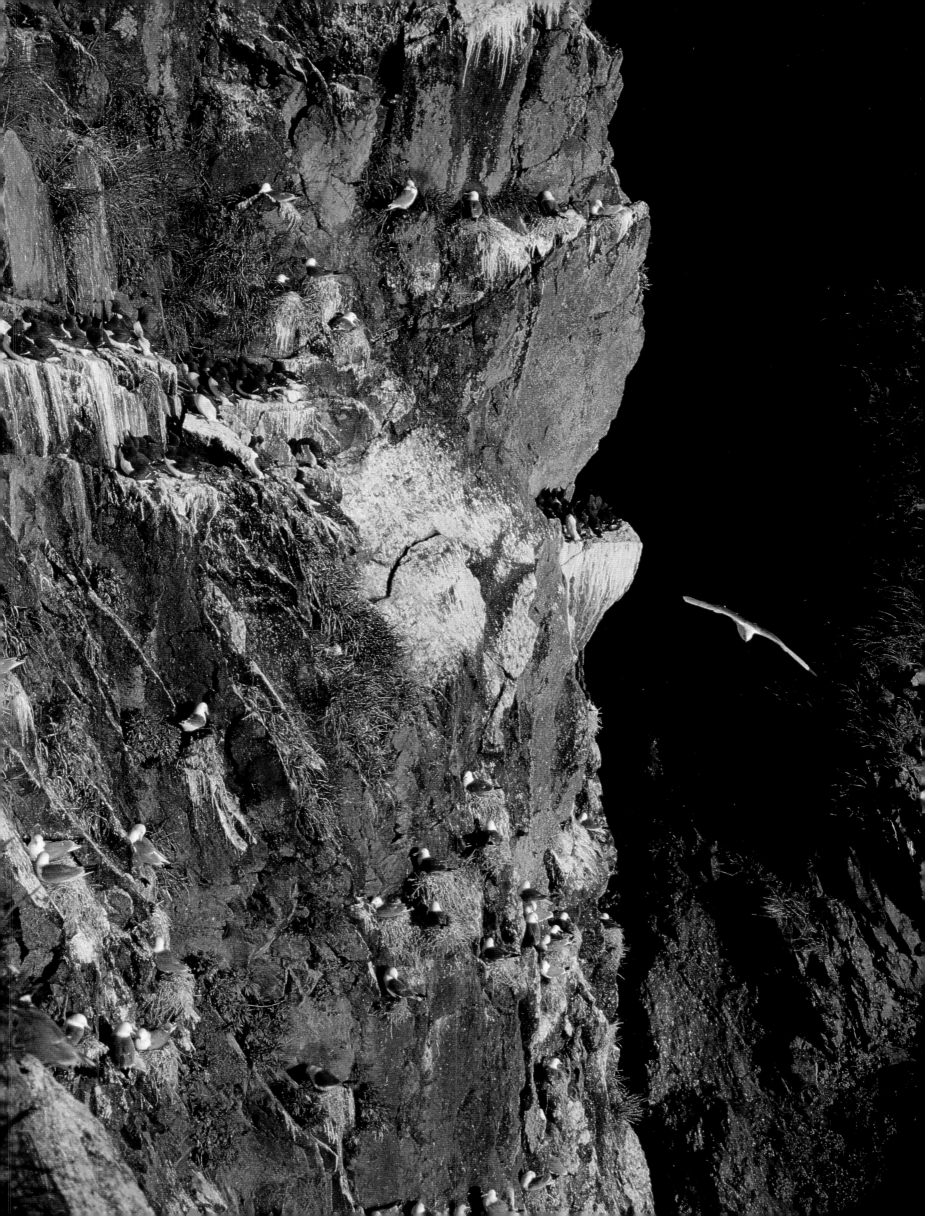

Gray wolf

Mature bull moose

Interior Alaska grizzly bear

glitter of frost & stars

Autumn is the season of painted leaves. Sere grasses gleam in the late afternoon sun, and crimson leaves flutter in the wind. Ice forms on tundra ponds, and storms dollop the peaks with snow. It is only the end of August, but already winter has arrived on the arctic shore. Pelage begins to lengthen, and underfur thicken; plumage develops, and young wings gain strength. All through the lengthening night, foraging accelerates as animals fatten for migration, the rut, or winter survival. Winter's lantern—the aurora borealis—already hangs in the sky.

Diminishing daylight triggers reverse migrations, feeding binges, food gathering, hibernation preparations, rutting seasons, and pelage and plumage color changes. Flocks of ducks, geese, swans, and cranes, all bolstered by summer broods, fill the sky with cacophonous anthems. Sheep dare lowland passes on the way from the high peaks to ranges of lesser snowfall. Caribou herds ford flooding rivers. Black and brown bears gorge for hibernation. Pikas, red squirrels, muskrats, and beaver work to expand winter larders. Anticipating months of ice-locked confinement, beaver and muskrats strengthen and refine their lodges. Bull moose, elk, deer, and caribou polish their antlers in anticipation of battle. Marmots and ground squirrels ready their dens. All creatures hedge against the famine overtaking the land. It is the day before winter.

□ Facing Page: *As autumn creeps over the Alaska Range, bull caribou lose the soft velvet covering on their antlers. Soon they will leave their summer pasturages for lowland rutting grounds.*

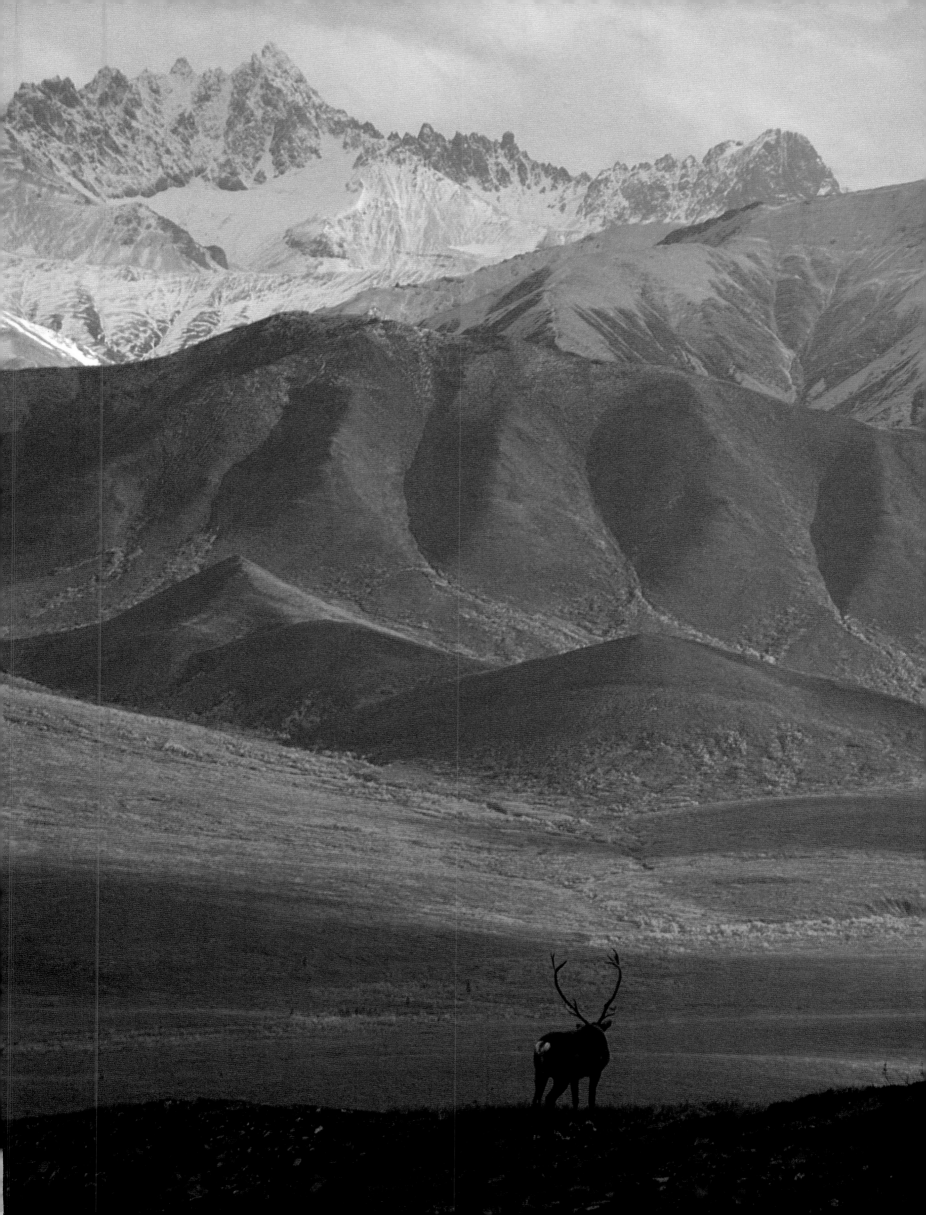

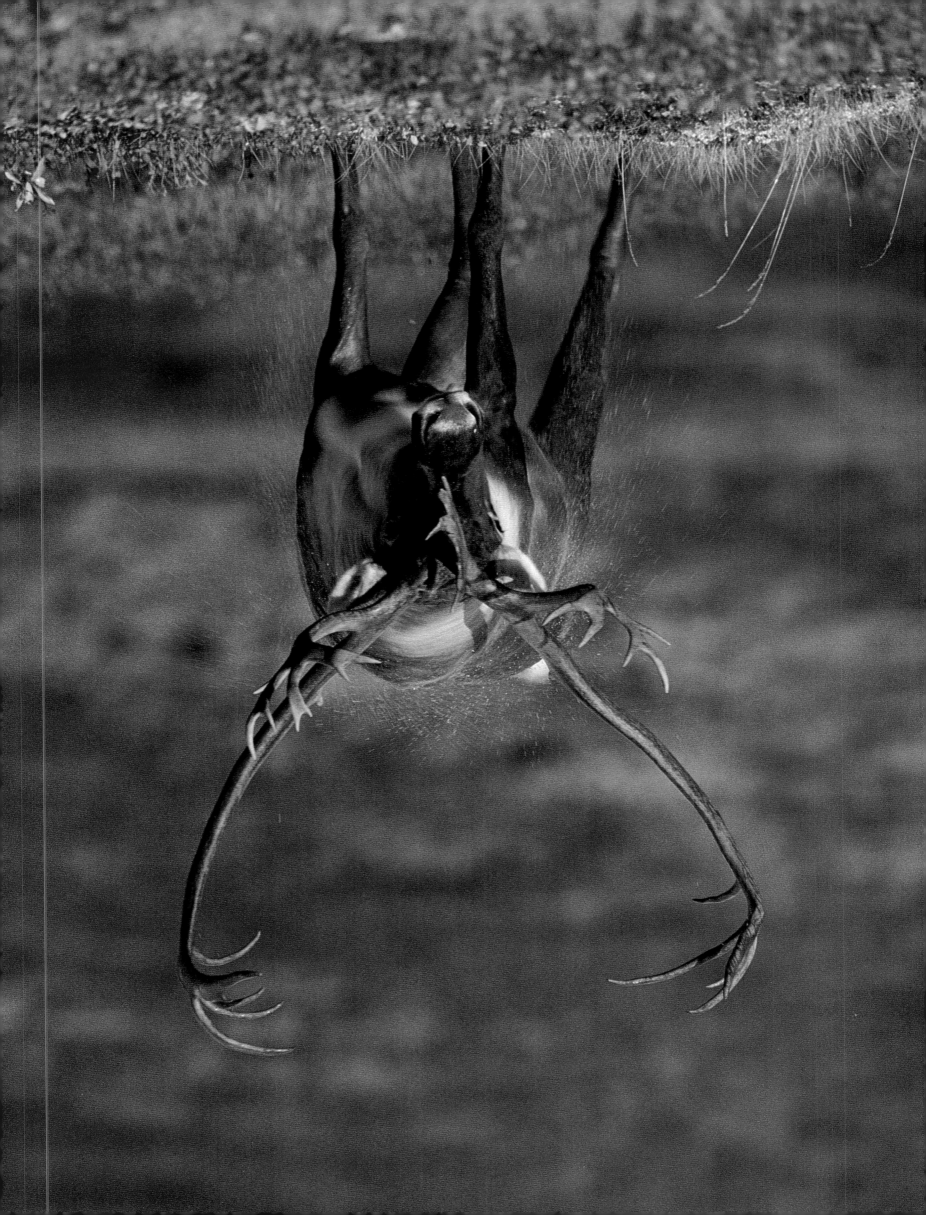

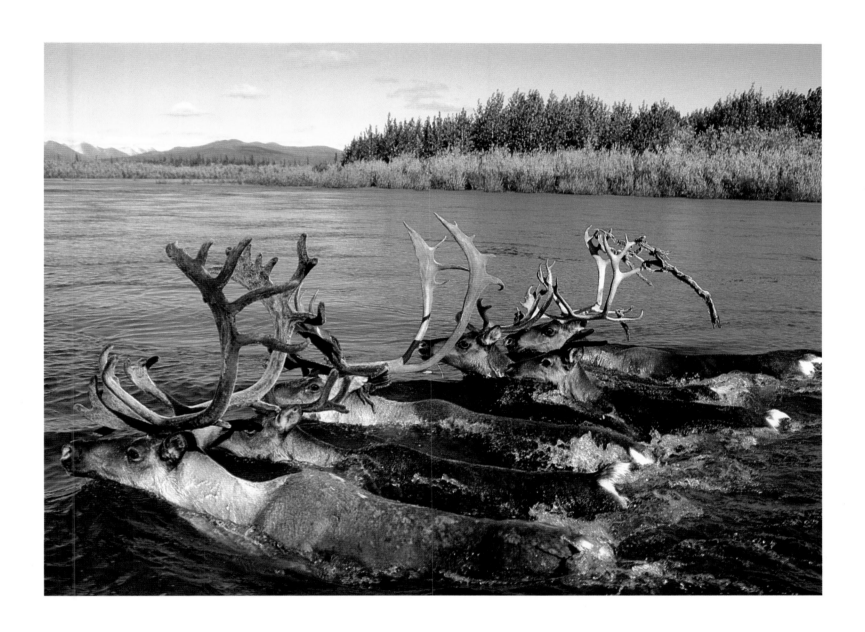

□ Facing Page: *All wild animals endure extremes of weather. A caribou's remarkable pelage protects it from cold in winter and rain in autumn, but not from insect torment. As bulls develop into their prime, their coats turn a beautiful chestnut with white neck, throat ruff, and flank line. Polished antlers gleam in late afternoon sun and rain.*

□ Above: *Natural obstacles slow down, not stop, migrations of arctic herds. Sexes frequently mingle during migration, but often groups of bulls travel alone. Antlers freshly stripped of velvet are stained red from the blood that nourished their growth.*

□ Above: *Just after shedding velvet, bull caribou begin to spar. These initial jousts are tentative tests of strength, not serious combat. Earnest dominance battles begin after mid-September and can occur until the end of the rut in late October. Most fighting is brief and violent, with severe injury not unknown. On some occasions, combatants will lock antlers and be unable to break free. Starvation awaits both.*
□ Facing Page: *Bull caribou can develop impressive racks with unique shovels, beams five feet long, and antler spreads four feet wide. Large antlers, symbols and tools of dominance, ensure breeding success.*

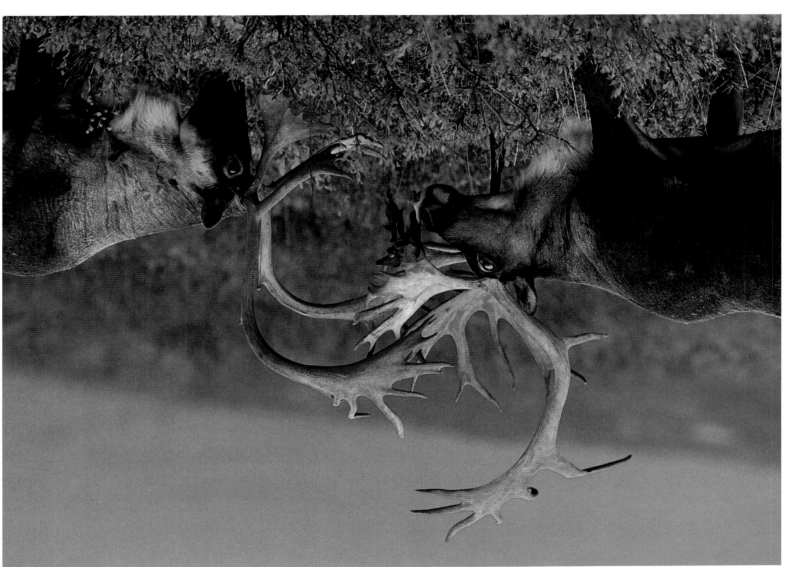

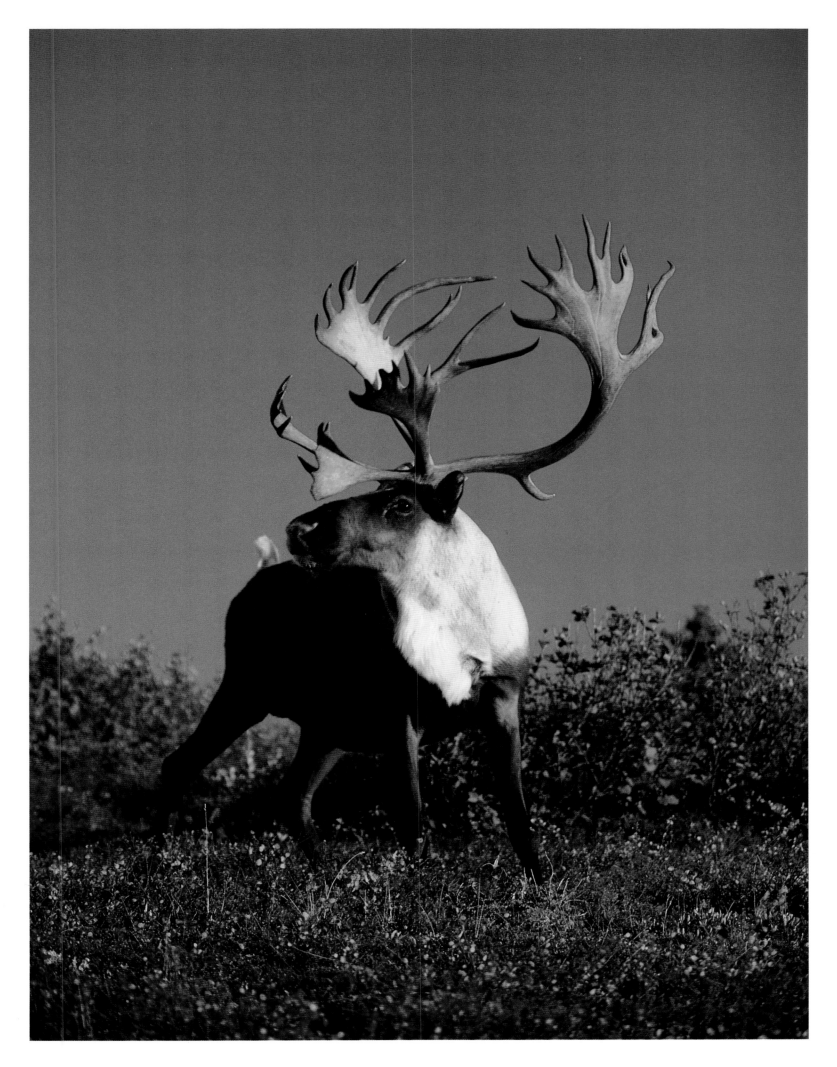

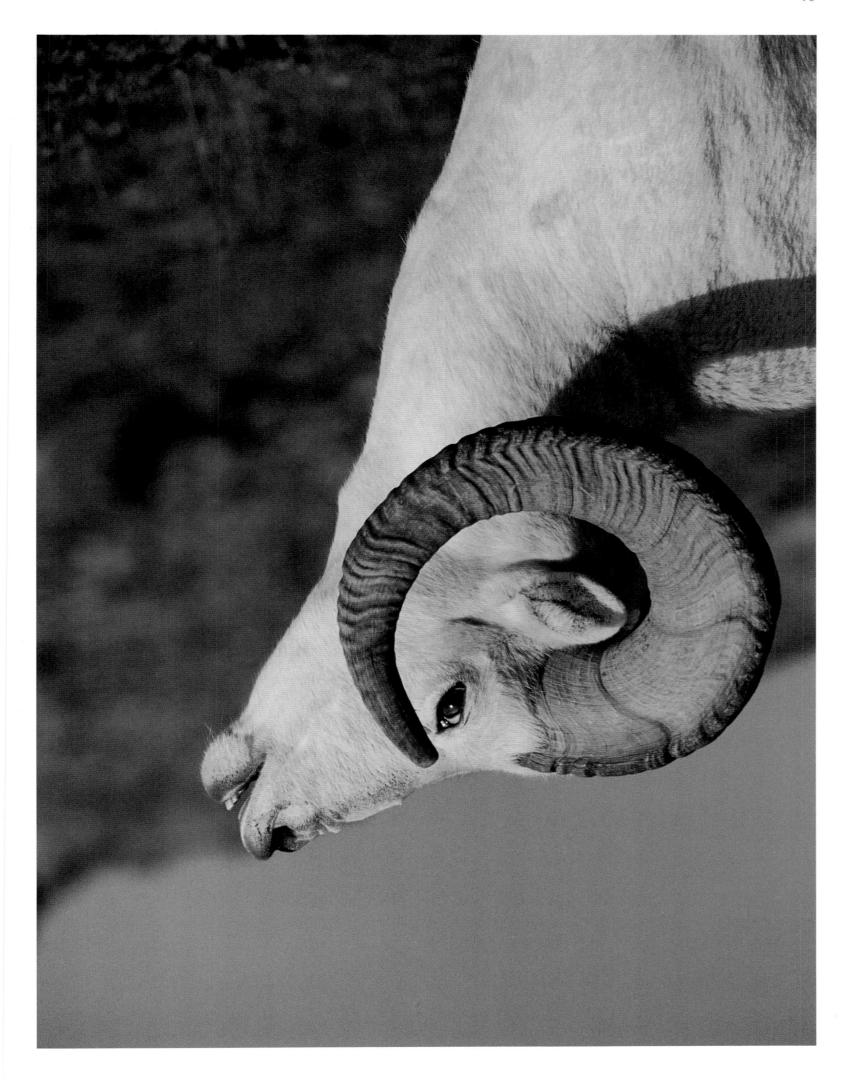

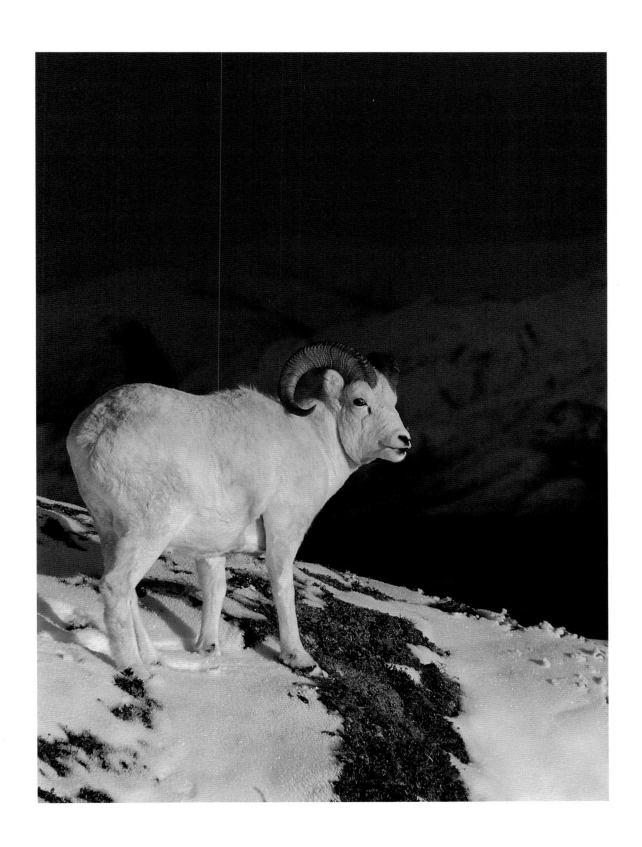

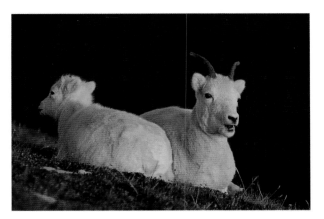

□ Facing Page: *Common to many animals, the lip curl, or flehmen, is a response to olfactory stimuli. Here, a ram has scented a ewe. By holding the head back and curling the lip, odor is held for processing by the Jacobson's organ.* □ Above: *Dall sheep experience autumn's first snows before neighbors in the valleys below.* □ Left: *By late autumn, lambs have grown large and strong, but have low body fat. All energy has gone into growth; the first winter will be a severe test for lambs.* □ Overleaf: *The first autumn dusting often triggers migrations. This ram is on winter range, where it forages through the snow.*

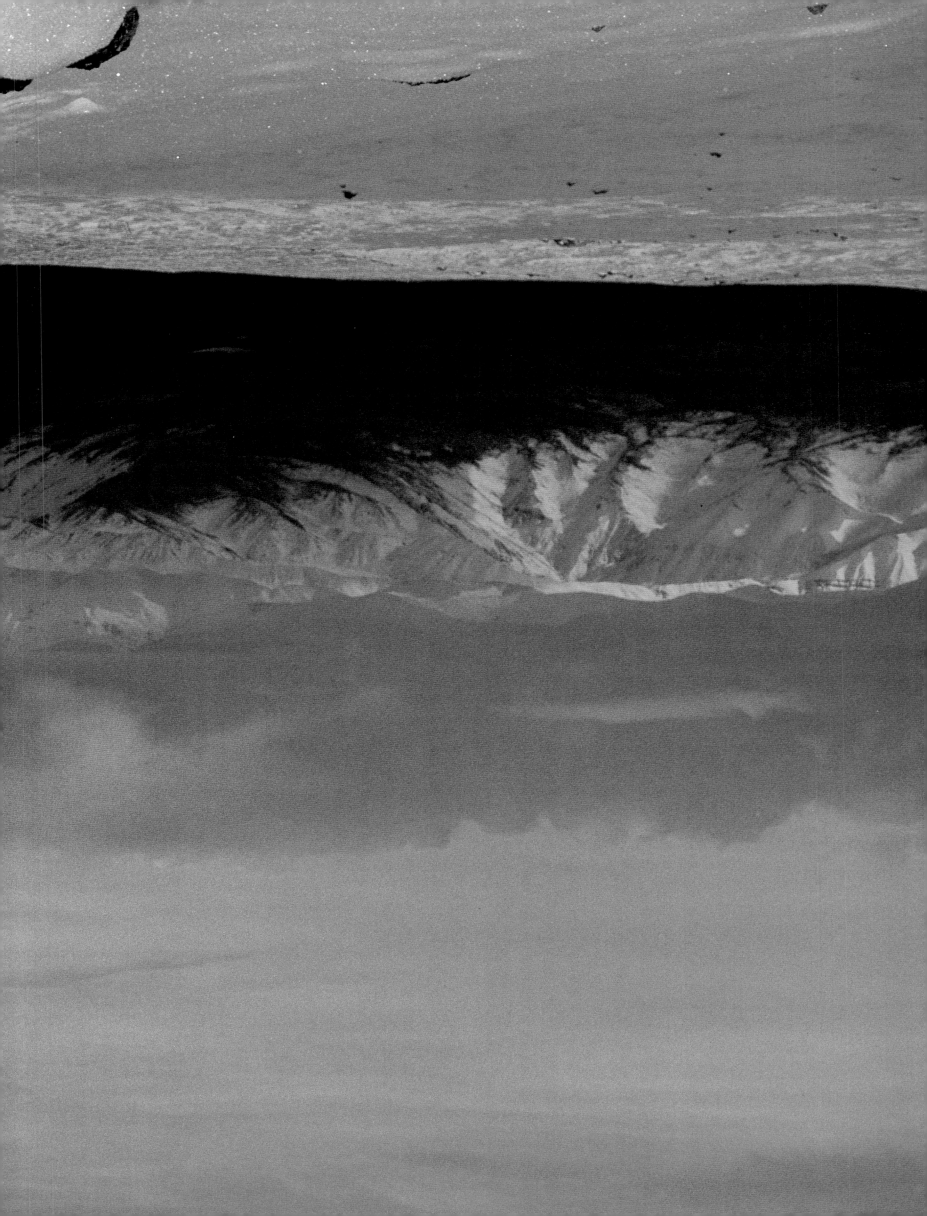

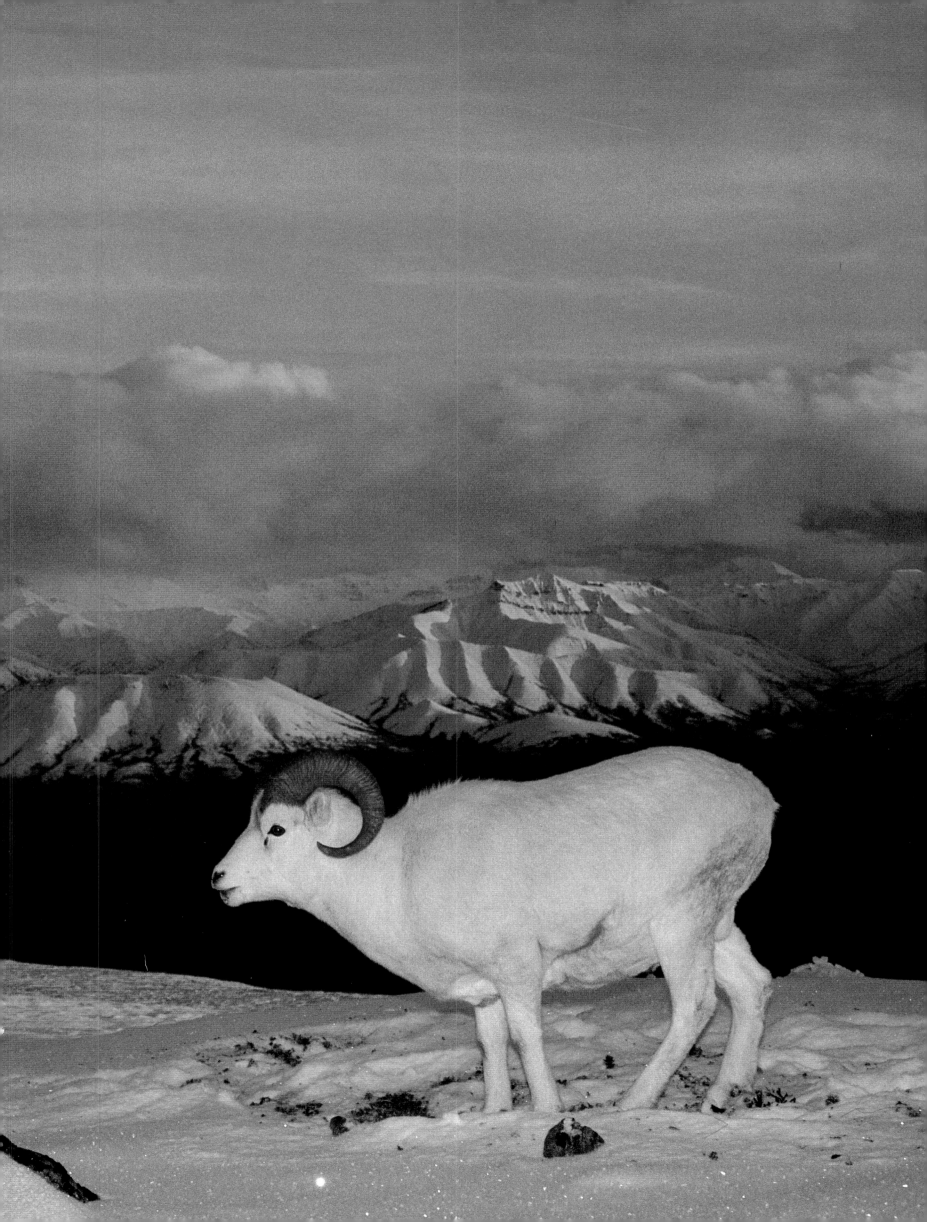

☐ Above: Brown bear wander autumn streams to feed on spawned-out salmon. By fall, most coastal bears have grown fat on summer diets rich in protein. ☐ Right: The only difference between "brown" and "grizzly" bears is, perhaps, habitat. Many "grizzlies" depend on berries instead of fish for fat reserves necessary for hibernation. "Hyperphagia" describes the bears' incessant late-season gorgings. ☐ Facing Page: Black bears eat berries, fish, and anything else they can find—including insects in rotten logs. ☐ Overleaf: Caribou migrate south to winter ranges of low snowfall and rich forage.

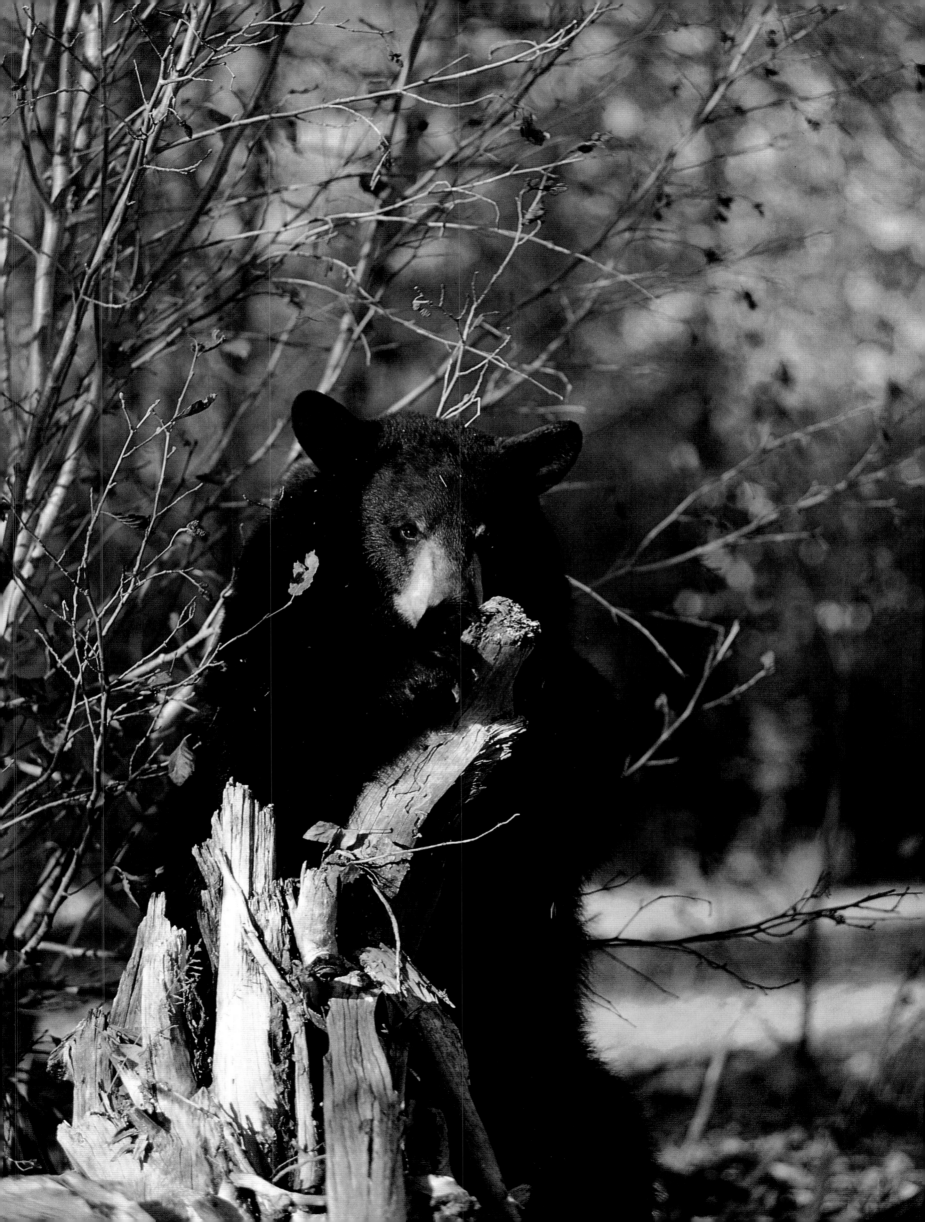

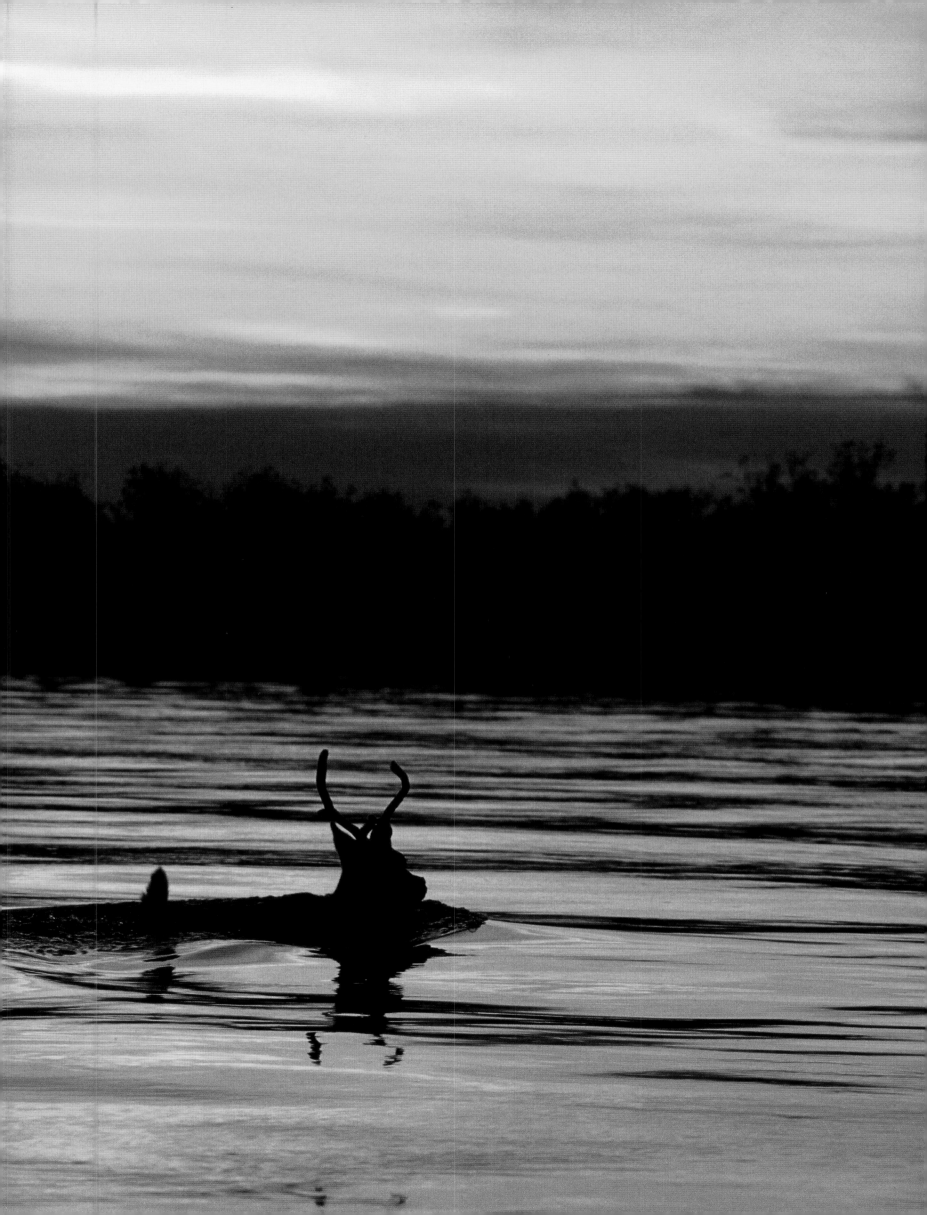

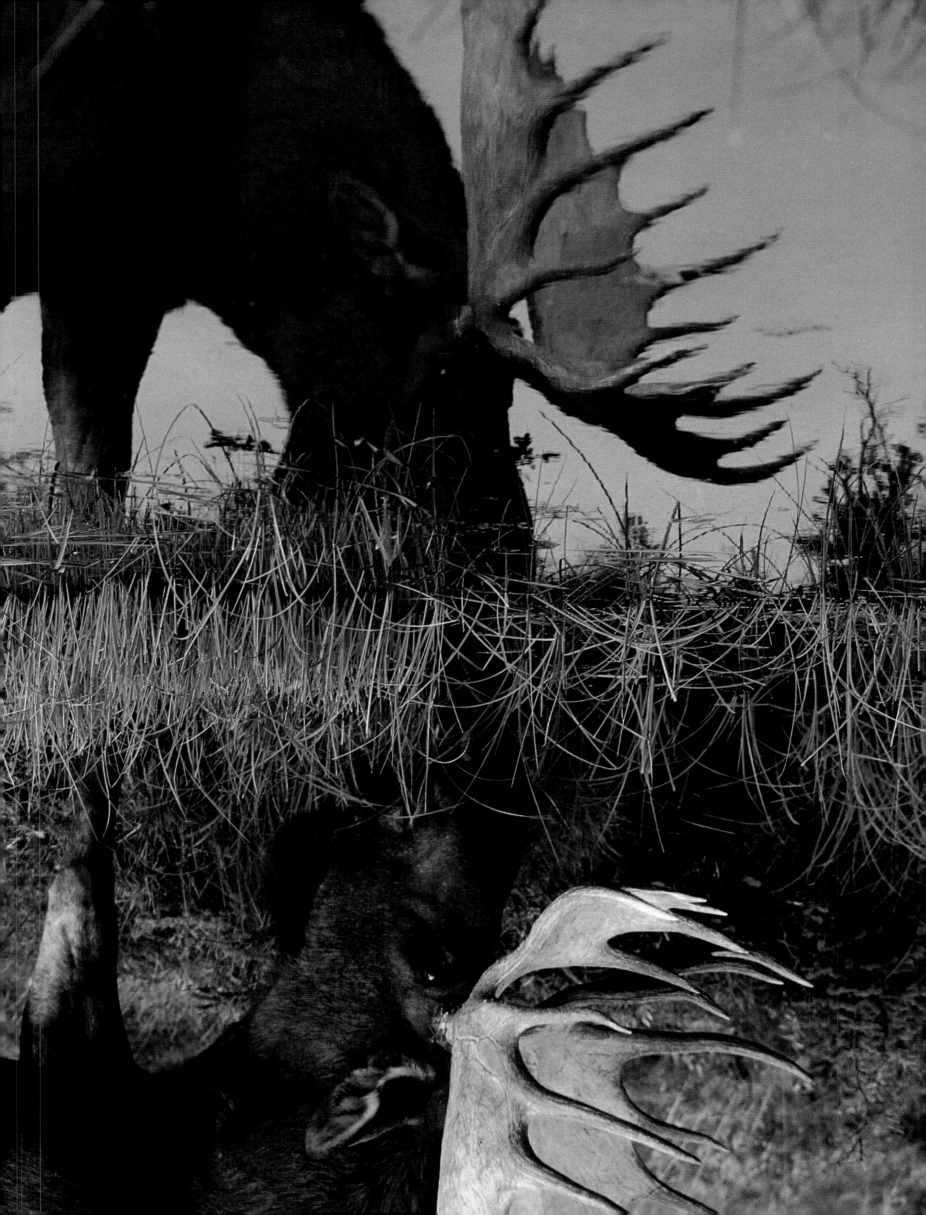

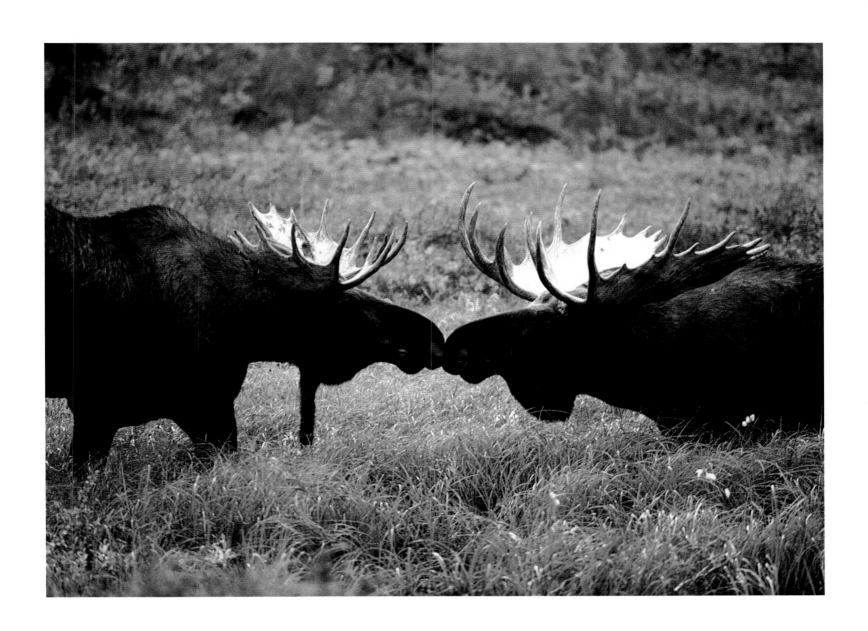

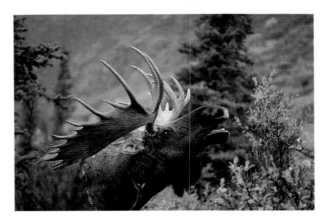

☐ Facing Page: *Mineral licks are often muddy, standing water. Moose and other herbivores drink the water and eat the mud for its mineral content. The ingestion of these magnesium and calcium rich soils balances out the potassium from plants. Calcium and phosphorus help build strong antlers and horns. The clay may also rid the system of internal parasites.*
☐ Above: *When moose touch noses they scent one another's breath, an intense way of exchanging information. Only the moose know what is learned.*
☐ Left: *During rut, the pungent aroma of another bull moose at a wallow causes this bull to lip curl.*

☐ **Above:** Dominance between bull moose is often settled by stylized horn displays and light sparring. Threat displays prevent needless fighting; serious battles between mismatched bulls are rare. Combat by mature, equal-sized bulls may result in serious wounds. ☐ **Right:** Most moose calf loss occurs in their first two months. In some areas, of one hundred calves born, only ten to fifteen survive to fall. Winter will be a major challenge. ☐ **Facing Page:** Large bulls enter the rut in peak condition, but the ensuing rigors take a serious toll. Ironically, prime animals enter winter in poor shape, and they may perish.

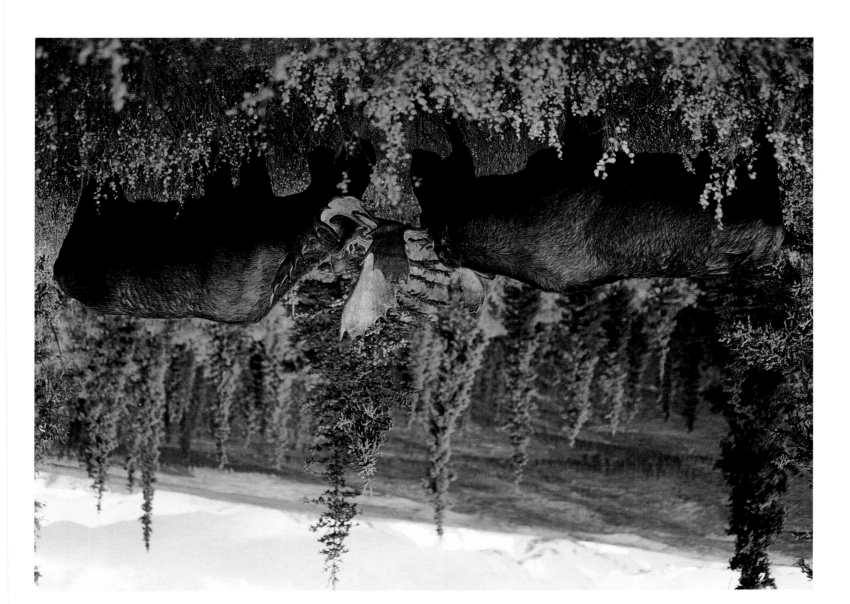

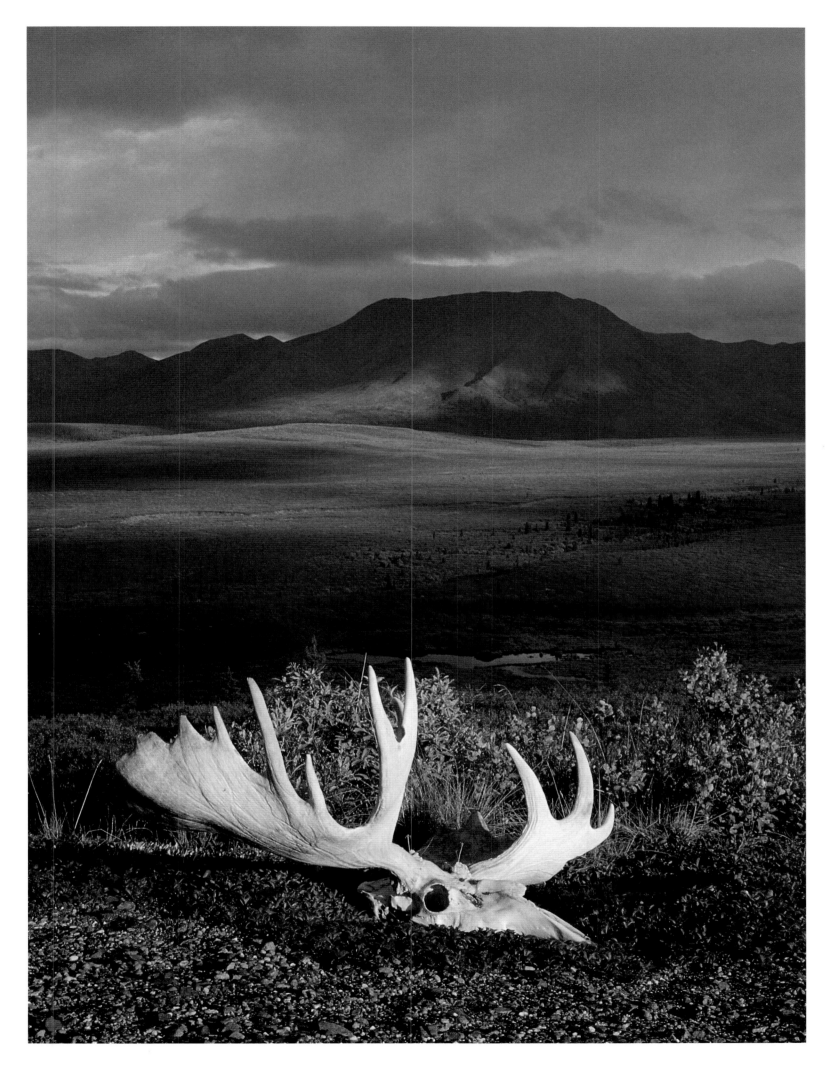

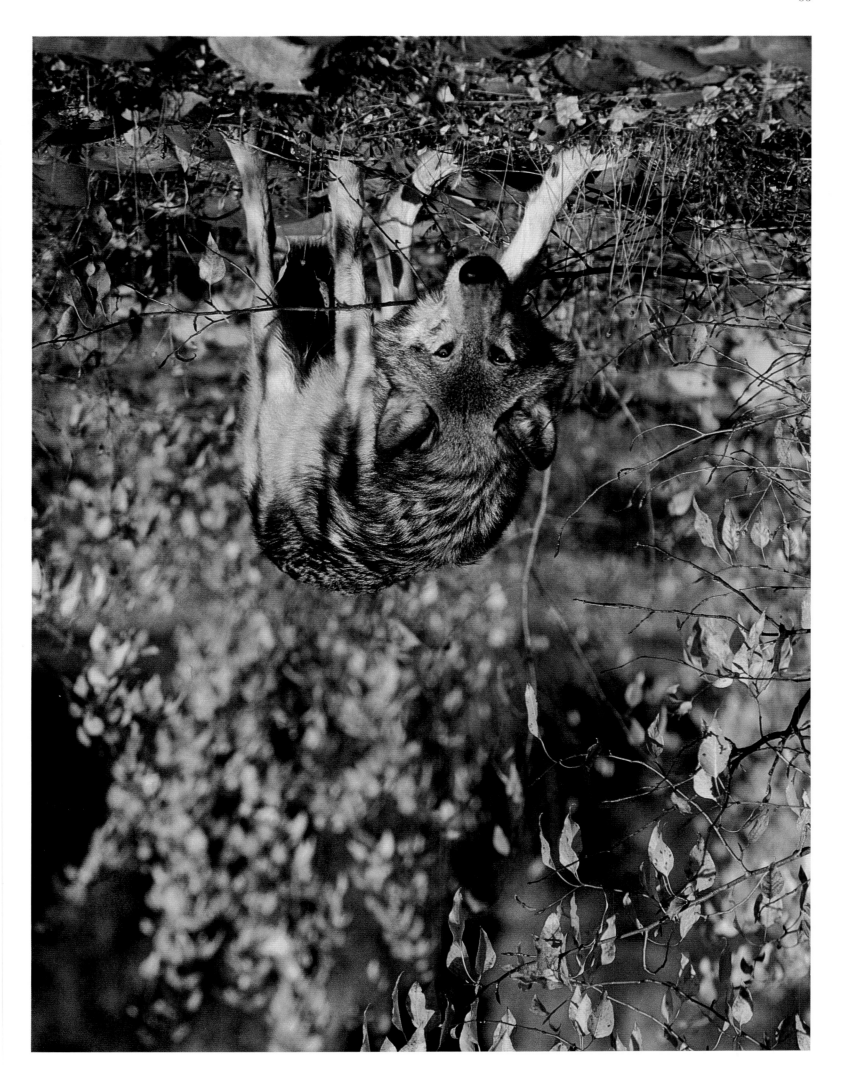

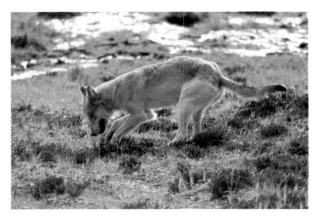

□ Facing Page: *Wolves travel watercourses and over mountain passes, ever vigilant for animals that may become prey.* □ Above: *In areas of heavy brush and timber, wolves are seldom seen. Tracks and howling may be the only signs of their existence.* □ Left: *Wolves hunt both large animals and small ones, too. Squirrels, beavers, and snowshoe hares are important diet additions. Here, a wolf digs out a ground squirrel.* □ Overleaf: *In 1932, only 69 trumpeter swans were counted worldwide. By 1990, 13,340 trumpeter swans, perhaps 80 percent of the world's entire poulation, were counted in Alaska.*

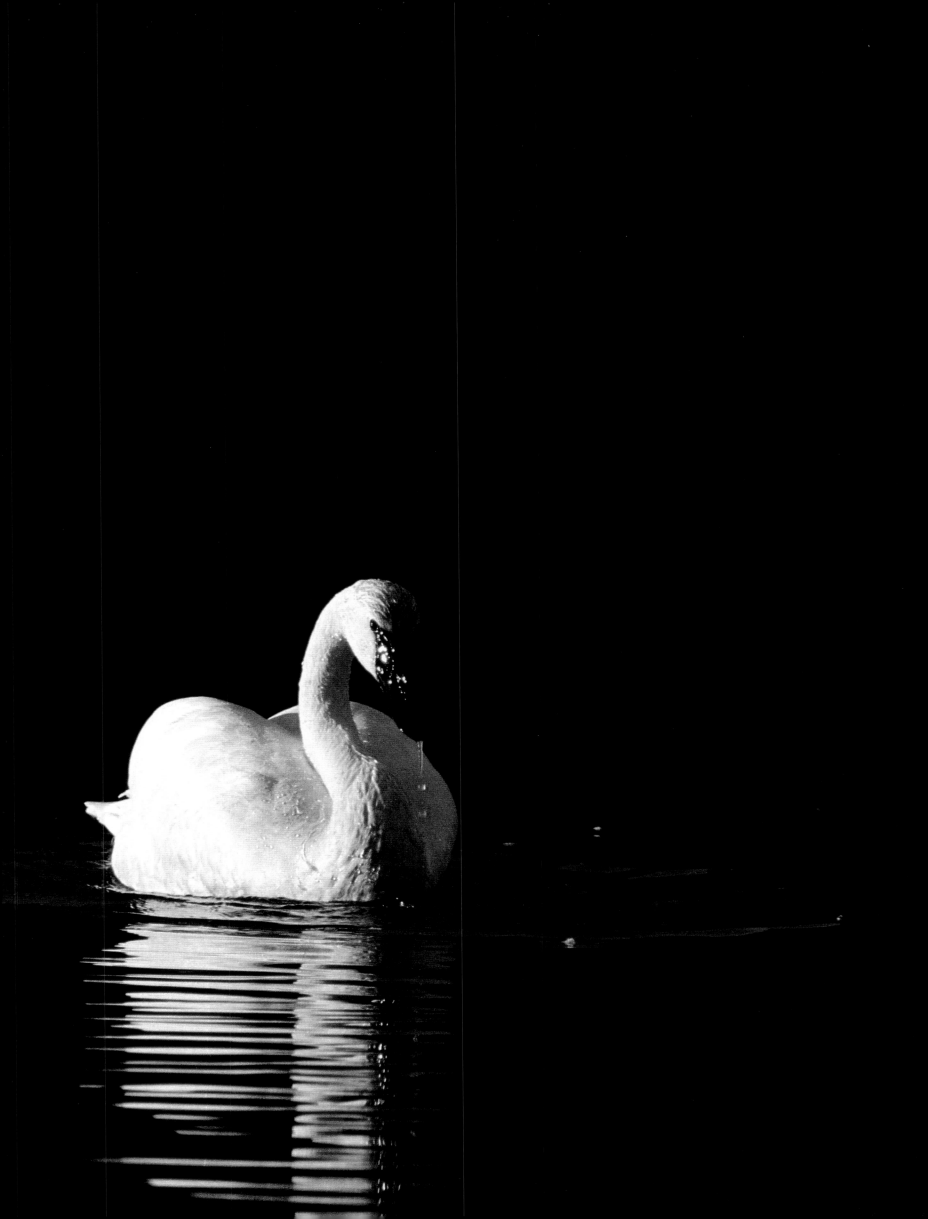

□ *Above: Trumpeter cobs are the largest of all waterfowl. Males (cobs) average 28 pounds; females (pens), 22 pounds. Some weigh up to 40 pounds, with wingspans of six to eight feet.* □ *Right: Mated for life, a cob and pen share in rearing their young, called cygnets, and migrate south together in autumn.* □ *Facing Page: In order to retain the warmth and waterproofing of plumage, waterfowl, like this hen mallard, spend much time preening.* □ *Overleaf: At migration's peak, up to 50,000 lesser sandhill cranes per day, out of 200,000, migrate through Interior's Delta/George Lake area.*

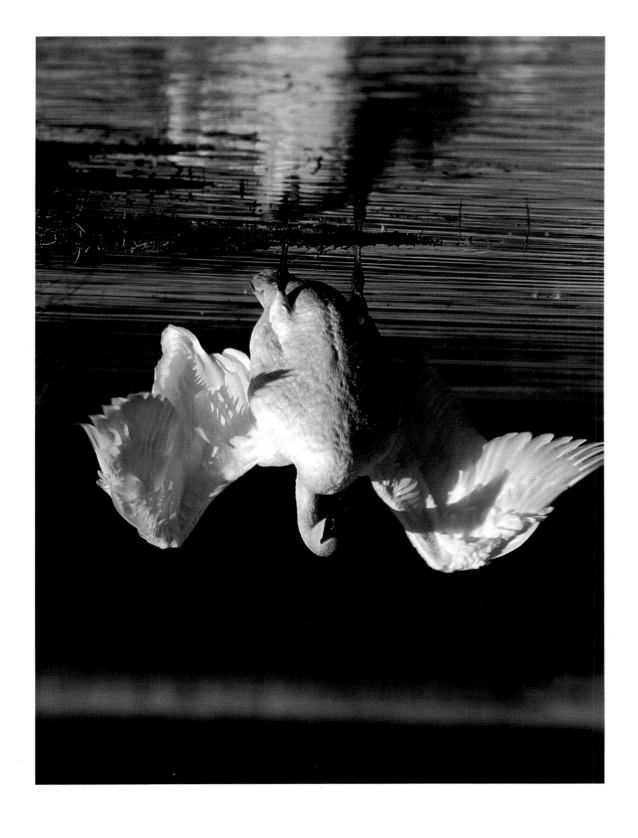

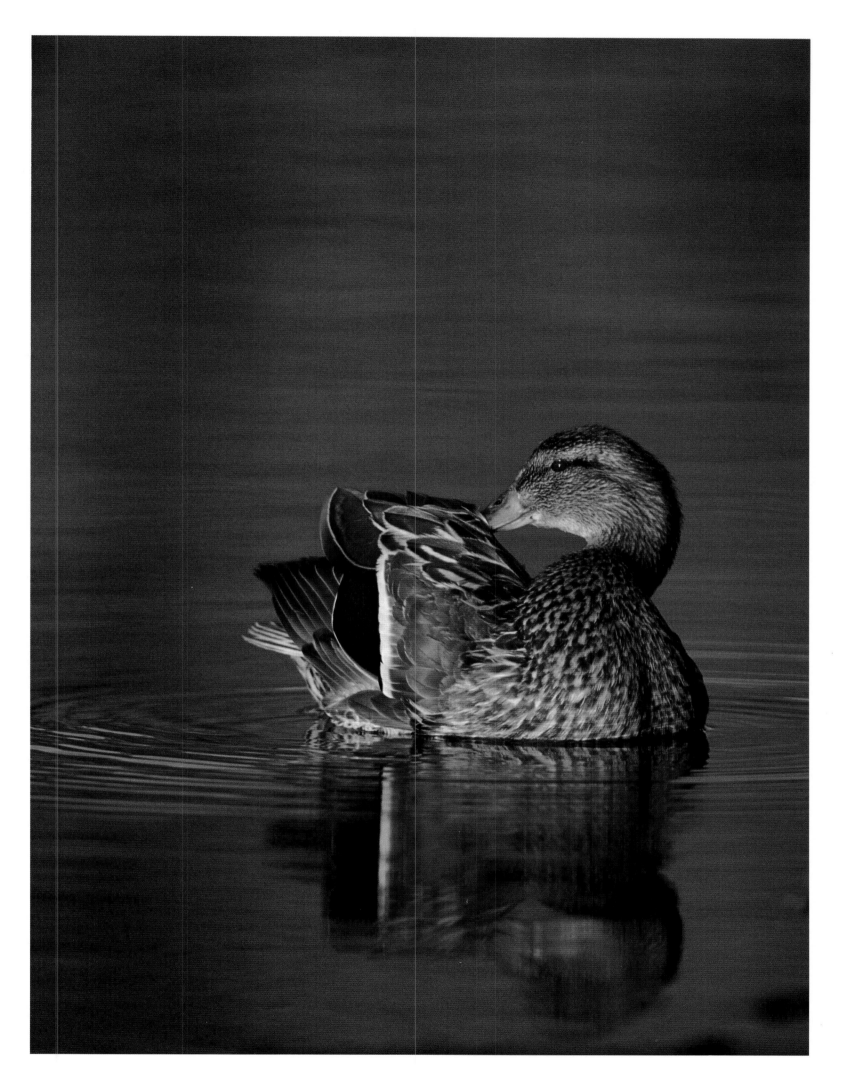

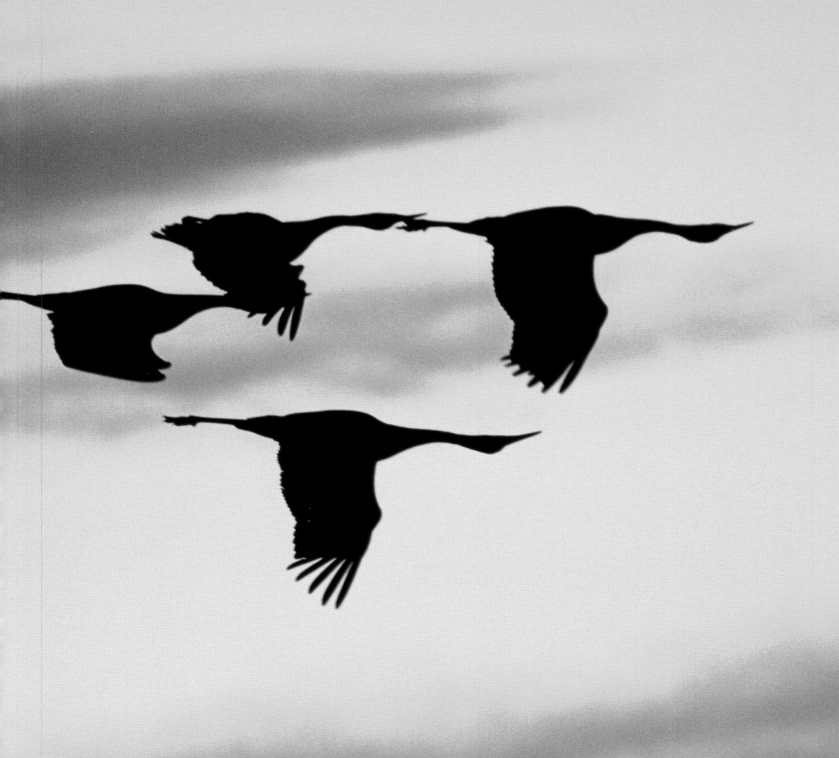

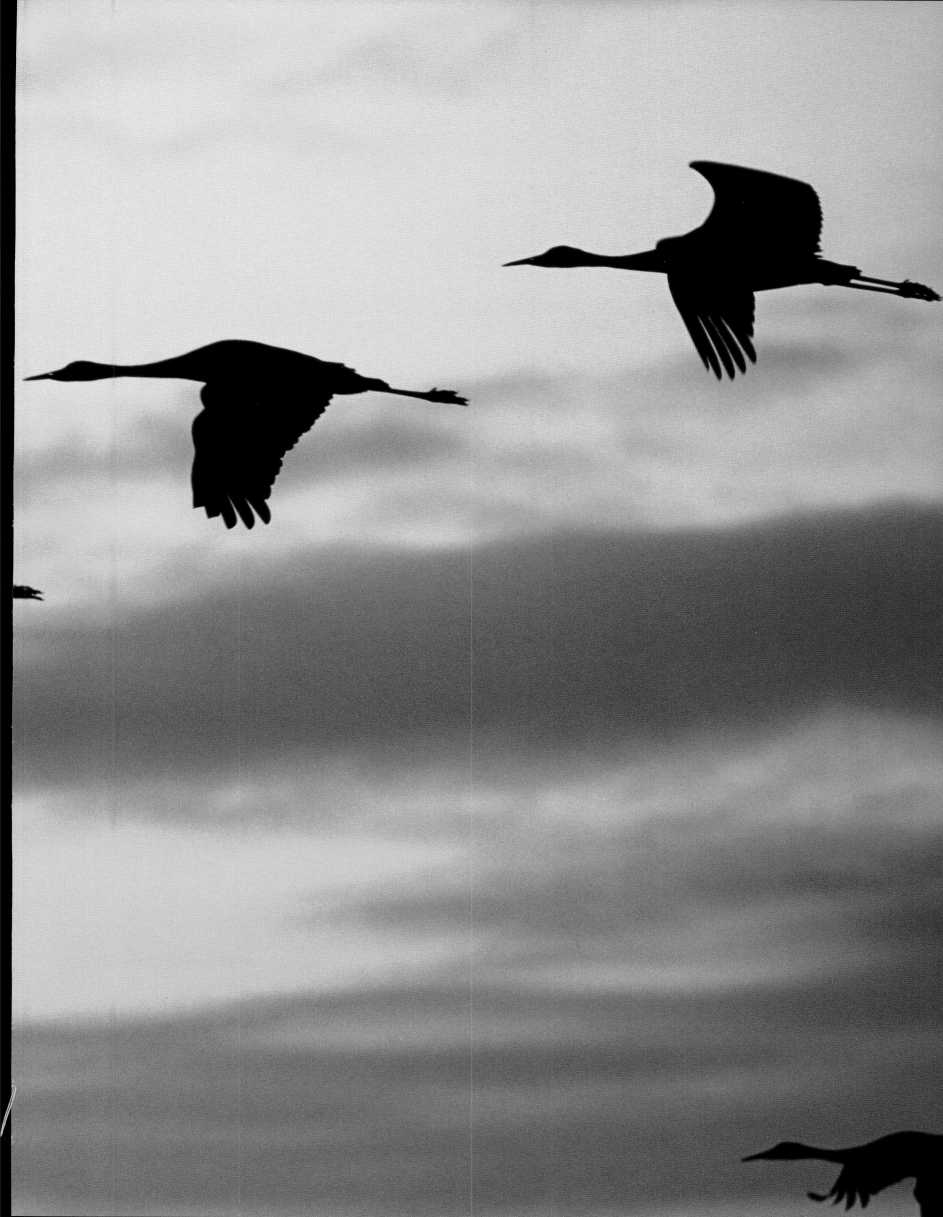

☐ Above: *Ten to twenty thousand snow geese pause on the Kenai River flats each year for a week of frenzied feeding. Birds add 20 percent to their weight before heading on to Wrangell Island. Flocks arrive from California, Washington, and British Columbia in early April.* ☐ Facing Page: *Lessening daylight in autumn triggers color changes in the showshoe, or "varying" hare. "Snowshoe" refers to the hare's large hind feet. Weather fluctuations sometimes catch hares out of color synchronization with the ground cover. A brown hare on snow is easily seen; a white one on bare ground is also vulnerable.*

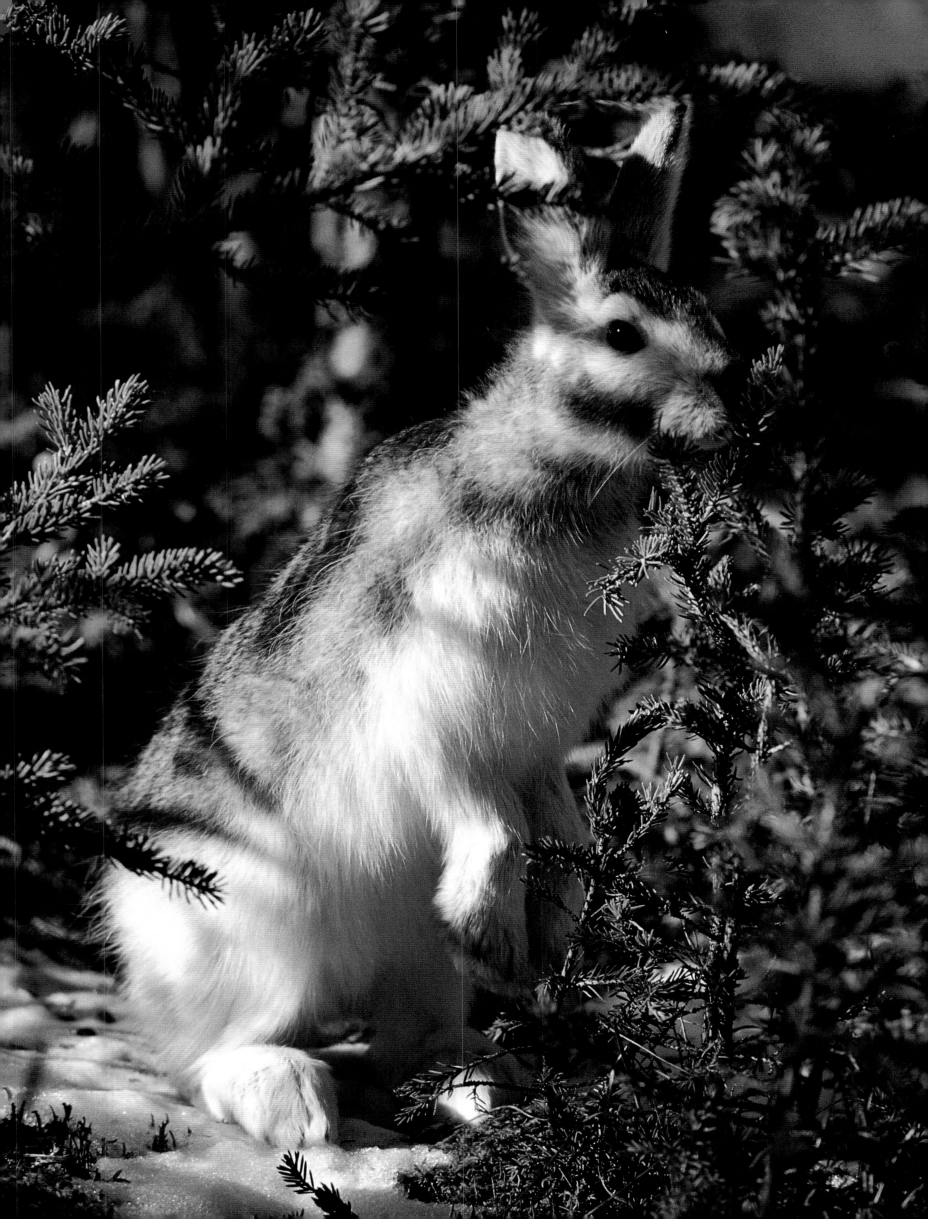

Drake harlequin duck

Polar bear

Northwestern crow

snow, darkness, & cosmic cold

Winter brings the cold, a dark time of testing when there never is enough to eat. Temperatures plunge to a record minus 80° Fahrenheit, and winds push the chill to beyond minus 100. Some regions have scant snowfall; others have daily accumulations that can be measured in *feet*. Drifts are deep and often rock-hard, locking away forage plants beneath. Above the arctic circle, the sun never rises, and in the Interior, *days* are scarcely five hours long. In the far north, the terms *diurnal* and *nocturnal* lose meaning. *All* residents become creatures of the night.

Gone are the migrants; gone to bed are those least able to cope with winter. Most simply persist. Muskoxen, with their superb shaggy coats, are poorly adapted for grazing in deep snow. Their range is limited to areas of low snowfall and windblown ridges. Sheep also graze wind-shorn slopes, depending on dense, hollow-hair coats and fat for protection from the wind and cold. Moose browse woody plants. Caribou paw through the snow for lichens, located through the snow by smell. Antlers, unneeded for survival, are shed. No matter how much dried forage the browsers and grazers consume, it is stored fat that determines survival. Arctic foxes shadow polar bears to pilfer scraps. Predators make kills and scavenge others. They have no real advantage; starvation is indiscriminate in the long darkness.

☐ Facing Page: *To survive in areas of deep snow, mountain goats sometimes winter in forests, on coastal cliffs, or descend into intertidal areas. Hemlock is a winter forage.*

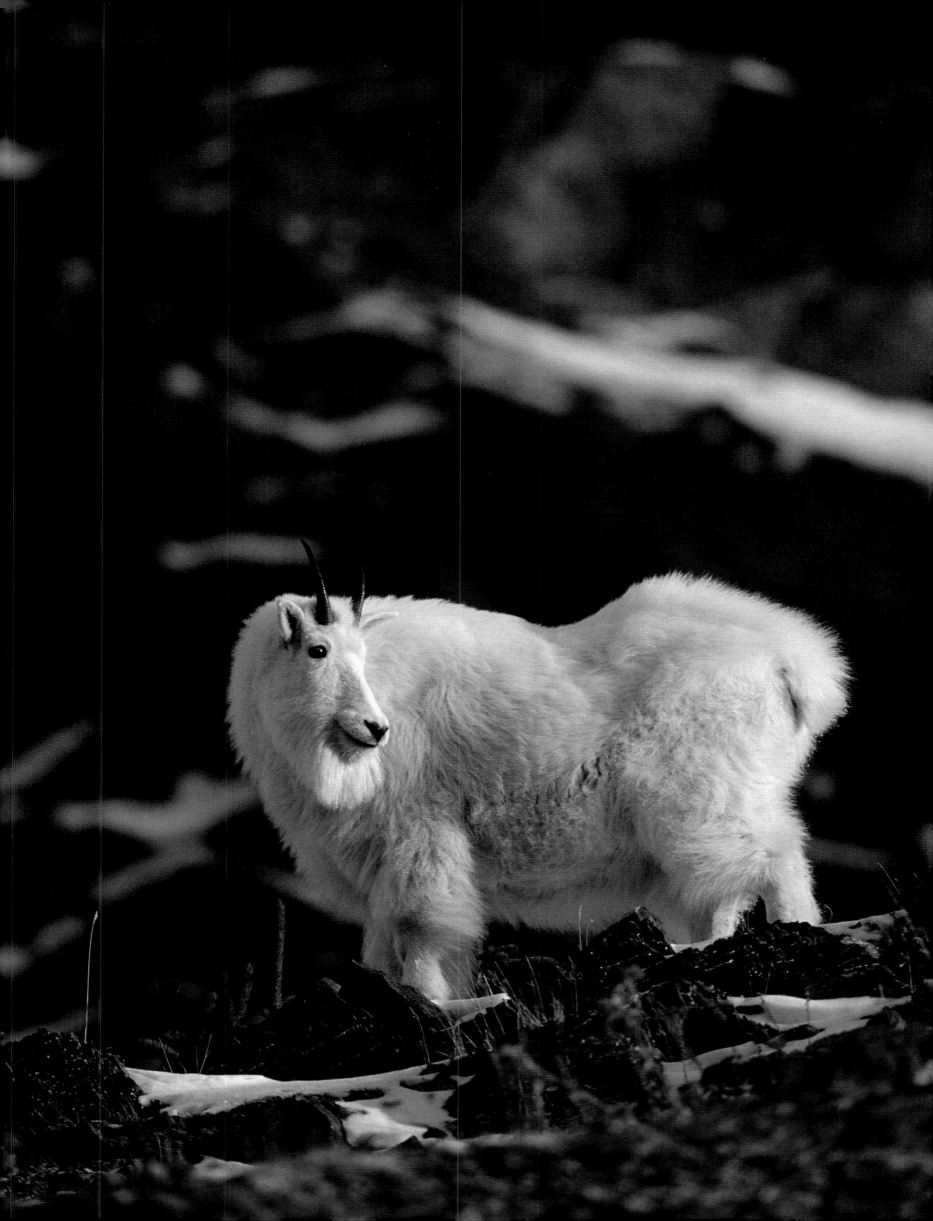

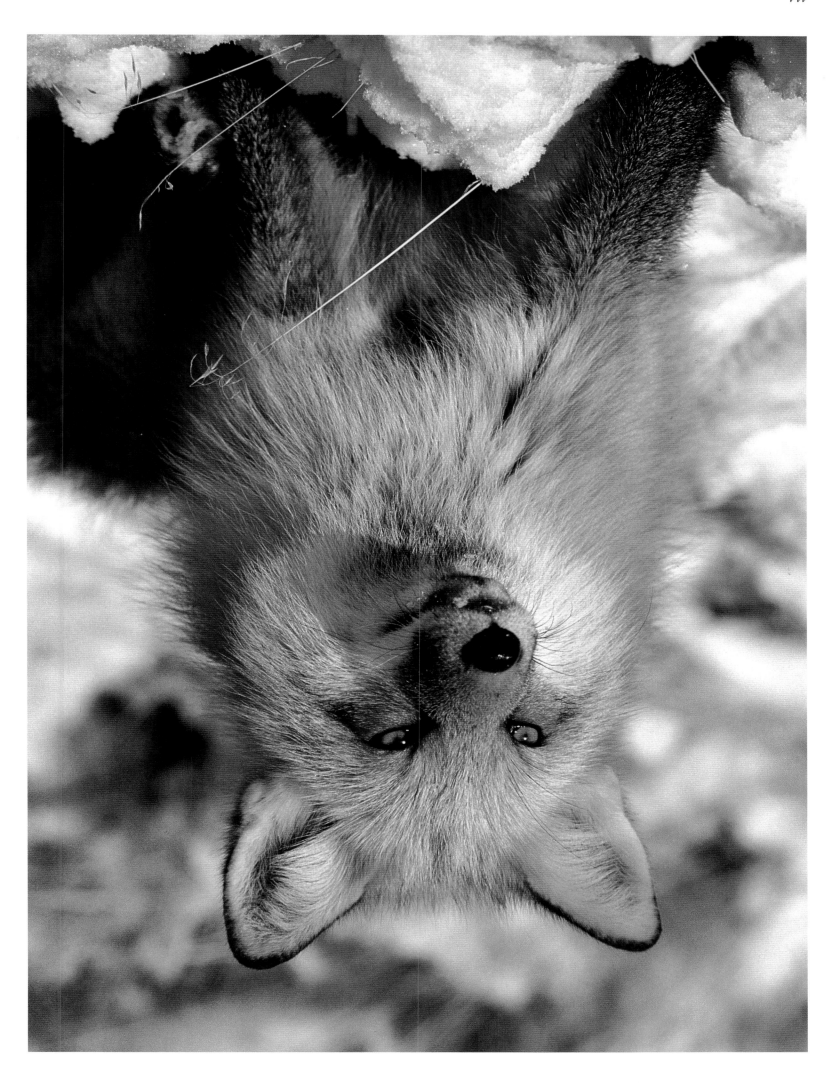

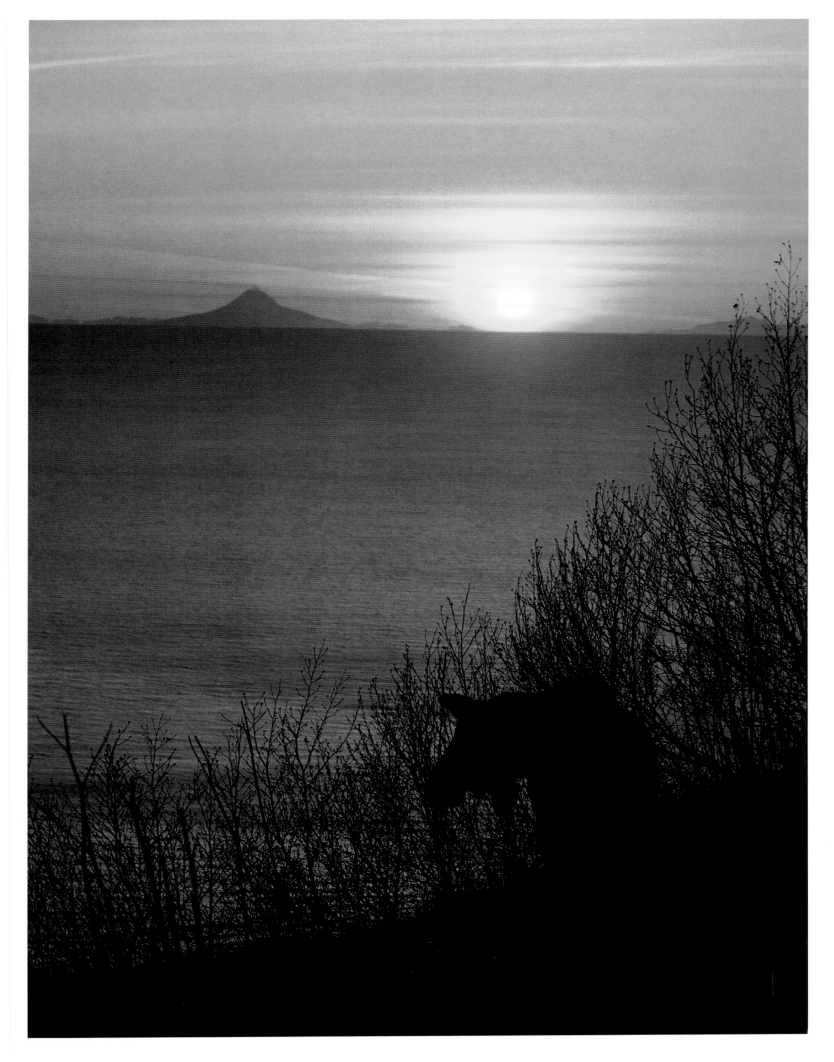

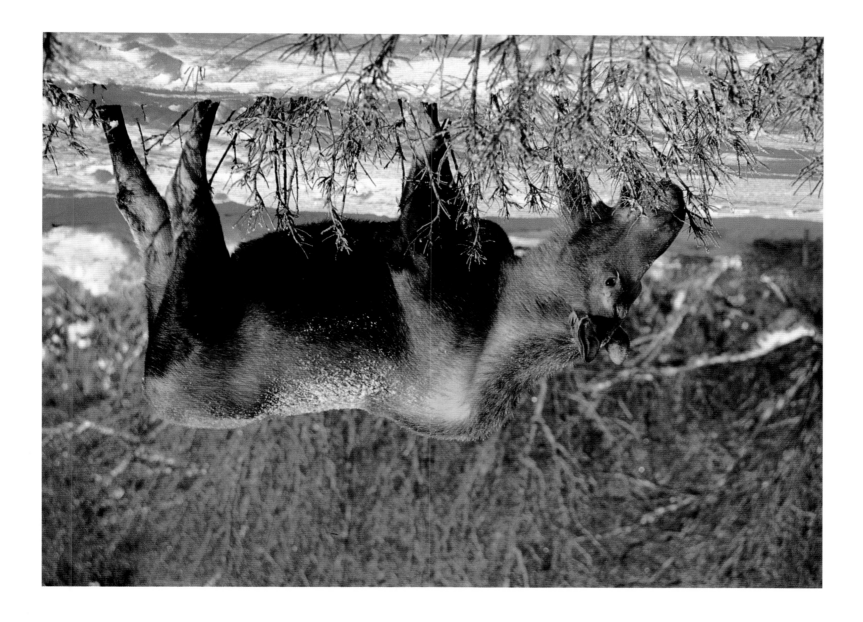

□ Above: Moose eat more high quality food in summer than in winter. Daily intake in winter is about half that of summer, not because of lowered availability, but because low quality winter browse is retained longer in the complex stomach. The energy derived from winter food is less than that required for survival. Adults live off stored fat and protein, which results in weight loss. When snow depths limit access to forage, malnutrition occurs even on prime ranges.

□ Facing Page: Augustine Volcano steams in the background on a cold evening as a moose forages for willows on a ridge that overlooks Kachemak Bay.

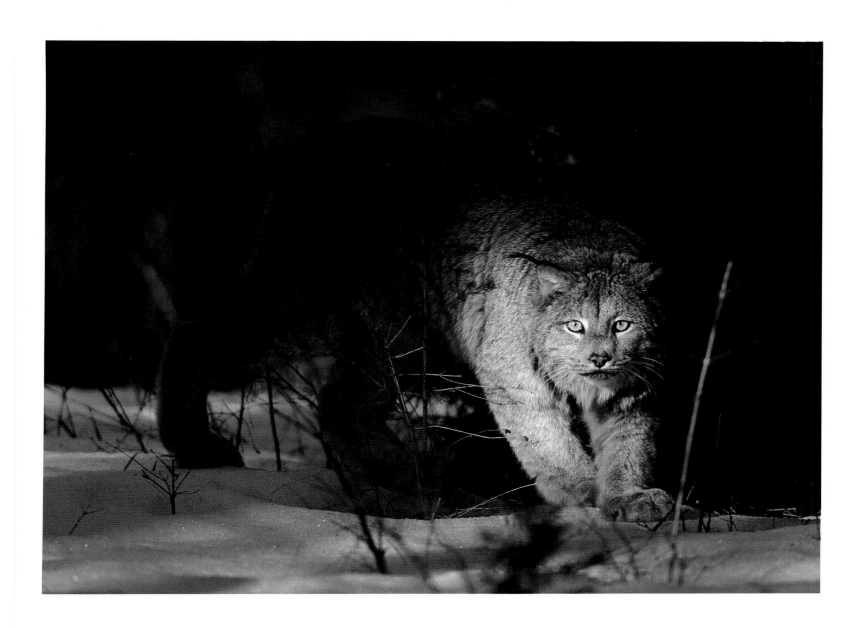

□ Facing Page: *Snowshoe hares are well adapted for winter with their color offering camouflage from predators. On their large hindfeet, they can outrun foxes and coyotes that flounder in deep snow. Willow thickets offer prime forage.* □ Above: *Armed with well-furred, saucer-sized paws and aided by excellent night vision and sharp hearing, lynx are principal predators of snowshoe hares. Lynx populations rise and fall along with the ten-year hare cycle. Both populations fluctuate from abundance, up to eighteen hares per acre to scarcity. Lynx have moved four hundred miles in search of areas of hare abundance.*

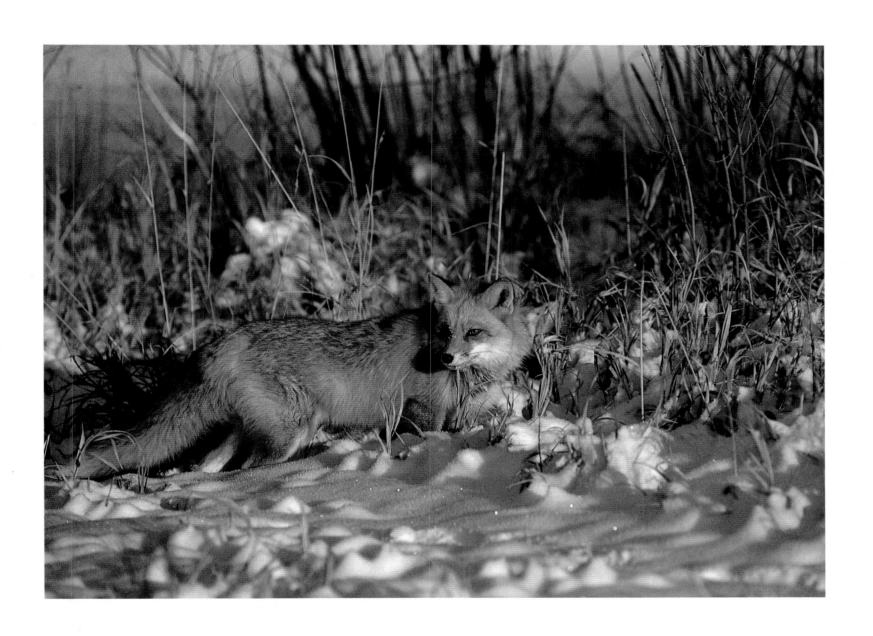

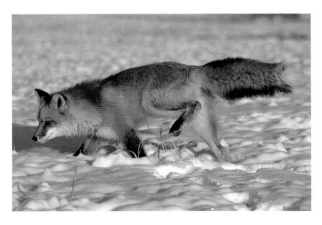

□ Facing Page: *Red foxes roam almost all Alaska, including many offshore islands. They are found in all habitat types from forest to plain. In ranges shared with arctic foxes, the red fox is dominant.*
□ Above and Left: *Deep snows can hamper hunting, but red foxes are excellent "mousers," able to hear their prey even when the hunted is under several inches of snow.* □ Overleaf: *Prior to the turn of the century, muskoxen in Alaska had been wiped out by hunters who used trade guns. A defensive circle, effective in protecting muskoxen against wolves, became a death ring when they faced armed men.*

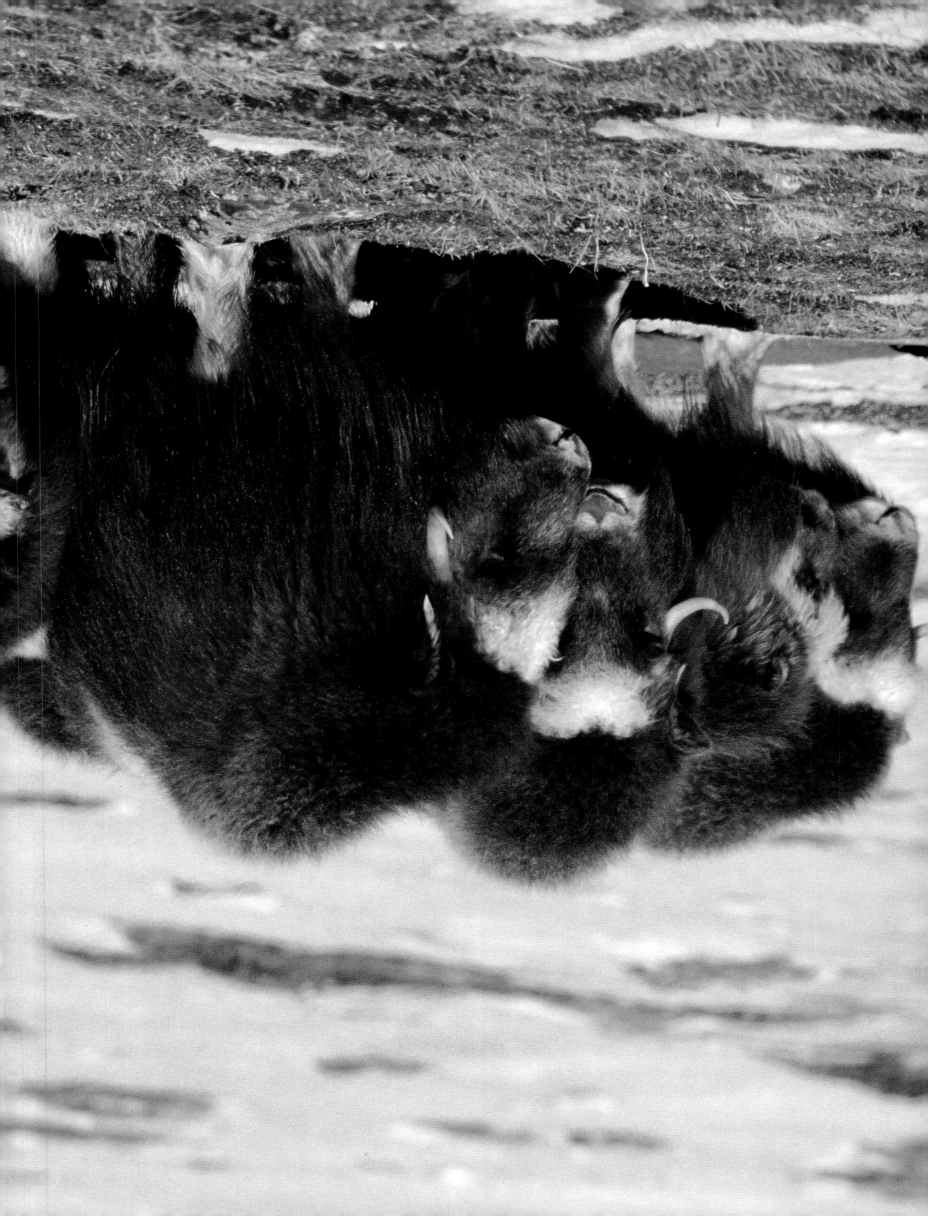

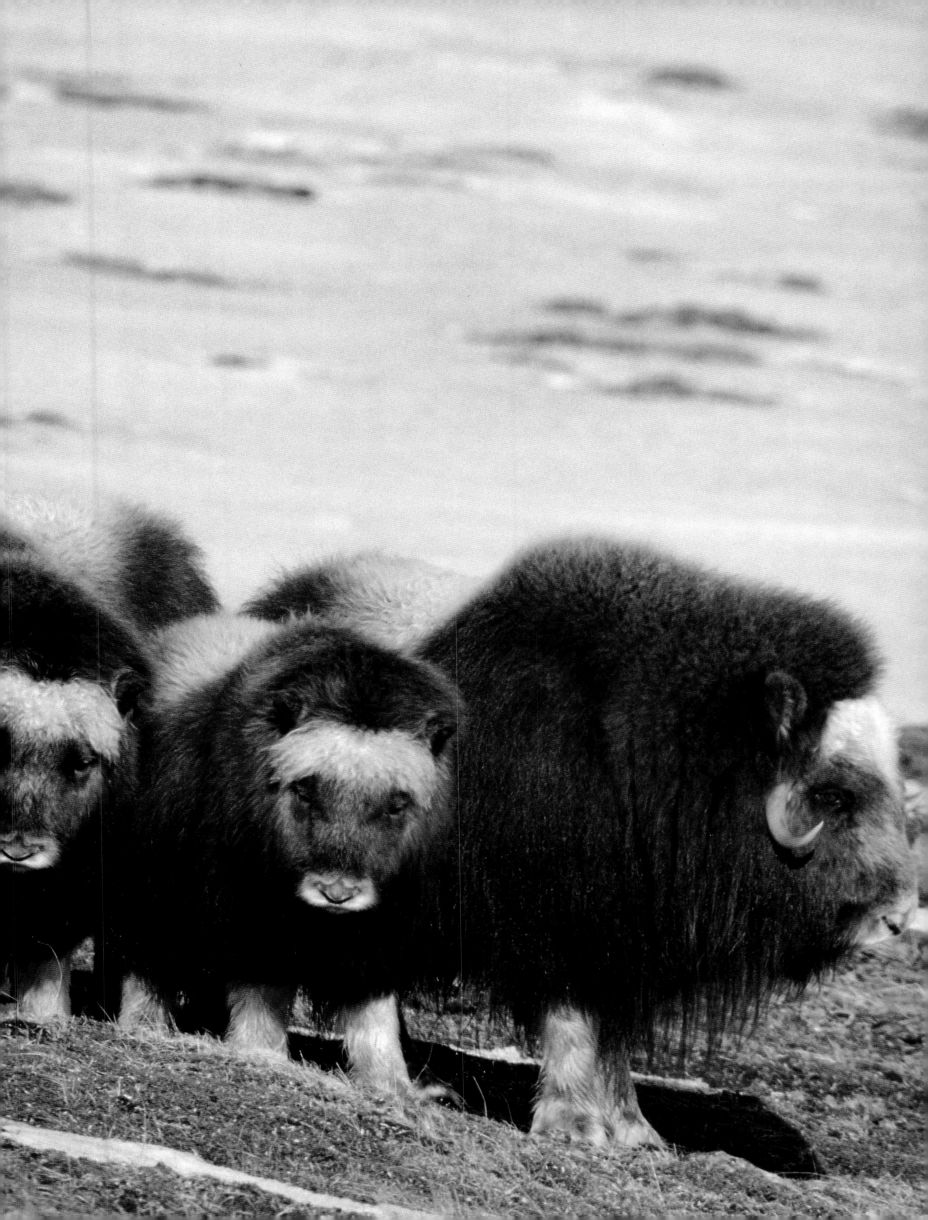

☐ Above: *In 1930, thirty-four muskoxen from Greenland were reintroduced to Alaska. Hundreds now roam Alaska's Cape Thompson, Nunivak and Nelson Islands, the North Slope, and Seward Peninsula.* ☐ Right: *Extra-long guard hairs and silky underfur, called qiviut, protect muskoxen from cold. Windblown areas with exposed grasses are important winter grazing areas.* ☐ Facing Page: *Willow ptarmigan migrate up to 150 miles between summer and winter ranges.* ☐ Overleaf: *The arctic sun does not rise above the horizon for weeks. When it does, it offers no warmth to the arctic fox.*

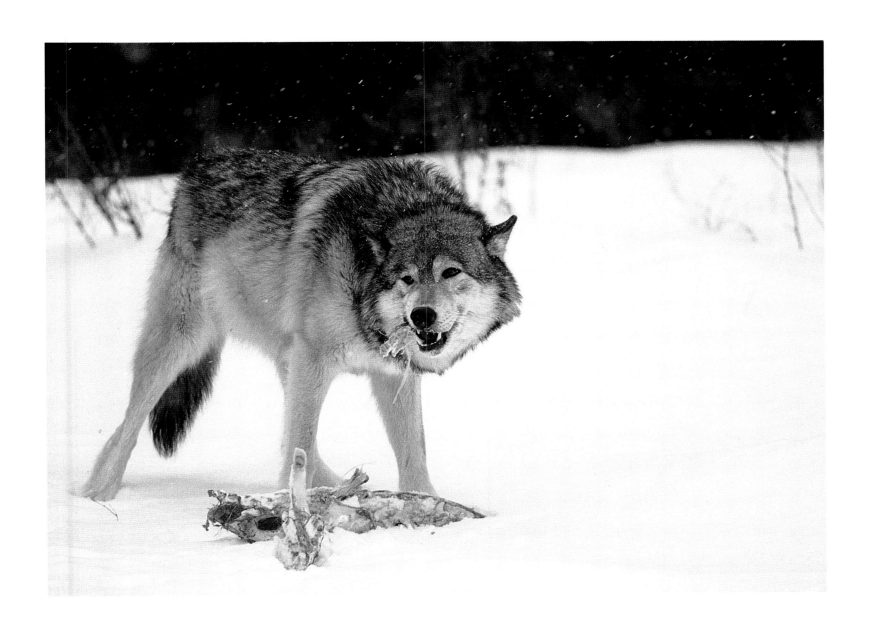

☐ Facing Page: *An adult male wolf in Alaska weighs from 80 to 115 pounds, a few topping 130. Wolves range in color from white to black. Litters may include pups of varied hues. Wolves, like other canids and bears, sometimes bite or chew tree limbs. Scent marking leaves a message for pack members and transients.* ☐ Above: *Population densities range from one wolf per 25 square miles to one per 150 or more square miles. Abundance varies, due to prey availability, disease, and other factors. Packs have well-defined territories. Researchers say the main cause of death in wolves is intra-specific strife.*

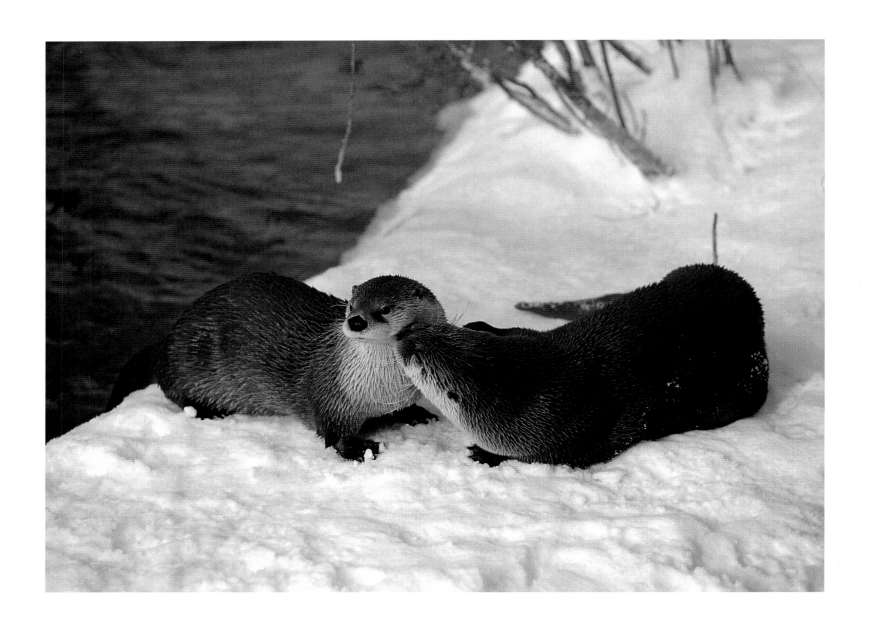

☐ Above: *Sometimes called river otters, land otters are graceful swimmers often seen in salt water as well as in fresh water. They eat a wide variety of foods, including fresh and salt water mollusks, fish, and even small birds and mammals. Otters can dive up to sixty feet deep and swim at six miles per hour. By running and sliding on their bellies, they can do up to fifteen miles per hour on land. At about thirty pounds, they are only one-third the size of sea otters.*
☐ Facing Page: *Mink, weighing about five pounds or less, are smaller cousins of the land and sea otters. Like otters, mink will eat anything they can catch.*

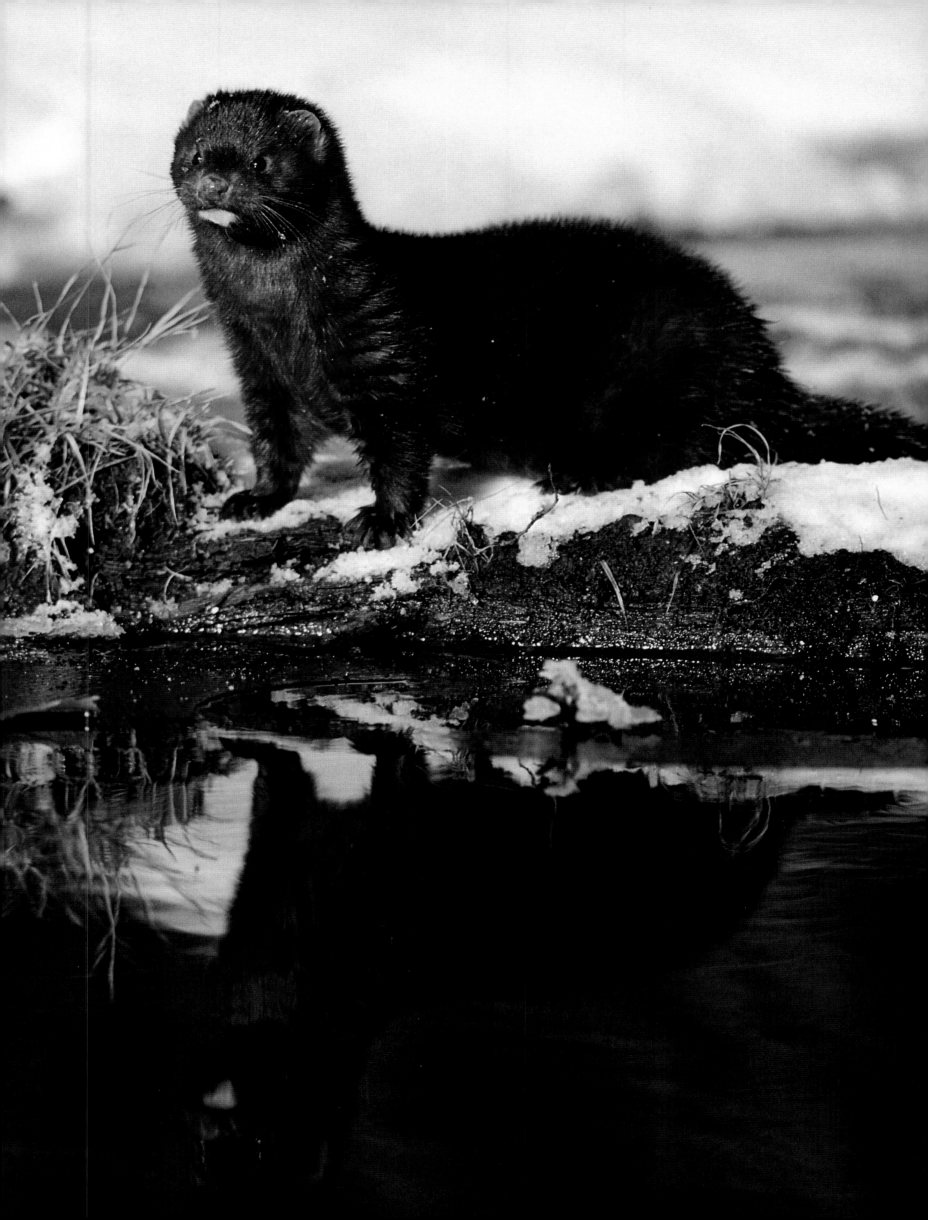

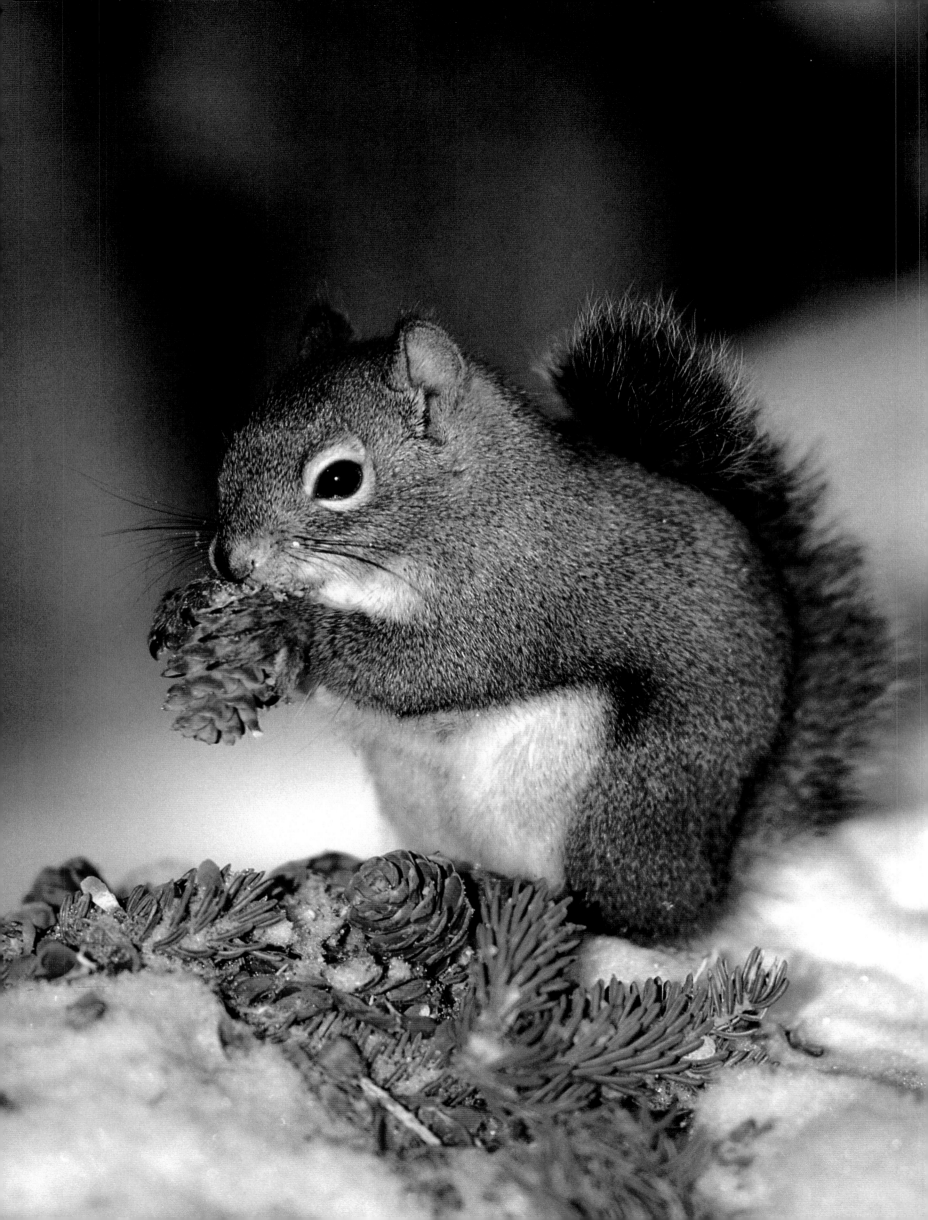

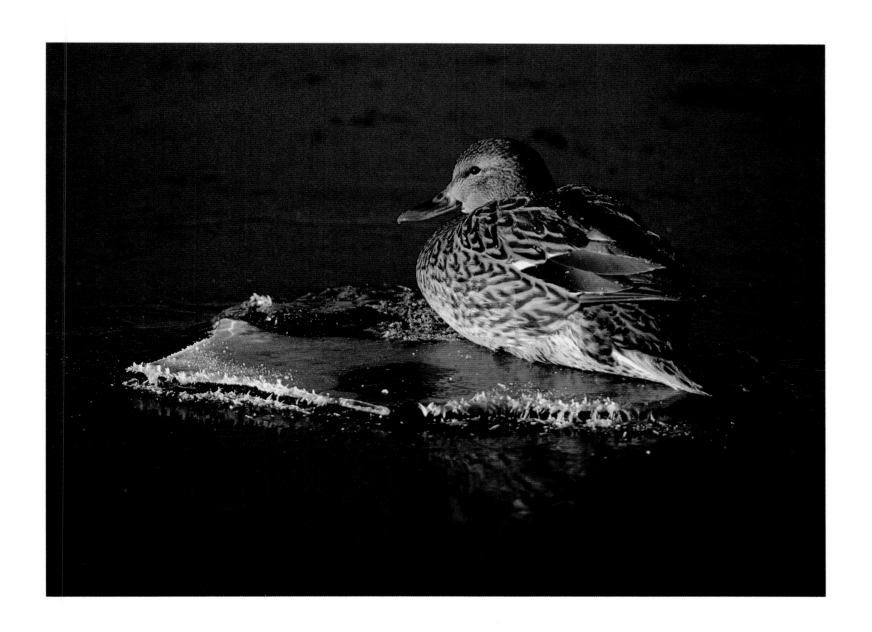

☐ Facing Page: *Red squirrels rely on spruce cones stored in middens for winter survival. Recent research has revealed that squirrels are adept at avoiding predators. Marten live off rodents, not squirrels. Suprisingly, red squirrels have been found to be important predators of baby snowshoe hares, called leverets. Their aggressiveness is further revealed by eyewitness accounts of weasels being attacked and driven from food sources.* ☐ Above: *The hardy mallard is among the last waterfowl to migrate south each autumn and the first to return. Large numbers of mallards, like this hen, overwinter in Alaska.*

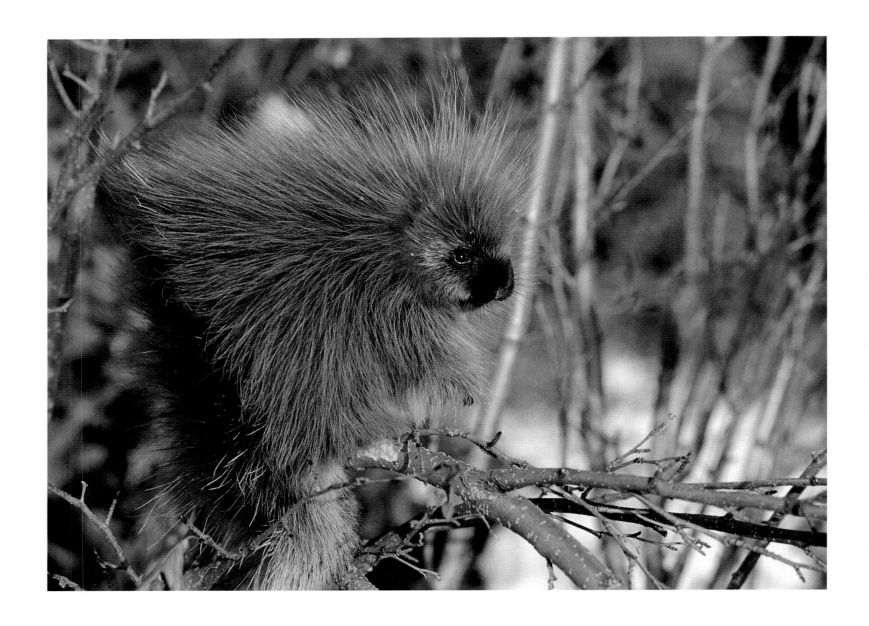

☐ Above: *In early winter and again in spring, the bark, buds, and twigs of willow and birch become part of a porcupine's diet. An arsenal of barbed quills protects this myopic and slow-moving animal from all but the most skilled predators. Even brown bears have suffered debilitating injuries from their contact with porcupines. At birth, baby porcupines, called porcupettes, are covered with long, grayish-black hair that, within hours, dries into protective quills.*

☐ Facing Page: *Downy woodpeckers live year-round in Alaska. A long, barbed tongue enables them to spear insects that are hidden in small holes.*

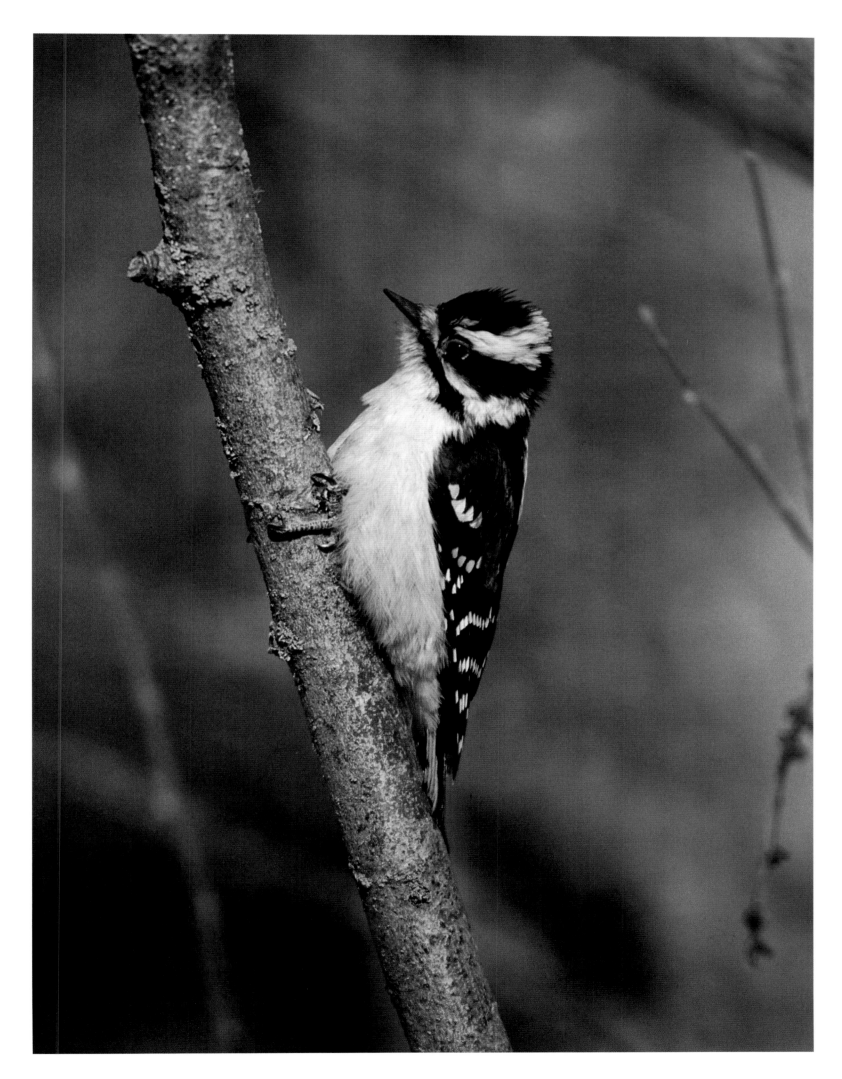

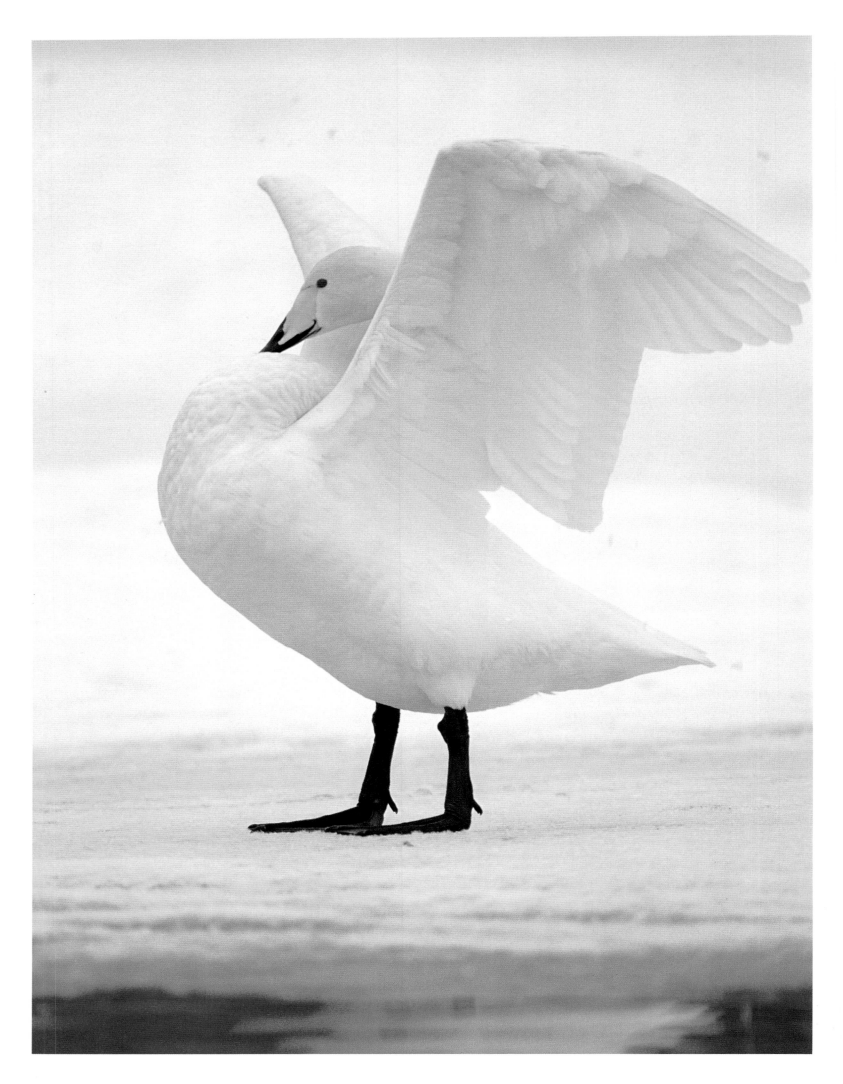

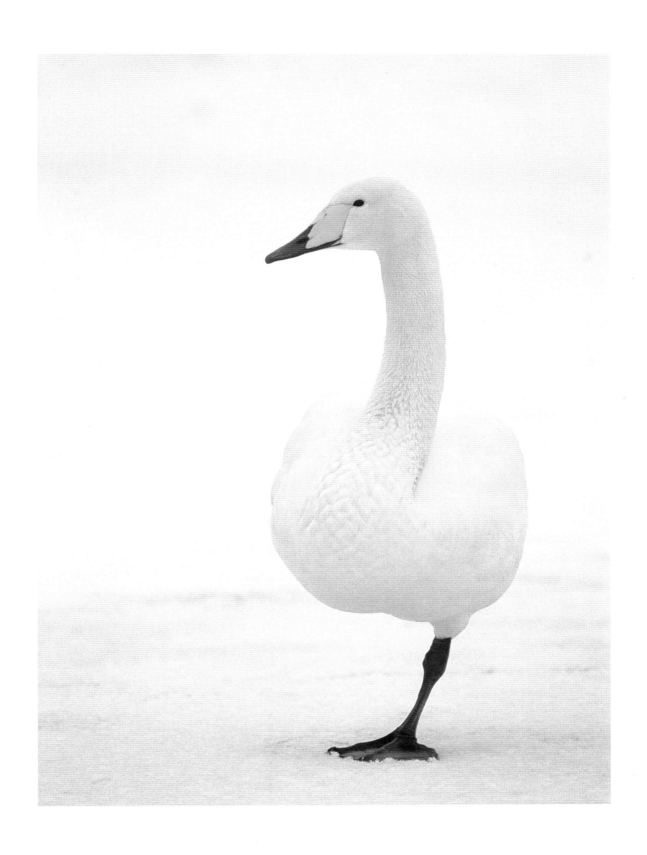

□ Facing Page: *Whooper swans are often described as the European counterpart of the trumpeter swan. Some consider the two birds to be one species. The two do share similar habits and appearance; however, the bill of the whooper swan is almost all yellow.* □ Above: *Whoopers swans winter in the Aleutians, rarely on Kodiak Island.* □ Left: *The upper Selawik River basin is the only known place in North America where whoopers have nested.* □ Overleaf: *Rutting season for Dall sheep extends through November into December. Head-butting battles between rams are for dominance, not for ewes.*

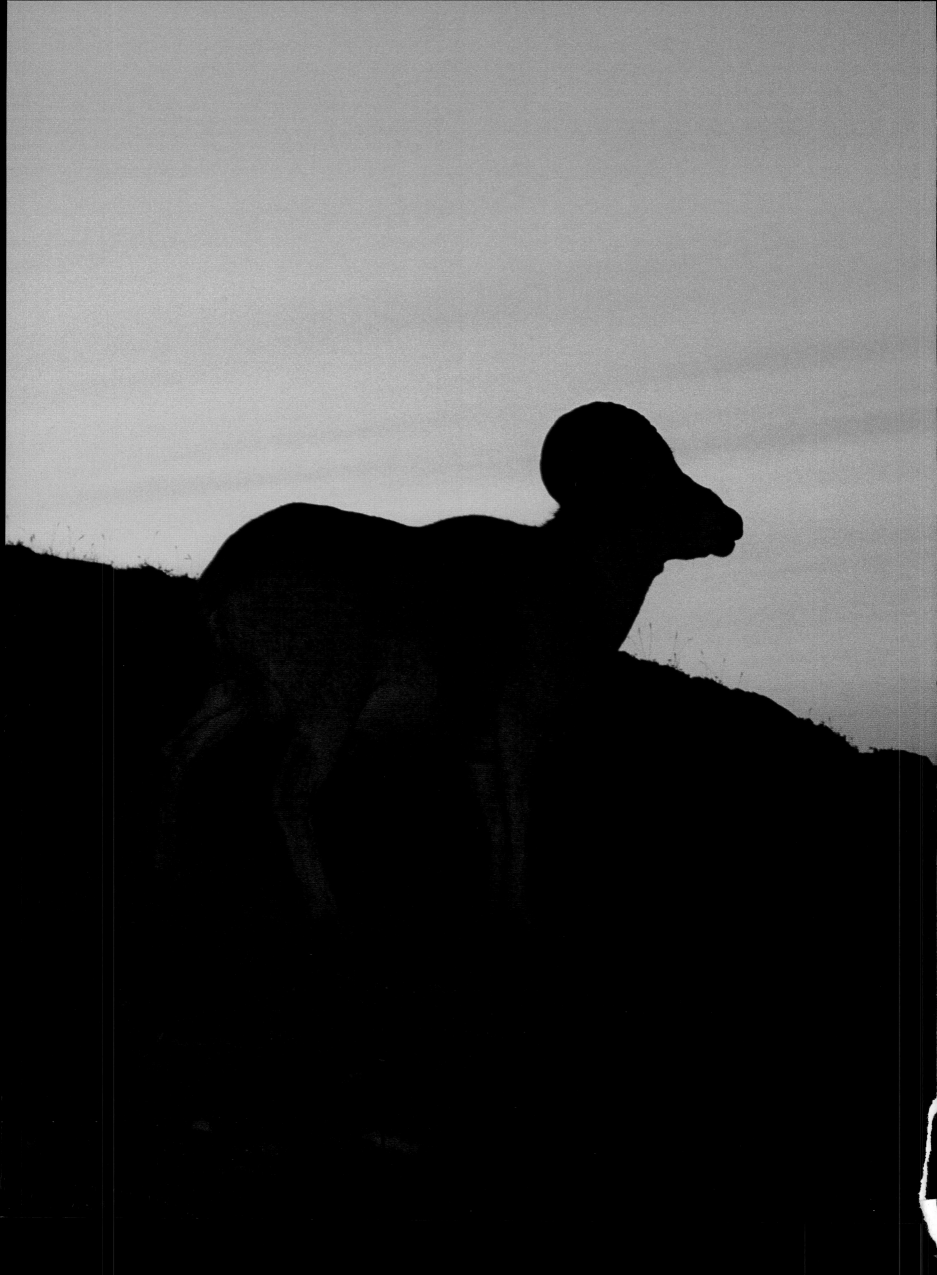

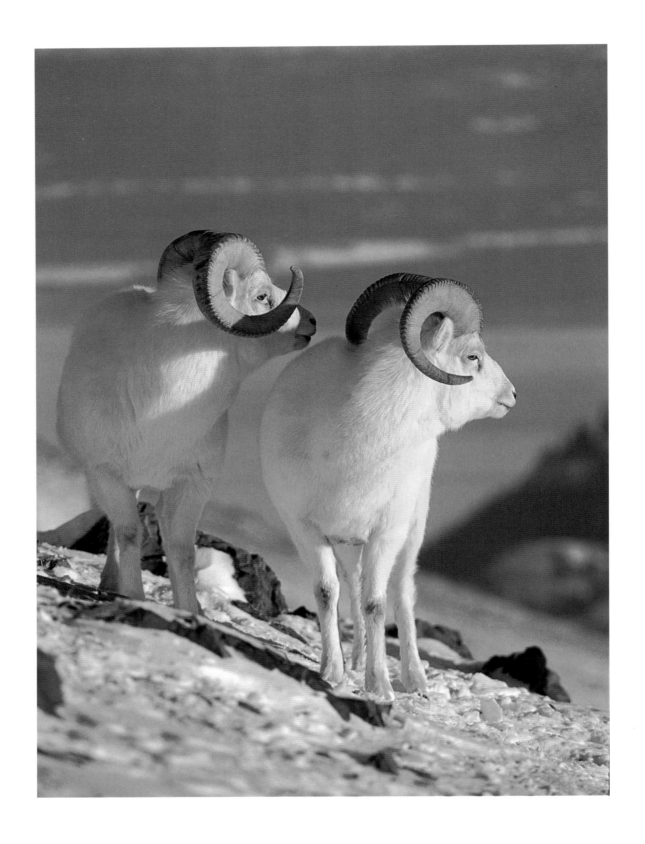

☐ Above: *Dominant rams, usually mature and heavy-horned, do most of the breeding. In this way, the genes of prime males only are passed on to future generations.* ☐ Right: *During the rut, in the days of little light, rams wander from ridge to ridge in search of estrus ewes. Serious dominance battles occur when a ram encounters a similar-sized stranger.* ☐ Facing Page: *Dall sheep are protected from the winter winds and cold, by an angora-like underhair and a coat of hollow hairs that is several inches long.* ☐ Overleaf: *In winter, bald eagles defend their prey along the coast and ice-free rivers such as the Kenai.*

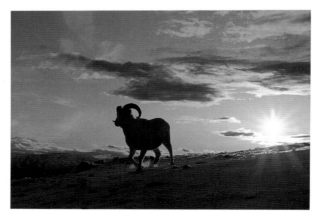

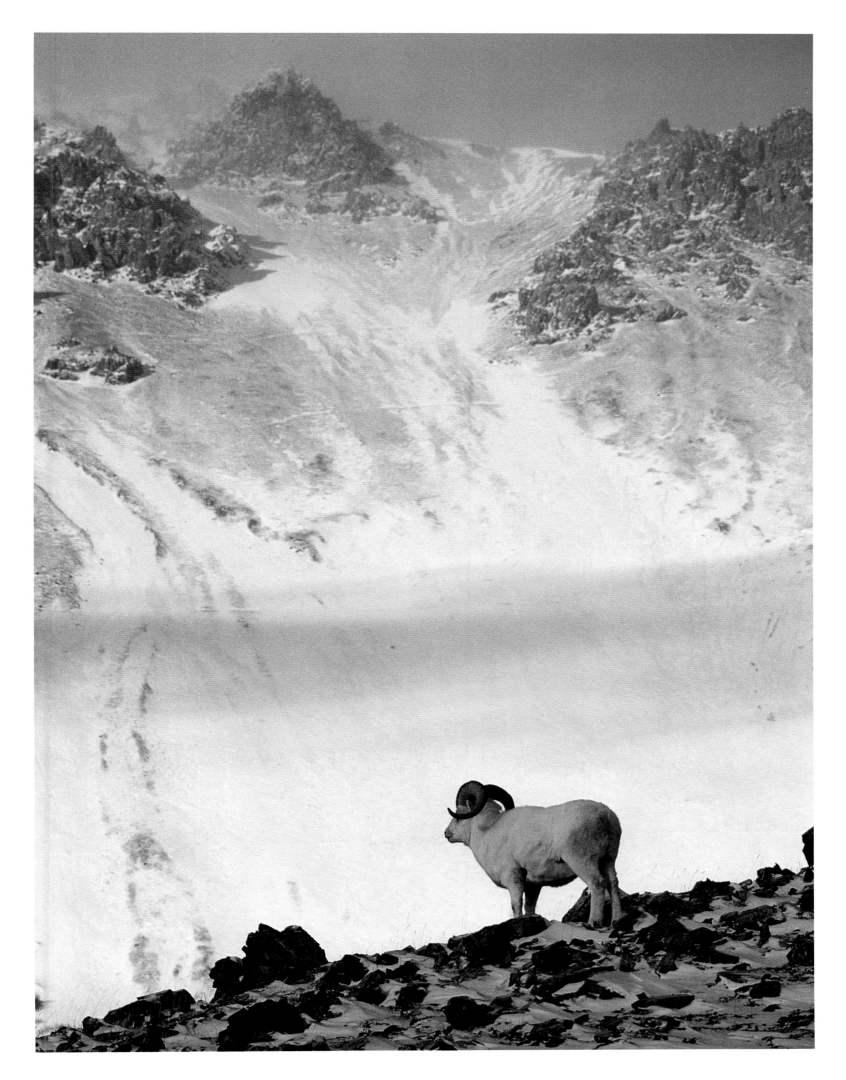

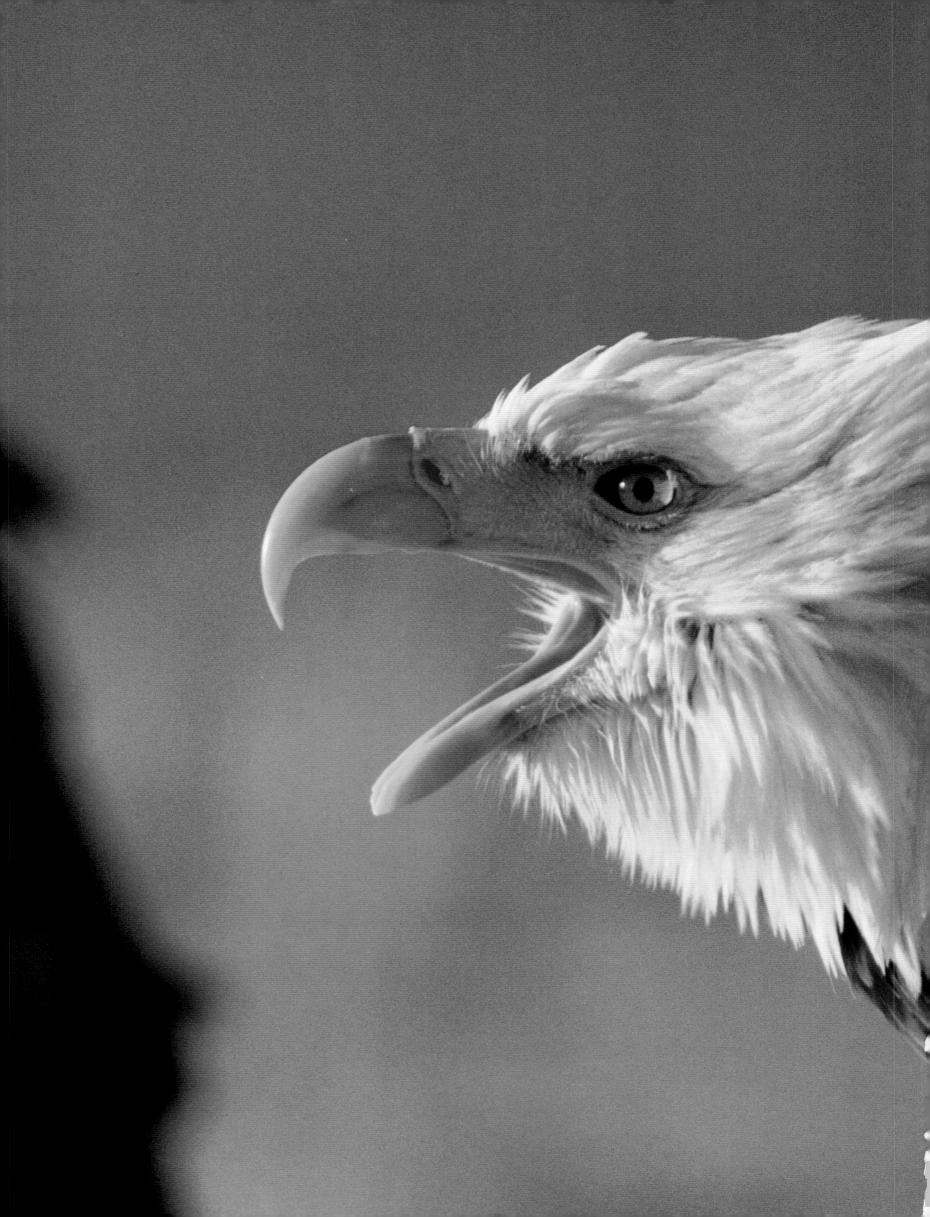

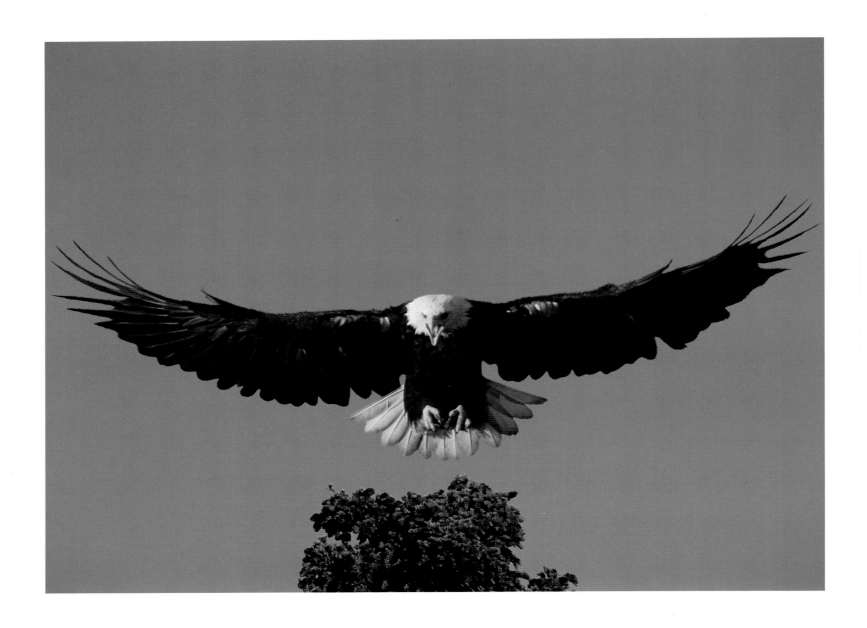

☐ Above: *With talons and wings fully extended, a bald eagle sets down on a black spruce. Eagle talons interlock in prey with a grasp almost impossible to break. The power of an eagle's foot resides in the rear and inside talons. These two talons are the longest and thickest of the four on each foot and can be three inches long.* ☐ Facing Page: *Female bald eagles are larger than the males. Eagles, which weigh ten to fourteen pounds, maneuver on wings that span seven to eight feet. They seem to lumber into the air and fly along with powerful beats. "Mantling" is a way the wings are used to protect food from other birds.*

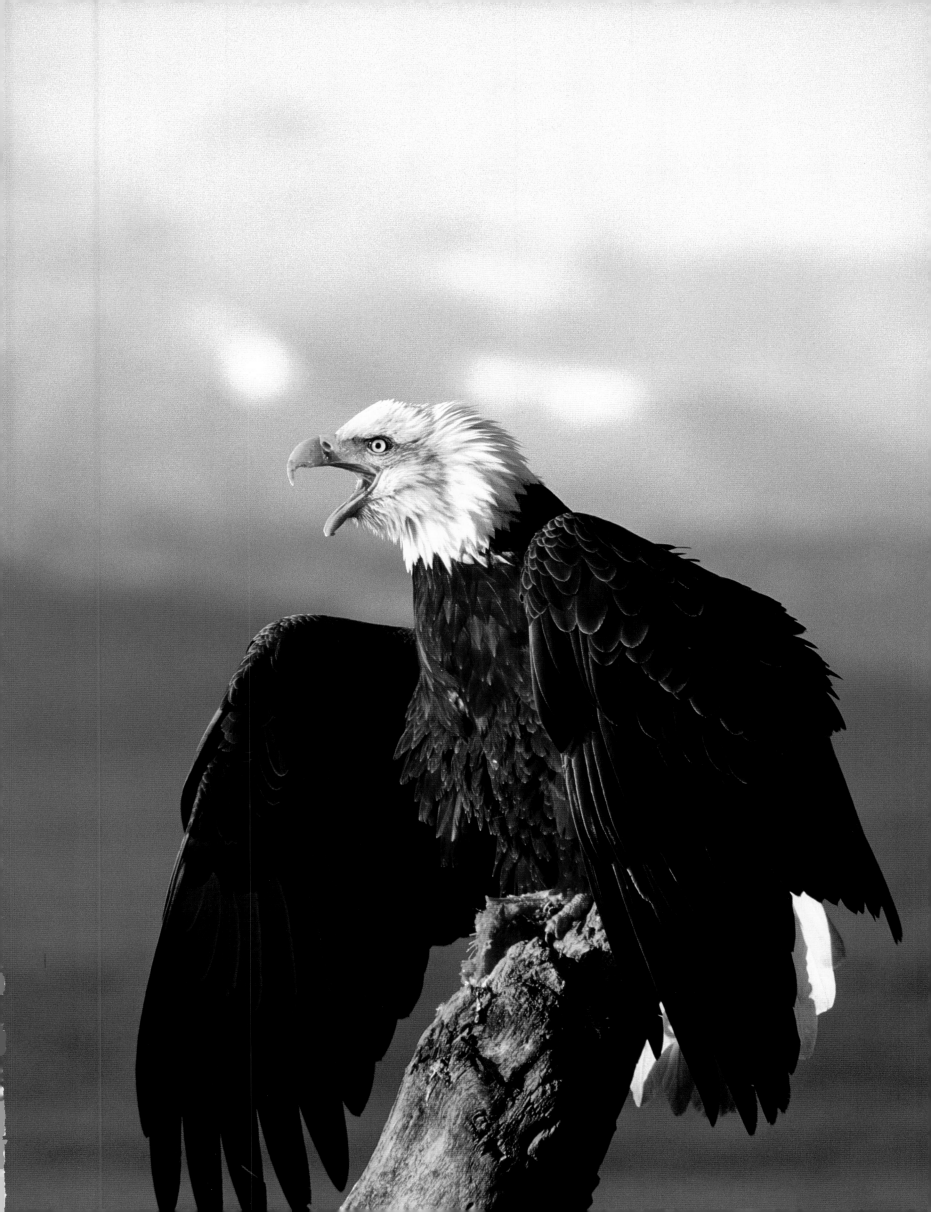

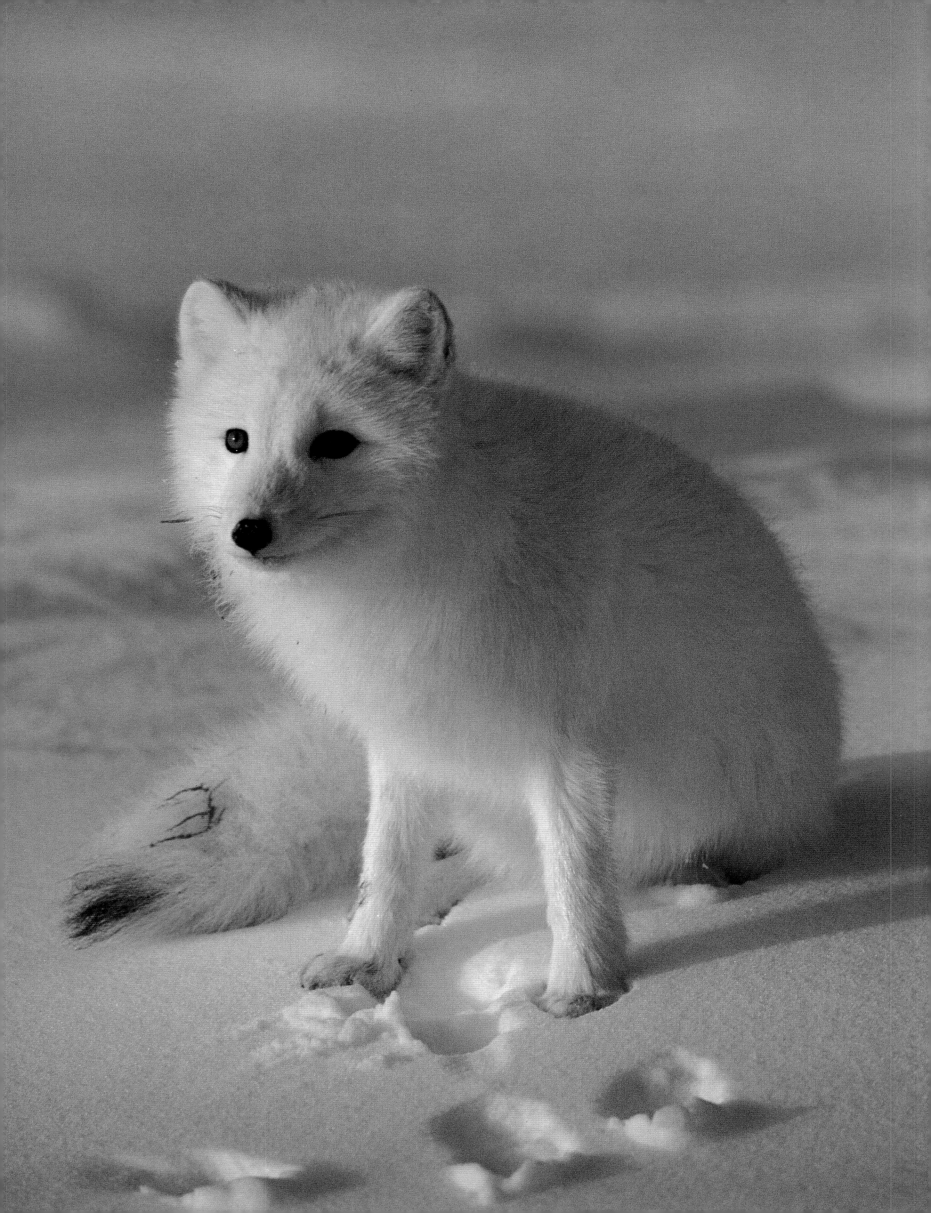

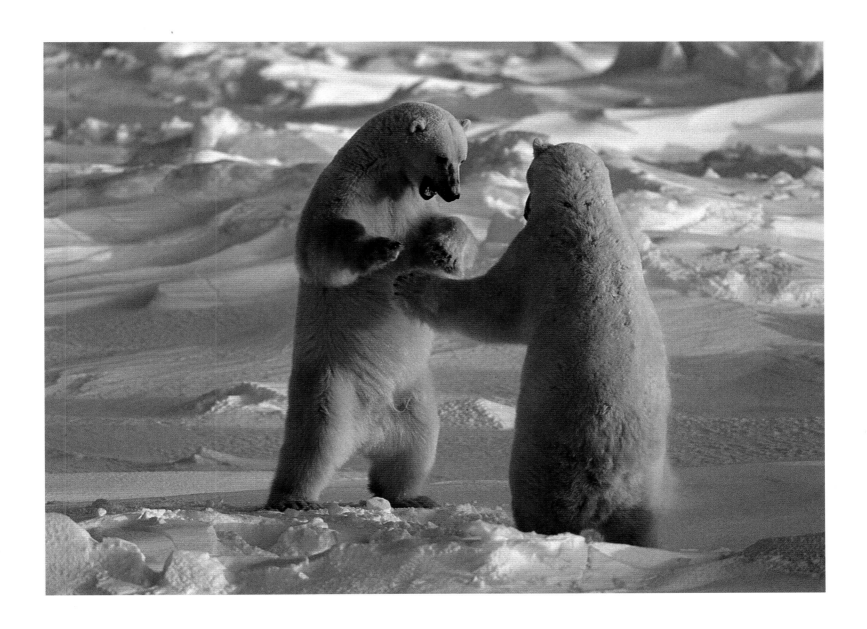

□ Facing Page: *Long, dense fur gives the arctic fox an appearance of being well fed and robust. Beneath a voluminous coat of the fox is a puny, malnourished frame. Feast or famine is the carnivore's way of life in the high arctic. If a fox happens on a bearded seal that has been killed by a polar bear, both animals may feast. A seal can weigh more than 750 pounds.*
□ Above: *Calm, cold weather can quickly close leads in sea ice, denying polar bears easy access to seals, their main prey. Juvenile polar bears, like these siblings, sometimes play-fight while waiting for the leads to open or for hunting conditions to improve.*

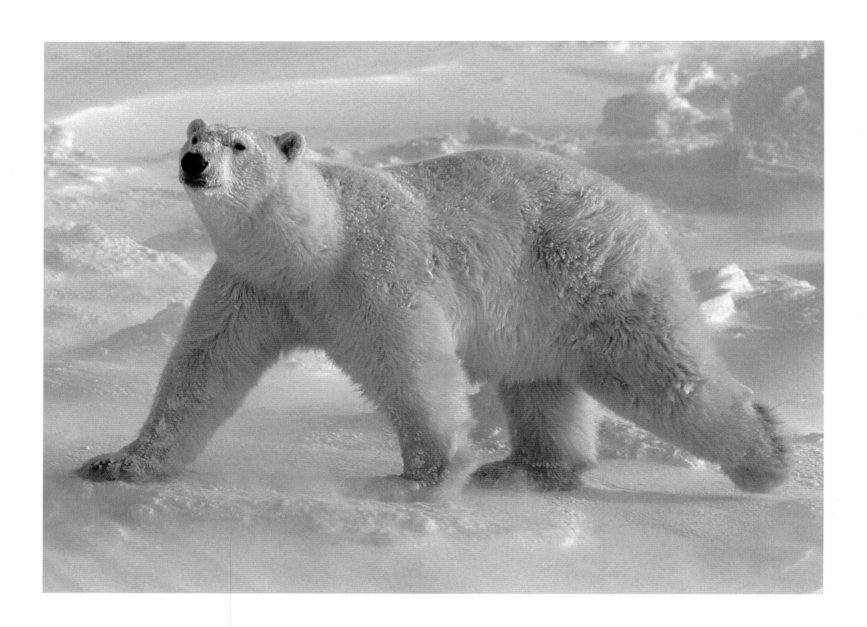

☐ Above: *Polar bear fur varies from white to almost yellow. Yellow summer fur results from oxidation; yellow winter fur is stained by seal oil. The individual hairs are actually hollow and clear; they only look white because of the scattering of the visible light. Solar heat passes readily through the hair to the dark skin beneath. Perhaps this absorbed energy is an aid to the polar bears in maintaining their body temperature.* ☐ Facing Page: *In the depths of the arctic winter, solar heating is non-existant. A bear's thick, wooly underfur and its two to four inches of subcutaneous fat offer vital protection from the cold.*

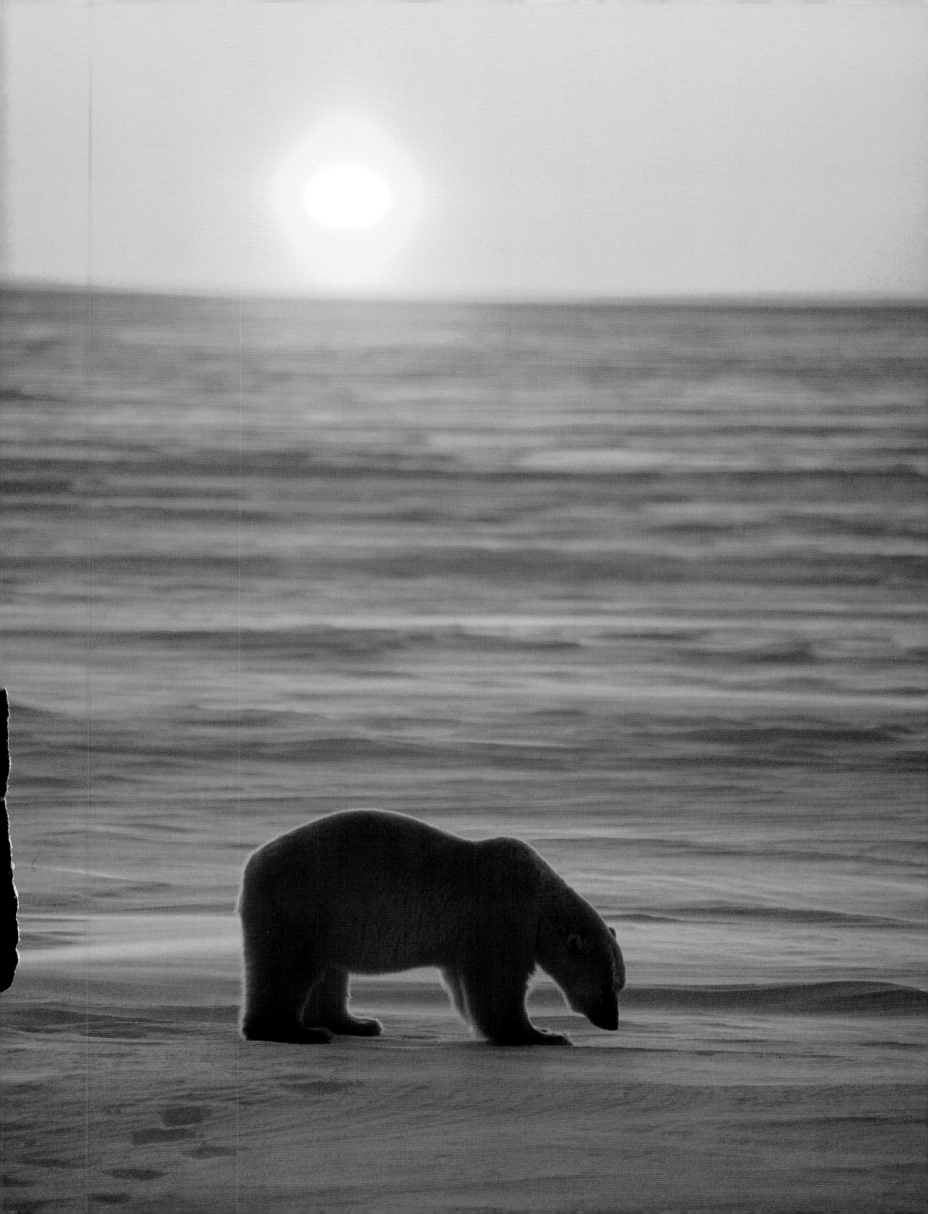

index

Admiralty Island . 17, 20
Alaska Peninsula . 17
Alaska, Southcentral . 9
Alaska-Yukon border . 11
Arctic National Wildlife Refuge . 10
Augustine Volcano . **113**
Aumiller, Larry . 17
Aurora Borealis . 24, 80
Beaver . 80
Bear
 Black 15, **16, 33, 52**, 80, **91**
 Brown/Grizzly **Cover, 3**, 10, **12**, 13-17, **27-31, 58, 59,** 80, **90**
 Polar **4-5**, 19, **108, 141-143**
Brooks Range . 12, 15, **45**
Caribou **2**, 10-12, **13**, 15, **25, 44-45**,52, 80,
 . **81-85, 92-93**, 108
Chickadees, Boreal . 23
Chilkat Bald Eagle Preserve . 17
Chilkat River . 17-18
Chugach Mountains . 9
Cold Bay . 15
Coyotes . 9, 16, 24, 26
Cranes, Sandhill . 9, 80, **104-105**
Crow, Northwestern . **108**
Deer, Sitka . **26,** 80
Denali National Park . 11, 23-24
Duck
 Harlequin . **108**
 Mallard . **103, 127**
 Pintail . 23, **37**
Eagle
 Bald **8, 17**, 18, 26, **34-35, 67, 136-139**
 Golden . 11, **64**
Elk . 15, 80
Falcon, Peregrine . 12
Fort Yukon . 16
Fox
 Red 10-11, 16, 24, 26, **62, 114-115**
 Arctic 14, **24, 26, 63**, 108, **120-121, 140**
Frog, Wood . 52
Goat, Mountain . 16, **109**
Geese
 Brant, Black . 15
 Canada . 9, 15, **23, 42, 43**
 Emperor . 15
 Snow . 9, **22, 106**
 White-fronted . 15, 22-23
Gulls . 16
Haines, Alaska . 17-18
Hare, Snowshoe 23, 26, **107, 110**
Hawks . 17, 26
Healy Ridge . 24
Homer Spit . 17
Izembek Lagoon . 15
Innoko National Wildlife Refuge . 22
Jaeger, Long-tailed . 11
Jay, Gray . 23
Kachemak Bay . **113**
Kenai River . 17
Kenai River Flats . 106
Kodiak Island . 17
Lemmings, Collared . 26
Loon
 Pacific . **39**
 Yellow-billed . **39**
 Red-throated . **14, 40-41**
Lynx, Canada . **7**, 26, **111**
Magpie, Black-billed . 10, 23
Marmot, Hoary . 26, 80
Marten . 16

Meier, Tom . 11
McNeil River State Game Sanctuary 16-17
Mink . **125**
Moose **10**, 15-16, 24, 26, **32, 52, 56-57**, 80, **94-97**,
 . 108, **112, 113**
Mosquitos . 14, 52
Mount Chamberlin . 15
Muskoxen . 108, **116-118**
Muskrat . 80
Nenana River Canyon . 23
Otter
 Land . 16, **124**
 Sea . 16, 19-20, **36**
Owl, Horned . 9, 26, **50, 53**
Oystercatcher, Black . **66**
Pika . **64,** 80
Pioneer Peak . 9
Plover, Golden . 12, **48-49**
Porcupine . **128**
Porpoise
 Dall . 19-22
 Harbor . 18
Pribilof Islands . 19
Prince William Sound . 16
Ptarmigan, Willow 9, 15, **26, 119**
Puffin
 Horned . **69**
 Tufted . **68**
Raptors . 15
Ravens . 9, 17, 23
Salmon, Red . **15, 60-61**
Salmon, Species . 16-17, 52
Scoters, White-winged . 22
Seabird Rookery . **79**
Seal
 Northern Fur . 19
 Harbor . 16, 18, 19, **21**
 Ice (Miscellaneous) . 19
Sea Lions
 California . 19
 Stellar . 19, 21
Sheep, Dall 9-12, 15, 26, **46-47**, 52, **54-55**, 80,
 . **86-89**, 108, **132-135**
Shorebirds . 9
Sparrow, Savannah . **51**
Squirrel
 Ground . 26, 80
 Red . 24, **65**, 80, **126**
Swan
 Trumpeter . 9, **38, 100-102**
 Whooper . **130-131**
Terns, Arctic . 16
Thrush, Varied . 9
Trout
 Steelhead . 16
 Char . 16
Voles, Red-backed . 23
Walrus . 19, **70-73**
Weasel (Ermine) . 23, 26
Whale
 Beluga . 16, 18
 Blue . 18
 Bowhead . 18
 Gray . 18
 Humpback . **1, 18-20, 75-78**
 Orca . 19-22, **52, 74**
Wolf 10-13, **11**, 15-16, 24, **26**, 80, **98-99, 122-123**
Wolverine . 15, 16
Woodpecker, Downy . **129**
Yukon River . 16